The Elements of Black-and-White Printing,
Second Edition

Going Beyond Darkroom Basics

The Elements of Black-and-White Printing,
Second Edition

Going Beyond Darkroom Basics

Carson Graves

Focal Press
Boston Oxford
Johannesburg
Melbourne New Delhi

 Butterworth-Heinemann supports the efforts of American Forests and the Global ReLeaf program in its campaign for the betterment of trees, forests, and our environment.

Library of Congress Cataloging-in-Publication Data
Graves, Carson, 1947–
 Elements of black-and-white printing : going beyond
 darkroom basics / Carson Graves, -- 2nd ed.
 p. cm.
 Includes bibliographical references and index.
 ISBN 0-240-80312-4 (alk. paper)
 1. Photography--Printing processes. I. Title

TR330 .G73 2000
771'.44--dc21

 00-052769

British Library Cataloguing-in-Publication Data
A catalogue record for this book is available from the British Library.

The publisher offers special discounts on bulk orders of this book. For more information, please contact:
Manager of Special Sales
Butterworth-Heinemann
225 Wildwood Avenue
Woburn, MA 01801-2041
Tel: 781-904-2500
Fax: 781-904-2620

For information on all Focal Press publications available, contact our World Wide Web home page at: http://www.focalpress.com

10 9 8 7 6 5 4 3 2 1

Printed in the United States of America

For Judy and Neal

Contents

Preface

The Elements of Black-and-White Printing is a resource for photographers who already have some experience in the darkroom but who want to understand more about the processes they are using. The benefit of this understanding is the ability to assume a greater control over what appears on the final print.*

In addition to explaining procedures, this book contains exercises to help you calibrate these procedures in your own darkroom and with the materials you prefer using. Use this book to guide your own experience and practice in the darkroom. The reward for this effort will be an understanding of printing that is both practical and flexible.

Two concepts, *print statement* and *expressive print*, help explain the purpose of this book:

- A print statement is the way that an image is crafted. It includes all of the choices that you make about an image in the darkroom, such as the materials you use, the print size, and even the print exposure. These choices, as much as the subject matter, affect how a viewer sees the image. Every image can have many technically correct print statements. Usually, however, only one print statement accurately expresses the content of a negative. In other words, some print statements are appropriate; others are not.

- An expressive print combines carefully seen subject matter with an appropriate print statement. The result is a print that satisfies a viewer on both an emotional and an intellectual level. Such prints radiate energy and luminosity while communicating the feelings and intentions of the photographer.

The Elements of Black-and-White Printing will help you make expressive prints by teaching you the techniques you need to produce appropriate print statements.

* For readers interested in brushing up on their basics, several useful books are available, including *Into Your Darkroom Step by Step* by Dennis Curtin and Steve Musselman, Focal Press, Boston, MA, 1981.

HOW TO USE THIS BOOK

There is no need to proceed through this book all at once. There are three points where you can pause, take what you have learned into the darkroom, and then continue only when you feel ready to learn more.

- The first pause is at the end of Chapter 3, "Changing Contrast for the Shadows." At that point you will have learned how to make correct decisions about exposure and contrast for your prints. These are the foundations of making an intentional print statement rather than an accidental one. If these techniques are new to you, practice them until they feel comfortable before proceeding.

- The second pause is at the end of Chapter 5, "Choosing a Paper and a Developer." This chapter and Chapter 4, "Photographic Chemistry—Creating a Developer," explain how print developers are formulated and how they interact with printing papers. These chapters are the basis of making an informed choice about which papers and developers are best for your print statement.

- The third pause is at the end of Chapter 8, "Toning." This chapter, Chapter 6, "Special Contrast Solutions," and Chapter 7, "Salvage Techniques," describe techniques that you can use to fine-tune your print statement. You may want to use some of these techniques right away. Others, you might want to use in the future. Skim the material first and concentrate on what interests you.

- Finally, Chapter 9, "Archival Processing," and Chapter 10, "Preservation and Presentation," instruct you on how to give your prints (and negatives) the best chance for long-term survival. This information will be increasingly important as you begin to produce prints that you want to keep and display.

The Elements of Black-and-White Printing concludes with appendices that provide information on darkroom safety; testing for and correcting enlarger alignment problems; making chemical conversions; annotated formulas for developers, toners, and other darkroom processes; suppliers for hard-to-find chemicals, darkroom equipment and safety information; and books containing additional information about black-and-white printing.

PREFACE TO THE SECOND EDITION

Many changes have been made to the text of the second edition to bring it up to date and to add more formulas and techniques. In addition, new for this edition is an appendix on safety in the darkroom, reflecting today's greater awareness of health and safety issues. In spite of this, the basic concepts of the black-and-white process that are the foundation of this book have not changed.

ACKNOWLEDGMENTS

As with the previous edition, a great number of people have made significant contributions to this book. These people include Maxim Muir for his encouragement and kind "loan" of two of his excellent developer formulas, Howard Etkind for his expertise in health and

safety issues, and Wendy Erickson of Ilford for publishing the first draft of what was to become the appendix on darkroom safety. Also thanks to Laren Lavery, Jennifer Plumley, and Marie Lee of Focal Press for their support, Margo Halverson and Charles Melcher for their excellent design work, and Carol Halberstadt for her editorial advice. Finally, my enduring appreciation to Judith Canty and Arnold Gassan for their years of friendship and support, and to all the photographers who gave their images for illustrations and whose contributions are listed in the back of this book.

Chapter 1

Reviewing Darkroom Fundamentals

Many photographers actually make worse prints after a year or two of experience in the darkroom than they did when they first started. It is so easy to expose and develop a piece of printing paper that they give in to the temptation to relax and begin taking short cuts without realizing the difference between convenience and bad habit. The resulting loss of print quality can happen so gradually that it isn't even noticed.

In a field as controlled by technology as photography, you need to periodically review your working procedures and discard any bad habits. If you neglect basics, such as developer temperature or enlarger alignment, then no amount of additional effort will produce a truly fine print.

This chapter covers the areas of basic darkroom technique, which is where most people create problems for themselves, and includes suggestions that you can follow to improve your own technique. The areas covered are:
- darkroom safety
- enlarger basics
- variable-contrast paper
- burning and dodging
- handling prints
- proper agitation

- chemical capacities
- temperatures and timing
- inspection lights

DARKROOM SAFETY

Every discussion of darkroom procedures should begin with making the darkroom a safe and comfortable working environment. Your safety and health require more of you than just reading the warning labels and liability disclaimers on a developer package, they mean learning about the ways that photographic chemicals can cause harm and how to protect yourself while using them.

Appendix A, "Darkroom Safety," contains important information you need to take common-sense precautions in the darkroom. Take time to study this appendix and then adapt your darkroom and working procedures as needed. In addition, where this book describes processes, such as toners and intensifiers that require special precautions, take note of the additional warnings that accompany the descriptions.

ENLARGER BASICS

All but budget-priced enlargers and enlarging lenses produce good results. Each, however, has individual characteristics that you should take into account. The same negative printed on different enlargers will have a different contrast and sharpness. There are three enlarger types:

- The most common is the *condenser* enlarger. This enlarger uses a tungsten light source, much like an ordinary household light bulb, which is focused by large lenses (condensers) before it passes through the negative.
- A second type is the *diffusion* enlarger. This enlarger uses a piece of frosted glass or plastic to scatter light nondirectionally before it passes through the negative. A variation of the diffusion enlarger uses a special fluorescent tube as a light source and is called a *cold-light* enlarger.
- Less common, but used by people working with graphic arts materials, is the *point-source* enlarger. This enlarger projects highly focused light from a bright, small-filament bulb through the negative.

Each of these enlarger types is capable of producing excellent black-and-white prints, but with certain tradeoffs. A condenser enlarger provides the best sharpness for the least cost. Diffusion enlargers are best at hiding dust spots and negative flaws but at the cost of slightly reduced print sharpness. A diffusion enlarger also produces prints with lower contrast than a condenser enlarger, requiring the use of higher contrast enlarging paper to produce equal results. Point-source enlargers produce the sharpest prints but are typically more expensive and more difficult to set up correctly.

You can adapt some enlargers to accept each of these light sources, so it is possible to experiment with more than one enlarger type to determine which is best for you. In spite of some claims to the contrary, no one enlarger type is inherently better than another.

Enlarger Alignment

For a print to be uniformly sharp, the planes of the negative, the lens, and the easel must all be parallel. If you haven't checked your enlarger for proper alignment, you should do so. Even new enlargers are rarely in proper alignment. See Appendix B, "Enlarger Alignment," for instructions on how to check an enlarger for alignment and for suggestions on how to adjust the alignment if necessary.

VARIABLE-CONTRAST PAPER

Many photographers appreciate the convenience of variable-contrast paper. This is printing paper that has several different contrasts built into the emulsion. Manufacturers of variable-contrast papers supply sets of differently colored filters that change the paper contrast. Although the contrast grades for each manufacturer's filters are slightly different, you can use filter sets from different manufacturers for most papers.

If you use variable-contrast paper, try to place the filter above the negative in the enlarger's lamphouse. Whenever you place a filter between the negative and the printing paper, you lose a small amount of sharpness due to dust and the accumulation of small scratches that are inevitable as you handle the filters. Placed above the negative, these flaws do not affect image sharpness as much. Not all enlargers permit the use of filters above the negative, however, and some photographers even claim not to be able to detect any difference in sharpness caused by the filter location.

When you use variable-contrast paper, always focus the enlarged image using white light. If you focus through a filter, especially one of the higher-contrast filters, the image you see with your eye will be in focus at a slightly different point than the image the paper sees. The result is an unsharp print.

Color Printing Filters and Variable-Contrast Paper

Instead of the filter sets designed specifically for variable-contrast papers, you can use the filters built into enlargers intended for color printing. This has the advantage of giving you many more contrast options than you have with the standard filter sets. Appendix C, "Variable-Contrast Filter Equivalents," lists color printing filter equivalents that you can use as a starting point for many popular variable-contrast papers.

BURNING AND DODGING

Done properly, burning and dodging enhance the details in a print. *Burning* is the adding of exposure to selected areas of a print to make them darker than they would be with only the main exposure. *Dodging* is the opposite: withholding part of the main exposure from selected print areas to make them lighter. Effective burning and dodging don't call attention to themselves and are invisible parts of the print statement. Unfortunately, inexperienced photographers either reveal their burning and dodging technique in the print or waste sheet after sheet of paper in an attempt to make their efforts look natural.

Problems generally occur because most photographers don't think about burning and dodging until they need a salvage technique for a print that is badly exposed or printed on paper of the wrong contrast. One of the goals of this book is to teach you ways to determine the correct print exposure and to select the right paper contrast. Proper exposure and contrast alone will eliminate a lot of burning and dodging and allow you to concentrate on using these techniques to enhance fine details.

There are as many methods for burning and dodging as there are people working in darkrooms. As long as the technique you use is comfortable and effective in adding exposure or withholding it, there is no reason to change. You should, however, keep in mind the following:

- Reflections in the darkroom are a significant problem. Examine the area around your enlarger, and either cover or remove possible sources of reflections. Any light-colored or shiny object near the enlarger can project stray reflections onto the print. The resulting loss of detail and added density (called *fog*) may not be immediately noticeable, but they have a significant impact on the subtle qualities that separate a good print from an average one.

- What you use to manipulate the light during burning and dodging is important. Always use a nonreflective and completely opaque object. Don't use a sheet of typing paper or an old print because a small amount of light is transmitted through the thin paper. This diffuse light can cause fog. Hands are also too reflective to use. If you like to use your hands to burn and dodge, try wearing a pair of black, nonreflective gloves. Inexpensive white cotton gloves sold by most cameras stores to handle film can be dyed black with India ink mixed in water.

- Limit the time the print is exposed to any light, even supposedly "safe" light. For example, if you use a red filter over the enlarger lens to determine which areas of the print to burn and dodge, remember that the light from a red filter can cause fog if left on too long.

- With variable-contrast paper, you can burn highlights and shadows through different contrast filters. When you burn a highlight through the lowest contrast filter, you minimize the "spillover" effect on the adjacent midtones and shadows. Likewise, you can burn a shadow tone through a high-contrast filter to avoid problems with nearby highlights and midtones. See Chapter 6, "Special Contrast Solutions," for more information on two-filter exposure of variable-contrast paper.

HANDLING PRINTS

Many good prints have been ruined by photographers who touch the printing paper with their bare hands while the print is being processed. Fingers contain many ridges and pores, and handling prints while they are in a chemical solution transfers that chemical from one print to another and from one tray to another. The result is contaminated trays of chemicals and stained prints. Instead, you should use print tongs (one per tray) to handle prints during

processing. Using tongs saves money by preventing ruined prints and keeps chemicals fresher for a longer time.

An even more important benefit of using print tongs is protecting your skin from direct contact with darkroom chemicals. Developers are alkaline, and stop bath and fix are acidic. The change in pH caused by dipping your hands in developer and then in stop bath causes the skin to dry out and eventually crack. Dry, cracked skin invites chemical absorption, which in turn increases the chance of your developing an allergic reaction to developers commonly known as metol poisoning.

At best, metol poisoning is a painful rash, and at worst, it can keep you from ever working comfortably in the darkroom again. Gloves and skin preparations, such as barrier creams, are good supplements, but nothing can replace the proper use of tongs both for print quality and personal comfort. Protecting you skin from contact with processing chemicals is discussed at greater length in Appendix A, "Darkroom Safety."

PROPER AGITATION

The purpose of agitation during development is to replace exhausted developer at the surface of the print emulsion with fresh developer. Letting a print sit still in the tray produces unevenly developed tones. This is why it is important to keep the print moving. How you do this is less important than making sure that you do it at regular intervals.

Effective agitation methods include rocking the tray (although in a small sink it is easy to spill developer into the stop bath), turning a print over at regular intervals, holding a print by one corner and moving it back and forth, or any combination of these. The important thing is using a consistent technique.

Regardless of how you agitate the print, pick it up approximately every 30 seconds and let it drain from the corner for about 5 seconds. Physically removing the print from the developer in this way breaks the surface tension of the liquid and ensures that fresh developer reaches all parts of the emulsion evenly when you place the print back in the tray.

Agitating a print in the stop, fix, and washing aid is equally important. Each step is a chemical process that must occur evenly and completely. It is never acceptable to leave a print in a solution while you are doing something else.

CHEMICAL CAPACITIES

Chemical solutions in the darkroom have short effective lives. As these chemicals are inexpensive relative to the cost of printing paper, it pays to plan your printing sessions around the capacities of your working solutions. The following suggestions are useful for standard print processing. For maximum print life, additional care is needed. See Chapter 9, "Archival Processing," for details.

Developer

Although individual developers vary, a general rule is that for a quart of working solution, develop a maximum of 20 8 × 10-inch prints. Be sure to include your test strips in the total. After reaching

this maximum, prints will no longer have a full, rich scale of tones. Also, a developer diluted to working strength oxidizes within a couple of hours even if it hasn't been used. Mix working developer only as you need it.

Stop

Although many commercial stop baths contain a dye that changes color to indicate exhaustion, these indicators change only after the solution is no longer working effectively. This allows developer by-products to contaminate your fixing bath. To maintain the efficiency of your fix, don't wait for the the stop bath's indicator to turn color; replace the stop bath every time you change your developer.

Fix

Used properly, a silver iodide test solution (available commercially from Edwal Scientific Products as Hypo-Chek) gives a good indication of when a fixing bath is exhausted for normal use. A drop or two of the test solution in the fixing tray will indicate by the presence of a milky white precipitate that the fix is no longer usable.

If you use a rapid-type fix, you must remove an ounce or two of the fix from the tray and test that rather than testing the entire tray of solution. Putting drops of the test solution directly in a tray of rapid fix won't indicate exhaustion until well after the fix has gone bad.

Many photographers leave open trays of partially used fix in their darkroom for days at a time. Unfortunately, water and acid evaporate from fixer, upsetting its pH balance and its ability to fix prints properly. Cover the fixing tray between printing sessions, or better yet, store the working fixer in an air tight bottle reserved especially for that purpose.

Washing Aid

Most commercial washing aids, such as Heico Chemicals Corporation's Perma Wash or Kodak's Hypo Clearing Agent, contain a chemical that replaces the thiosulfate in a print (left over from the fix) with a more water soluble compound. This shortens the time needed to wash the print. A washing aid doesn't substitute for actually washing a print; the chemicals left in the print after treatment are still harmful to the image.

As you process prints in a washing aid, its effectiveness is decreased. Follow the manufacturer's capacity recommendations for the particular product you are using. Pay special attention to any instructions about the tray life of the product.

CHEMICAL TEMPERATURES

Although photographers are usually very careful about the temperature of their film developer, few pay much attention to the temperature of their print developer. This is a common cause of poor prints.

Chemical reactions, such as development, are temperature sensitive. They are more active at higher temperatures, and less

active at lower temperatures. The ideal temperature for most darkroom chemicals is 70° if you are using a Fahrenheit thermometer or 20° if you are using a Celsius thermometer. The two temperatures aren't exactly the same, but each represents a major mark on darkroom thermometers, and thus are easier to see (and maintain) under normal working conditions.

Most developers contain two active ingredients, called *developing agents*, which have different temperature sensitivities. These ingredients are metol (also known as Elon, a Kodak proprietary name) and hydroquinone. Metol develops the midrange and light tones in a print, and hydroquinone enhances the dark tones. Together, they produce a full-scale image (one with a complete range of tones), but only under the correct temperature conditions.

Metol reacts in a predictable way to changes in temperature, increasing and decreasing in activity gradually and at an even rate. Hydroquinone is less predictable. At temperatures higher than 75° F, it is aggressively active, overemphasizing dark tones. As the temperature drops to less than 65° F, hydroquinone loses its ability to develop tones at all, leaving a print gray and muddy in the shadows.

If you try to compensate for a developer that is too hot or too cold by changing exposure or development times, you can end up with a print that has either dark muddy tones, or one with chalky white highlights and dense featureless shadows. If you use a developer that is only a little too warm or a little too cool, you affect your prints in a less drastic way, probably without even realizing it.

The other chemicals in a black-and-white darkroom aren't as temperature sensitive as the developer, but it is a good idea to keep them within 5° F of the developer temperature. This is especially true of the wash water. A cold water wash (below 65° F) is almost completely ineffective for removing residual fix. A warm water wash (over 80° F) will actually cause the emulsion of a print to float off the paper base if the print is washed too long.

Maintaining Even Temperatures

Check the temperature of your chemicals frequently. If the air temperature of your darkroom is much higher or lower than the ideal chemical temperature, use a water bath.

You can make a water bath by placing trays containing your processing chemicals inside larger trays of water at the correct temperature (Figure 1-1). The larger mass of water cools down or warms up more slowly than the smaller volume of the chemical. As the temperature of the water bath rises or falls, adjust it by adding more hot or cold water until it is correct again.

Some photographers use their sink as a large water bath, putting a raised lip around the drain so that they can fill the sink with two or three inches of water in which to place the processing trays.

Figure 1-1 A typical water bath arrangement. Placing your chemical trays inside a larger tray of water maintains the inside tray's temperature when the air temperature is significantly higher or lower than 70° F. Note the separate print tongs for each tray.

TIMING

Careful timing ensures correct print processing. The chemical reactions that occur as a print moves from developer to stop to fix require a certain amount of time to complete. They can also harm a print if allowed to continue too long. Use the following processing times when you print. Note that all of the times assume a temperature of 70° F.

Developer

Use 2 minutes as a standard for developing a print, even for resin-coated paper, which tends to produce a visible image more quickly than fiber-based paper. Having a standard development time gives you the option of using different development times to produce predictable changes in contrast and density. The usefulness of this is discussed in Chapter 3, "Changing Contrast for the Shadows."

Developer-Incorporated Papers and Developing Times

Some enlarging papers are manufactured with components of the paper developer already present in the emulsion. These papers are designed for use with automatic processors where speed is an important factor, although they can be used in ordinary tray processing. Most developer-incorporated papers are labeled as such on the box.

In normal tray processing, a developer-incorporated paper produces a visible image more quickly than conventional paper. In spite of this, you should adhere to a standard development time, as the subtle tones of the image still take time to appear.

One additional precaution to observe when using developer incorporated paper is not to develop conventional paper in a tray after you have processed developer-incorporated paper in it. Residual chemicals left behind from the incorporated developer components can stain conventional paper, especially if it is fiber-based.

Stop Bath

Agitate a print in stop bath for 1 minute if you are using fiber-based paper and 30 seconds if you are using resin-coated paper. Most photographers don't keep their prints in the stop bath long enough

because they think that the only purpose of a stop bath is to neutralize the alkalinity of the developer. Although it is true that this process takes only a few seconds, another function of the stop bath is to remove the residue of bromide compounds created in the emulsion of the paper while it is developing. This requires the full recommended time. If any bromide compounds are left in an emulsion when the print goes into the fix, they appear as permanent gray stains.

Fix

Fix a print for 5 minutes in a standard fix (one containing sodium thiosulfate) or for 2 minutes in a rapid type-fix (one containing ammonium thiosulfate). Less than the recommended time incompletely fixes the emulsion, and more than the recommended time can cause the emulsion and paper fibers to reabsorb the chemical residue of the fixing process. If you are developing test strips or work prints that you don't intend to keep, you can remove them from the fix for inspection after only a minute.

Washing Aid

Three minutes in a washing aid is enough for most conventional fiber-based papers if you agitate the prints properly. Resin-coated papers require only 1 minute.

Washing

After treatment in a washing aid, wash resin-coated paper for 10 minutes and fiber-based paper for at least 20 minutes. Be sure that prints are kept separate and given adequate agitation.

Washing times assume a system in which there is a complete change of water every 5 minutes. You can check the efficiency of a print washer by adding ½ to 1 ounce of food dye to the wash water and timing to see how long it takes for the color to go away. It should disappear in 5 minutes. Washing efficiency isn't helped by increasing the flow of water beyond this point. You will only waste water.

INSPECTION LIGHTS

A darkroom should contain a white inspection light so that you can evaluate a print as soon as it is fixed. The type and intensity of this inspection light are very important. It should simulate the conditions under which you will normally view your prints when they are finished.

If the inspection light is brighter than your normal viewing conditions, you will tend to make prints that are too dark. If the light is too dim, your prints will tend to be too light. If the inspection light is a standard fluorescent tube, the blue rich color spectrum of that light will cause you to make prints with too much contrast.

It is important to stress that the inspection light should simulate your normal viewing conditions, not duplicate them. There are many differences between your darkroom and the average living room wall or art gallery and you must make allowances for these differences. Start by making some observations

about what viewing conditions you prefer for your photographs. In general, the most satisfactory lighting seems to come from tungsten bulbs with perhaps a small mixture of fluorescent light or indirect daylight. Take a light meter reading off of a neutral-density gray card in conditions you consider ideal.

Once you discover an optimum intensity for your viewing light, adjust your darkroom inspection light to have the same intensity at the location where you normally examine your prints. You want to duplicate the intensity of light falling on the print, not the wattage of the bulb itself. A low-wattage bulb at close range will cast as much light as a higher wattage bulb at a greater distance.

Finally, when you are printing, allow your eyes at least 30 to 45 seconds to adjust to the the inspection light after you turn it on. Remember that under a dim safelight your pupils are highly dilated and must have time to contract under the relatively bright illumination of the inspection light.

Confirm the correct intensity of your inspection light by making three prints from the same negative. Make the first print for what appears to be the correct exposure under your inspection light. Then make a second print with about 5% to 10% more exposure than the first, and a third print with about 5% less exposure than the first. When the prints are fully processed and dry, compare them to see if the first print still represents the best exposure. If the print with more exposure now looks better, increase the intensity of the inspection light. If the print with less exposure looks the best, decrease the intensity of the inspection light. Repeat the test until what you see under your inspection light matches what you expect in the dry print.

Figure 1-2 Examine wet prints under an inspection light that duplicates the intensity and color spectrum of your ideal print viewing light. Note that it helps to squeege the the print on a flat surface to remove excess liquid that could affect how you judge the tones.

"Dry Down" in Prints

Most photographers have experienced a situation in which a print looks fine when they inspect it in the darkroom but somehow loses the sparkling highlights and detailed shadows they originally saw when the print dries. This phenomenon is commonly called *dry down* and can happen even when you have carefully adjusted your inspection lights.

Dry down occurs because the gelatin emulsion of a print swells when it is wet and contracts when it is dry. Highlight tones are less visible in a wet and swollen emulsion than they are when the emulsion is dry. In the same way, shadow tones that are distinct and separate when a print is wet become compressed and lose their separation when the print is dry.

Differences in the composition and manufacturing of print emulsions explain why some types of printing papers exhibit a greater dry down effect than others (and why some photographers debate the actual existence of dry down). If your paper exhibits a noticeable dry down, you can minimize the effect by taking the print out of the fixing tray, rinsing the print in water, and squeegeeing the surface dry on the flat bottom of an unused tray or a piece of Plexiglass before you inspect it. This, combined with a careful use of your inspection light, will allow you to accurately judge how a wet print will look when it is dry.

SUMMARY

- Your health and safety in the darkroom requires that you learn more about the chemicals you use than just reading the warning labels on the products. You must become informed about the ways photographic chemicals can cause harm and what you must do to minimize the risks from handling them.
- There are three enlarger types: condenser, diffusion, and point-source. Each has specific characteristics and produces different print statements, although no one system is inherently better than another.
- Proper enlarger alignment is critical for making uniformly sharp prints.
- Variable-contrast papers, when used with the appropriate filters, are convenient ways to have access to a variety of contrast grades at minimal expense. Placing the filters above the negative stage generally produces sharper prints than placing the filters between the negative and the printing paper.
- Burning and dodging are two techniques that can improve the tones in selected areas of a print. Successful burning and dodging aren't noticeable.
- Print tongs reduce the possibility of contaminating a print and eliminate the necessity of bringing your hands into contact with darkroom chemicals.
- Proper agitation and correct timing ensure even development, and prevent stains and other contamination.
- Processing chemicals are inexpensive relative to the cost of printing paper. Know the capacity of the different chemicals you use and replace them before they cause problems.

- You can maintain even chemical temperatures by using a water bath. A water bath uses a volume of water surrounding the processing trays to hold them at a constant temperature for a longer time than normal.
- Carefully time each step of the printing process. The chemical reactions that occur as a print moves from developer to stop to fix require a certain amount of time to complete. They can also harm a print if allowed to continue too long.
- The type and intensity of your inspection light should simulate the viewing conditions of your finished prints. Too bright or too dim an inspection light can make your prints darker or lighter than you want.

Chapter **2**

Exposing for the Highlights

There are many books and theories to help photographers expose their negatives, but relatively little has been written and even less is generally understood about exposing prints. In a way, this acknowledges the priority that negatives have over prints. You can always make a new print, but you only have one chance to expose a negative.

Today, with the increasing cost of quality printing paper, it makes little sense to use up materials just to find the right print exposure. Knowing how to find an exposure efficiently not only saves money, but also allows you to concentrate your efforts on refining the print statement.

HOW EXPOSURE AFFECTS A PRINT

When you expose a print, the amount of light striking the paper in the lightest areas of the image (the highlights) determines how those areas will appear after development. Nothing else that you do in the darkroom short of badly processing the print can change the appearance of those highlights. This isn't to say that exposure doesn't also affect the darker areas of the print, but it is in the highlights that you first notice the effects of exposure changes. It only takes a small change in exposure to turn a luminous and

bright highlight into one that is gray and muddy. This difference doesn't show up as dramatically in the other areas of the print (Figure 2-1).

Figure 2-1 This graph shows how changes in exposure affect highlights more than darker print tones. Consider the effect of adding one unit of additional exposure to a print that has already received one unit of exposure in the highlights, five units in the mid-tones, and ten units in the shadows. The additional exposure unit increases the exposure in the highlights by 100%, the exposure in the mid-tones by 20%, and the exposure in the shadows by only 10%. The effect in the highlights is 10 times more than in the shadows.

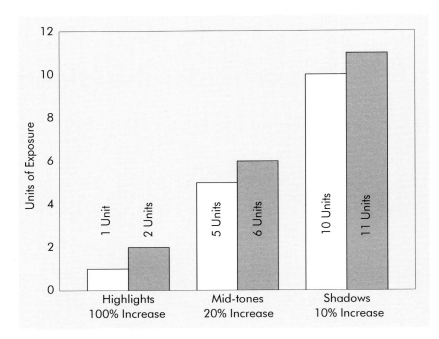

Readers familiar with the zone system, a method of exposing negatives, will recognize this technique. It is the same as exposing a negative in the camera, where you also determine exposure based on the areas of least density. The only difference is that the areas of least density in a negative are the shadows, while in the print (a positive), these areas are highlights. Since black-and-white film and printing paper contain similar light-sensitive emulsions, this fact should not really be surprising.

FINDING YOUR MOST IMPORTANT HIGHLIGHT

The best exposure for a print is one that accurately interprets the highlight tones in the negative. To find this exposure, you first determine which highlight is the most important in the image and then decide how that highlight should look on the print.

Deciding which highlight in an image is the most important means understanding the significance of that highlight to the print statement. For example, the way that snow appears in a winter landscape is probably critical to a successful print of that scene. Likewise, in a portrait containing Caucasian skin, the rendering of that highlight tone is usually important.

When deciding on the most important highlight in an image, ask yourself which one must be rendered accurately for a print of that image to convey the meaning you want. Don't choose a highlight just because it is the lightest or the largest in the image. Unimportant highlights can appear a variety of ways or can be burned and dodged without significantly changing the print statement.

Identifying Highlights

Once you determine the most important highlight, you need to decide how that highlight should look on the print. There are four basic ways that a highlight can appear: as a blank white, as a very light gray tone, as a textured light gray, and as a tone just lighter than middle gray. Using these terms to describe the highlights in your negative will help you make your decision about how you want them to appear.

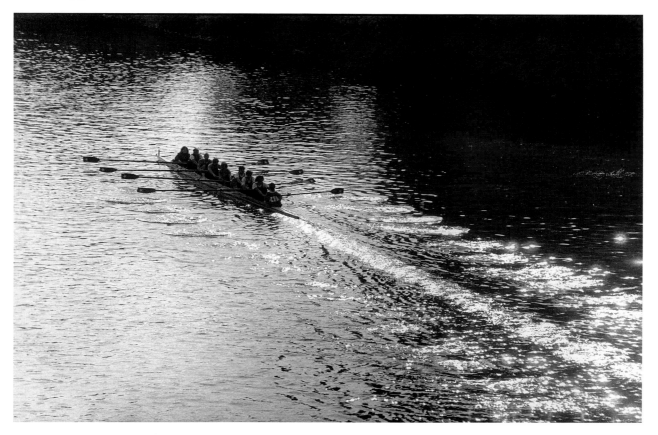

Blank White

A blank white highlight is the same as the white base of the printing paper (Figure 2-2). A highlight can't get any lighter than this. Typically, this highlight appears in a print only when an image contains bright lights shown either directly or in a reflective surface.

Figure 2-2 An image containing a blank white tone. The sparkles on the water behind the rowers are the lightest tone that printing paper can produce.

Figure 2-3 An image containing an area with the first appearance of gray. The seat and railings of the boat in the foreground are a light gray tone that has no detail or texture. Although it is a featureless highlight, the seat and railings have the appearance of a solid object, unlike the specular reflections in Figure 2-2.

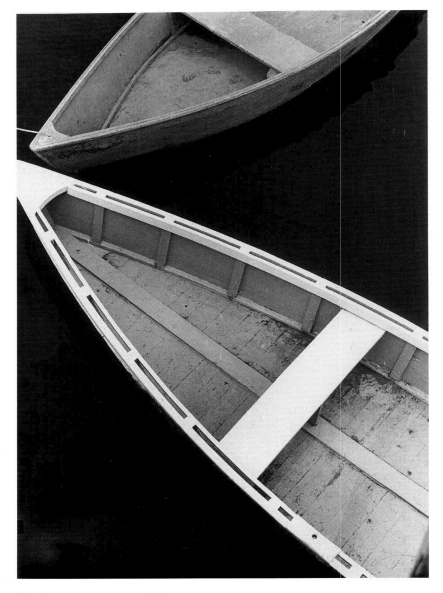

First Appearance of Gray

The first appearance of a gray tone in a print is often used to represent a bright object that doesn't have any detail or texture, such as smooth, white painted metal or wood (Figure 2-3). It is sometimes difficult to tell the difference between this highlight and a blank white highlight unless they are side by side.

Textured Highlight

A textured highlight is normally the tone in which white objects with fine detail appear in prints (Figure 2-4). Examples are weathered white painted wood and white beach sand when you are close enough to see the individual features.

Figure 2-4 An image containing a textured highlight. The church dome shows a full range of highlights from blank white to just lighter than middle gray. The predominant highlight, however, shows the texture and detail of the stucco.

Darker Highlights

Darker highlights are typically the way that concrete sidewalks, the clear north sky, and Caucasian skin appear in prints (Figure 2-5). Especially in portraits, most people notice when white skin tone is rendered correctly.

Figure 2-5 An image containing darker highlights. Evenly lit Caucasian skin tone is a good example of a darker highlight on most prints.

MAKING EXPOSURE TESTS

After deciding which is the most important highlight in the image and how you want it to look, the next step is making that highlight appear the way you want it on the print. This involves making an exposure test based on your printing paper's ability to produce a highlight that matches your description.

Most photographers make exposure tests by progressively uncovering a single small strip of printing paper while exposing it under an enlarger. The result is what is normally called a *test strip* because it contains different exposures on a single piece of paper (Figure 2-6).

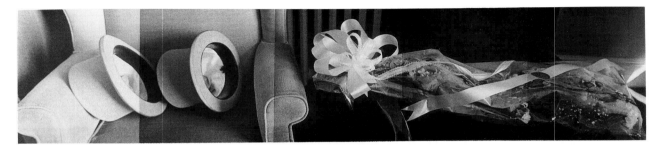

Figure 2-6 Example of an exposure test containing different exposures on one piece of paper. The question of which exposure represents the correct exposure for the final print is difficult to answer because each exposure is on a different part of the image.

Unfortunately, each exposure is in a different area of the print. Some of these areas might contain highlights, but others might not. It is unlikely that the most important highlight will appear in all areas of the test strip. This prevents you from making accurate comparisons. You can only guess what an exposure in one part of the print will look like in another.

An additional problem with the exposure test shown in Figure 2-6 is that it requires several different exposures on a single piece of paper. A law of photochemical reactions known as the *intermittency effect* states that dividing an exposure into several shorter time segments produces a different density than a continuous exposure of the same total duration. In other words, four 5-second exposures won't produce the same print tones as one 20-second exposure.

An accurate exposure test requires that you compare the same highlight at different exposures and that each exposure be a continuous one. The following is a description of such a test. Follow these steps each time you make a print for one of the exercises in this book.

Preparation

For the exposure test, you need a full sheet of normal-contrast printing paper, a pair of scissors, and two light-tight containers, such as empty paper boxes.

1 Place the negative you want to print in the enlarger, focus the image on your easel, and locate the area containing the most important highlight. This isn't necessarily the brightest highlight, but the one that is most meaningful in the image.

2 Stop the enlarging lens down two or three stops from its maximum aperture and set the timer to 5 seconds. Turn the enlarger light off.

3 Cut a full 8 × 10-inch sheet of normal-contrast printing paper into four approximately equal pieces. These are the test strips. Put three test strips in one of the light-tight containers.

Exposing the Test Strips

1 Place the first test strip on the easel at the location of the most important highlight, and expose it for 5 seconds. Put the exposed strip in the second light-tight container.
2 Reset the timer to 10 seconds. Place a second test strip in the same location as the first, and give it a 10-second exposure. Put it in the box with the first exposed test strip.
3 Reset the timer to 15 seconds. Place a third test strip in the same location, and give it a 15-second exposure. Put it in the light-tight box with the other two exposed test strips.
4 Reset the timer to 20 seconds, and expose the fourth test strip for 20 seconds.

Processing the Test Strips

Develop all four test strips together for 2 minutes. After the stop bath, fix the test strips for at least 1 minute.

Evaluating the Results

1 Examine the test strips under an inspection light. Arrange the strips in order from lightest to darkest. The 5-second exposure should be too light in the highlights, and the 20-second exposure should be too dark. The results should resemble Figure 2-7. Don't concern yourself with what is happening in the mid-tones or the shadows.
2 If all of the test strips are too light or if the darkest is the one that looks correct, make a new set of test strips with the enlarger lens opened one stop or with exposure times of 10, 20, 30, and 40 seconds.
3 If all of the test strips look too dark or if the lightest is the one that looks correct, make a new set of test strips with the enlarger lens stopped down one stop.

A valid set of test strips "brackets" the correct exposure. Don't be misled into thinking that an exposure is correct until you have actually produced at least one test strip that you know is too light and one that you know is too dark.

Figure 2-7 A correctly made set of test strips. Strip (a) is obviously too light, while strip (d) is obviously too dark. The correct exposure must be somewhere in between. Knowing ahead of time how a highlight should look makes it easier to decide which test strip represents the correct print exposure.

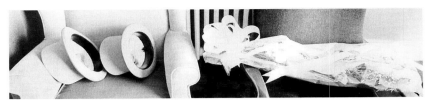

(a) 5 seconds exposure

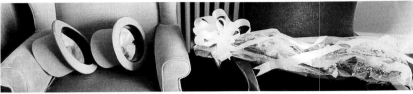

(b) 10 seconds exposure

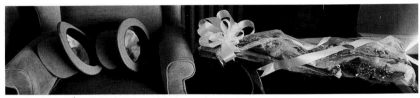

(c) 15 seconds exposure

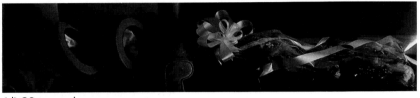

(d) 20 seconds exposure

Determining the Exposure

Once you have a valid set of test strips, pick the one that contains the best highlight rendering. The exposure time of that test strip is the correct exposure (Figure 2-8). If you can't decide which of two test strips represents the best exposure, choose one halfway between the exposures for those two.

AVOIDING SAFELIGHT FOG

Before you can accurately expose for the highlights, you must first be sure that your safelights aren't causing those highlights to look darker than they should. When this happens, it is called *safelight fog*. Safelight fog can cause you to underexpose a print if you base the exposure on the highlights.

The word *safe* in safelight is only a relative term because, despite manufacturers' claims to the contrary, all safelights will fog paper eventually. The goal of a safelight is to provide a maximum amount of working light without fogging your print during the time it takes to go between the paper box and the fixing tray.

An old photographer's myth is that you can test for safelight fog by removing a piece of printing paper from the box, covering half of it for a few minutes, and then developing it. The assumption is that if the uncovered half doesn't turn gray in the developer, the safelights aren't fogging your paper.

This test isn't accurate because it doesn't duplicate the way you actually work. When you are printing, safelight fog is added to any exposure you give a print. Safelight fog occurs much more quickly on exposed paper than on unexposed paper. An accurate test for fog requires testing your safelights on a correctly exposed print.

To conduct a safelight test, you need a negative that has a large area of textured highlights. Figure 2-9 is an example of a good image to use.

If you don't have a suitable negative available, photograph a close-up of a white painted house or barn. The more texture in the siding, the better. Don't be tempted to use a negative just because you like the image. You are performing a test of your safelights, and you don't want to be distracted by image qualities that aren't related to the information you are seeking.

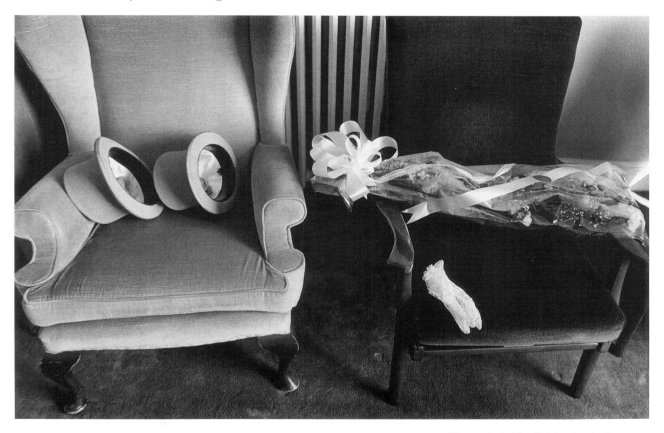

Figure 2-8 The finished print from the test strips in Figure 2-7. The correct rendition of the bridal bouquet determined the final exposure.

Figure 2-9 A good image for a safelight test. This image contains mostly textured highlights. Any safelight fog will first show up in these highlights. Compare this illustration to Figure 2-10.

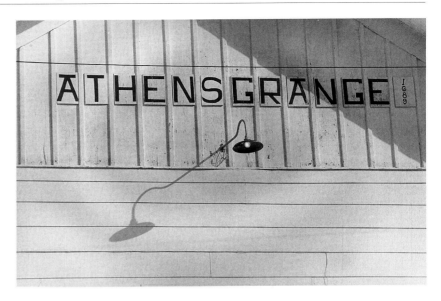

The Safelight Test

1 Turn off all of the lights in your darkroom, including the safelights. Wait 2 or 3 minutes to let your eyes adjust to the darkness, and observe whether any light is coming in through cracks in doors, covered windows, or any other locations. Stop and fix any significant light leaks before proceeding.

2 Working in complete darkness, make a series of test strips of the textured highlight area, and process them.

3 Evaluate the test strips and choose an exposure that renders the highlights accurately. Although it might take several tries before you have a valid set of test strips, it is better not to rush the process. The more care you take at this stage, the more accurate the test will be. Be sure that there is just enough gray in the highlights to show the texture clearly.

4 Make a full print in total darkness at the exposure you found. Confirm that it contains the correct highlights and make a record of the exposure time.

5 Again, working in darkness, expose another sheet of printing paper for the same amount of time as the first. Carry the print over to the approximate location of the developing tray, and cover half of the highlight area with an opaque piece of thick paper or cardboard.

6 Turn the safelights on, and leave them on for approximately 5 minutes. The actual time should duplicate the maximum amount of time that you handle a piece of paper before putting it into the fix. If you normally have paper out longer than 5 minutes, adjust the test time accordingly.

7 At the end of the 5 minutes, turn off the safelights, and develop and fix the print. Don't turn on any lights again until after the print has been in the fix for at least 1 minute.

Analyzing the Safelight Test

If your safelights are causing fog, the fog will show up on your test print in the area of the highlight. The covered half of the highlight will be noticeably lighter than the uncovered half as illustrated in Figure 2-10. If there is no difference in either half of the highlight in the test print, your safelights are safe for your normal printing procedures.

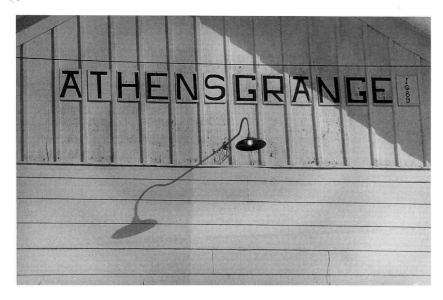

Figure 2-10 A safelight test showing fog. The left half of this print shows the effect of safelight fog. Notice the line running down the middle of the print. If the image had contained mostly darker tones, the chances of detecting safelight fog would have been greatly reduced.

If your test shows fog, here are some suggestions on how to correct its most common causes.

- Check all safelight filters for cracks and replace any that have them. Older or abused safelight filters can develop cracks in their coating that let white light through.
- Use a lower wattage bulb in the safelight or cover a portion of the safelight with black paper to reduce the light intensity.
- Move the safelight farther away from the enlarger and sink where you develop prints. As distance doubles, light intensity decreases by a factor of 4 (the square of the distance).
- If you are mechanically inclined, you can make a safelight dimmer from a standard household rheostat and an outlet box. Plug your safelights into the dimmer box and adjust the light intensity until the light output is safe.

Once you adopt one of these solutions, don't assume that you have solved your safelight fog problem until you have rerun the safelight test and gotten the proper results.

Safelight Color

Manufacturers generally recommend an amber or light brown safelight filter for use with enlarging paper. In practice, you can also use dark red filters. The following table lists the Kodak designation for some common safelight filters and what photographic materials you can use them with.

Filter:	Color:	Suitable for:
Series OA	Greenish Yellow	Contact speed paper, but not for for enlarging speed paper
Series OC	Light Amber	Black-and-white enlarging paper
Series 1	Red	Blue-sensitive film and paper
Series 1A	Light Red	Orthochromatic film and paper
Series 2	Dark Red	Orthochromatic film and paper but also usable for black-and-white enlarging paper
Series 13	Amber	Panchromatic enlarging paper

STANDARD BLACK AND WHITE PATCHES

Identifying tones on a black-and-white print is highly subjective. A dark gray tone can appear black next to a highlight. Likewise, a very light gray tone next to a shadow looks the same as a blank white highlight. These differences are impossible to distinguish accurately until you compare one tone directly to the other.

You can prepare small pieces of printing paper (called *patches*) that you know contain maximum black and maximum white tones to aid in identifying the tones on your prints. Use these patches as standard references for maximum black shadows and blank white highlights.

Creating Standard Patches

1 Cut a sheet of normal-contrast printing paper in half. Put one half back in an empty paper box or other light-tight place. Expose the other half under the enlarger for 1 minute with the lens at maximum aperture and no negative in the negative carrier.

2 Develop both the exposed and unexposed halves of the print for 2 minutes. Stop and fix as you normally would.

3 When the paper is dry, cut each half into approximately two-inch square pieces. These are your standard black and white patches.

Using Standard Patches

The white standard patch represents the lightest tone that a particular printing paper can produce under your normal processing conditions. The black standard patch represents the maximum black that a particular printing paper can produce under those same conditions.

Use the standard patches by keeping one black and one white patch dry for comparing with tones on finished prints. If you regularly tone your prints, you should tone an additional pair of patches. Keep another pair of standard patches in a tray of water when you print and use them for comparing with wet print tones.

Different brands of paper require different standard patches. You will use the standard black patch in the next test.

THE PROPER PROOF

Most photographers think of a contact proof as a quick and easy way to see small prints of all of their negatives. With only this goal in mind, they tend to make contact prints in any convenient manner. A properly made contact proof, however, also contains valuable information about the exposure and development of the film that can save you time in the darkroom and help you correct any errors in your procedures.

Making a Proper Proof

The secret to gaining this knowledge is to standardize the way you expose a contact proof. This means first of all standardizing the exposing light source.

Producing a Standard Light Intensity With an Enlarger

1. Place a negative in the enlarger and project the image onto an area of approximately 10 × 12 inches on the baseboard.
2. Focus the image and mark the position of the enlarger head on the column with a marker or piece of tape.
3. Take the negative out of the enlarger, and set the lens at f/8.

This procedure creates a light intensity on the baseboard of your enlarger that you can always duplicate. The actual height of the enlarger isn't as important as the fact that you can return the enlarger head to the mark you made on the column and focus the light in the same way each time you make contact proofs.

Finding a Standard Exposure

Before beginning this test, obtain an unexposed but developed and fixed length of the film you normally use. If you are using roll film, a length of film 6 to 10 inches long is good. This duplicates the lightest possible areas of your negatives, a density known as *film base plus fog*.

1. Cut a sheet of your usual printing paper into strips slightly larger than the piece of film you are going to use in the test.
2. Sandwich the film and paper, emulsions together, in your contact printing frame. If you don't have a contact frame, lay the film and paper sandwich under a sheet of ¼-inch-thick glass.
3. Place the contact frame on the enlarger baseboard, and expose for 5 seconds with your standard intensity light.
4. Repeat steps 2 and 3 at exposures of 10, 15, and 20 seconds.
5. Process the test strips and examine them under your inspection light.

The exposures should produce a range of tones from dark gray to maximum black (Figure 2-11). Use your standard black patch to determine which exposure first produces a maximum black tone. If none of the exposure tests turn the test strip maximum black or if all of them do, repeat the test after first adjusting the exposure time or the lens aperture appropriately.

Figure 2-11 Test strips used to determine the exposure for a proper proof. The four illustrations here are "prints" of a length of unexposed but developed and fixed 35mm film. They represent a test to find the exposure necessary to render clear film base as maximum black on a contact proof.

(a) 5 seconds exposure

(b) 10 seconds exposure

(c) 15 seconds exposure

(d) 20 seconds exposure

The minimum exposure time that it takes for the contact print of the clear film base to turn maximum black is the standard exposure you should give all contact proofs made with that film and paper. When you make contact proofs with a different film or on a different brand of paper, you must make a new test for a standard exposure time.

Evaluating a Proper Proof

The standard exposure to use for a proper proof is the exposure time it takes for the lightest possible part of the negative (the film's base) to produce a maximum black tone on the print. When the film base is rendered on the proof as maximum black, any other tones in the negative that are properly exposed and developed will also appear in the correct relative relationships on the proof.

How exactly the tones on the proper proof relate to the enlarged print depend on the type of enlarger you use. For example, if you print with a condenser enlarger, your proof images should appear slightly lower in contrast than you want them to look in the final enlargement. If you use a diffusion enlarger, the contrast of the proof images should

appear closer to what you want in the final print. If there is something wrong with a negative in either exposure or contrast, you can identify the problem in the following manner.

Negative Exposure

A properly exposed negative on a properly made contact proof looks approximately the way you would want the final print to look. If a particular image looks too dark overall, it is underexposed; if it looks too light overall, it is overexposed.

Negative Contrast

Examine the images in the proper proof closely, using a magnifying glass if necessary. Allowing for your particular enlarger type, if the shadows and midtones of a particular image look correct but the highlights are too light, it indicates greater than normal contrast. If the highlights look too dark, it indicates less than normal contrast.

Figure 2-12 The proper proof. This detail of a contact sheet shows the different aspects of a proper proof. Notice how the clear film edges have disappeared, leaving only the frame numbers visible. This is the correct exposure for a proper proof. Frames 10 through 12 and 16 show approximately correct tones, indicating that these frames are correctly exposed. Frames 17 and 18 are too light, indicating that they are overexposed.

Using a Proper Proof

A proper proof gives you an indication, in advance of printing, of which negatives should print well on normal-contrast paper and which will require extra work. The fact that the exposure and contrast of a negative aren't optimum doesn't mean that you can't make a satisfactory print. The information simply saves you time and guesswork.

Another use for the proper proof is to spot trends in your working procedures before they create significant problems. An occasional bad frame on a contact proof isn't a signal of anything wrong, but consistent over- or underexposure can indicate that you either need to change the exposure index you use for that film or that you need to replace the battery in your light meter. Also, if your negatives consistently have too much or too little contrast, it might mean that you need to change your standard film developing time or even that your darkroom thermometer may need recalibration or replacing.

EMULSION SPEEDS OF PRINTING PAPER

Emulsion speed, the light sensitivity of printing paper, is directly related to a paper's ability to render accurate highlight tones. A paper that requires 10 seconds of exposure to produce a textured highlight has a faster emulsion speed than one that requires 12 seconds to produce the same highlight. Not only do different brands and contrasts of printing paper have different emulsion speeds, but frequently so do different boxes of the same brand and contrast. Even different variable-contrast filters can change the emulsion speed of a printing paper.

This means that if you determine the correct exposure for a print but need to change the contrast, you must rerun the exposure test for the new grade of paper or filter. If you know in advance the exposure change required by the new paper contrast, you can save this time and effort. The following test allows you to calibrate the different types and contrasts of paper you normally use so that you can switch between them without having to run new exposure tests.

Testing Different Emulsion Speeds

For the emulsion speed test, use the negative you used for your safelight test or another negative that contains large areas of textured highlights. Since this test requires that you distinguish subtle differences in the highlights of different prints, the larger and more distinct the highlight, the more accurate the test will be. Throughout this test, resist any temptation to burn and dodge.

1 Make a print on normal-contrast paper that you feel represents the most accurate rendering of the textured highlights in the image. Don't worry if the midtone and shadow areas don't look the way you want them; you will learn to control these tones in the next chapter. This is the control print. Carefully note the exposure time.

2 Using grade 3 paper or a number 3 filter (if you are using variable-contrast paper), make a print that matches the tone, texture, and detail of the highlight in the control print. Again, note the exposure time required.

3 Repeat step 2 for all grades of paper or filter numbers you normally use. Take care to match the highlights as closely as possible, each time noting the final exposure time.

4 When the prints are dry, examine them, and make sure that the important highlight still matches in all prints. If you have to, remake any prints that don't match.

5 Using the control print on normal-contrast paper as a starting point, calculate the percentage difference in exposure for each grade or filter number, and record this exposure factor in your notes and also in large letters on the lid of each paper box. If you are using filters, place an adhesive label with this information on the handle of each filter.

As an example, if the exposure time for the control print was 10 seconds and the exposure time on grade 3 paper was 15 seconds, the exposure increase for grade 3 is 50%, or 1.5 times the exposure

on grade 2.* Once you have this information, all you have to do to switch from grade 2 to grade 3 paper is multiply the correct grade 2 exposure by 1.5. You don't have to run a new exposure test, although you might want to keep a calculator by your enlarger.

Some printing paper manufacturers claim that different contrast grades of their paper have identical emulsion speeds. Although this is convenient when it is true, don't accept such claims until you test them. Variables in shipping and storage can change even the emulsion speed of different boxes with the same emulsion number. Always test a new box of printing paper before you use it. In fact, running this test again at a later date is a good idea. You might find that as you gain experience, your perception of print tones will change your opinion of what constitutes a matching highlight.

One advantage of variable-contrast filters is that their exposure factors don't change from box to box of paper. While each box of variable-contrast paper will probably have a different emulsion speed, the relative exposure differences between filters will always stay the same.

SUMMARY

In this chapter you have learned about the importance of correct exposure in rendering a highlight tone on a print. To help you find the correct highlight exposure, follow these suggestions:

- Always make test strips using separate pieces of paper exposed to the area of the negative containing the most important highlight. Be sure that you give each test strip a single, continuous exposure.

- When evaluating test strips, make sure that you have at least one that is too light and one that is too dark. If the lightest or darkest strip looks like the correct exposure, make a new set of strips at either a longer or shorter exposure.

- Run a safelight test in your darkroom to determine the effect of fog on the highlight of an exposed print. Be sure to correct any problem that the test indicates before you continue with any other tests in this book.

- Make standard black and white patches as references to see if the highlights and shadows in your prints match your expectations.

- Standardize the way you make contact proofs of your negatives by exposing them for the minimum amount of time required to produce a maximum black tone in the area covered by the film's clear base. This gives you information about the exposure and contrast of your negatives before you print them.

- Test the emulsion speeds of the different grades of paper you use so that you can switch from one grade to another without having to rerun an exposure test and without losing the correct highlight rendering of the negative you are printing.

* You can calculate the exposure factor by dividing the exposure time for the paper you are testing by the exposure for the control print. In the example above, 15 is divided by 10 to obtain 1.5.

Chapter **3**

Changing Contrast for the Shadows

Finding the correct exposure is only the first half of the printing equation. The essential second half is matching the proper contrast, or paper grade, to the image. The purpose of paper grades in printing is to use changes in contrast to control the appearance of the shadows in the print.

This means that while you are printing, you make decisions about exposure and contrast one at a time. First you determine the correct exposure based on the highlights, then you choose a paper grade (or filter number) that best renders the shadow tones. Once the highlights and shadows are correct, the middle tones fall into the proper relationship between them.

Thinking of printing as a two-step process enables you to work on the part of the image with the technique that controls it best. Most photographers don't keep the two steps separate and end up burning in highlights or dodging shadows. Working with only one part of the tonal scale at a time eliminates confusion.

WHAT CONTRAST IS

Contrast in photography is the range of tones between the lightest highlight and the darkest shadow. Although the concept of contrast is the same for both negatives and prints, it helps to think of them separately because their functions are different.

Figure 3-1 How contrast affects image content. The range of tones and how they appear on the print are a major part of an image. In this print, the highlight rendering of the sunlit urns, surrounded by dark shadows, provides the visual focus of the image.

Negative Contrast

In a negative, contrast is determined by two factors: the range of tones in the original scene and how you develop the film. Some photographers spend a lot of time and effort controlling the contrast of their negatives, and some don't. Usually, however, every photographer ends up with negatives containing a variety of different contrasts.

Although there are precise scientific methods for determining the contrast of a negative, making some generalizations can be helpful. You can usefully describe high contrast, low contrast, and normal contrast.

High-Contrast Negatives

A high-contrast negative is one in which there is a large difference between the highlight and shadow densities. Typical high-contrast scenes are found outdoors on a bright, sunny day. Negatives that are exposed in such situations and are not given special develop-ment to compensate for the contrast of the scene produce prints with extremely light highlights and very dark shadows.

Low-Contrast Negatives

A low-contrast negative is one that has only a small difference in density between the highlights and shadows. A typical low-contrast scene (indoors in dim light, for example) produces a negative that prints with light-gray shadows and dark-gray highlights.

Normal-Contrast Negatives

A normal-contrast negative is one with an average density difference between the highlights and shadows. Typically, normal-contrast negatives produce prints with a sense of bright highlights and dark shadows without either appearing in extremes.

Print Contrast

Unlike film, which contains no contrast until you expose and develop it, photographic printing paper is manufactured with a specific contrast. When exposed to a negative, printing paper will render the negative's tones in a predetermined way.

Some printing papers contain one specific type of contrast. These papers are called *graded papers* and are usually designated with a contrast number, or *grade*. Grade 2 paper is normal contrast, grade 1 is low contrast, and grades 3 and higher are high contrast.

Other printing papers contain both high-contrast and low-contrast layers of light-sensitive emulsion. These are *variable-contrast papers*. When you use variable-contrast paper, you expose negatives through one of a set of filters that control the amount of exposure reaching each light-sensitive layer. The filters are usually numbered in a manner equivalent to paper grades. For example, a number 2 filter produces a contrast that is equivalent to grade 2 paper.

The reason for having so many contrast grades is to allow you to select a paper that matches the contrast range of the negative. The first step in matching paper and negative contrast is deciding how you want the shadows in your print to look.

SHADOW TONES

In a print, a shadow can appear in one of four basic ways: as maximum black, as a dark gray tone slightly lighter than maximum black, as a dark shadow with the appearance of detail, and as a medium dark tone, just darker than middle gray. Once you identify the most important shadow, you then know how you want it to appear on the print. The following descriptions will help you recognize these shadows.

Maximum Black Shadows

A maximum black shadow is the darkest tone that a print can be made to yield. It is the same tone you produced when you made a maximum black patch in Chapter 2. Maximum black shadows are typically flat, featureless areas of a print, such as doorways and windows opening into unlit rooms.

How dark maximum black actually is depends on the printing paper you are using. Some brands of paper produce a darker maximum black than others. Whenever you want to determine if a shadow in a print is maximum black, use a standard black patch

made from the same brand of paper. If the two tones match, the shadow is maximum black. If the shadow tone on the print is noticeably lighter than the standard black patch, then it is a dark gray.

Figure 3-2 An image containing a maximum black tone. The shadows in this print are dark and impenetrable. To see the effect of a maximum black shadow on an image, try looking at this illustration while squinting your eyes. With the image slightly out of focus, the double triangle of the shadow is the most noticeable shape.

Dark Gray Shadows

This shadow is the first tone in a print that is noticeably lighter than maximum black. Any very dark object in an image for which you want a sense of space or volume should appear in this tone. It is hard to determine the difference between this shadow and maximum black unless the two are side by side. A standard black patch is useful in making this distinction.

Figure 3-3 An image containing a noticeable area of dark gray shadows. The dark water in the foreground is too dark to show any detail but is light enough to show that the water is actually there. The visual appearance of the shadow tone in this image is substantially different from the image in Figure 3-2.

Dark Detailed Shadows

This is the tone of any dark shadow in which you want detail and texture to appear. Typical examples of this tone are deep shadows under bushes, black hair, or dark fur on animals. Because you are looking for both a sense of darkness and detail, this shadow is easy to spot.

Figure 3-4 An image containing detailed shadows. The form and texture of the black dress are clearly revealed in this image. A darker rendering of this shadow tone would completely change the meaning of the image.

Medium Dark Shadows

Open shadows in the landscape, average dark foliage, new blue jeans, and brown hair on people are typical values for this shadow tone. Details on a print with this shadow are easy to see and obvious to the viewer. Any tone lighter than this will not be a shadow value.

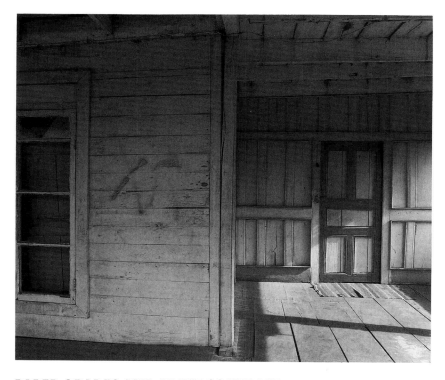

Figure 3-5 An image containing open shadows. The interior of this building is primarily in shadow, but it is light enough to show all of the details of its construction.

PAPER GRADES AND PRINT CONTRAST

Two factors determine print contrast: the contrast of the negative and the capacity of the printing paper to render contrast. For all practical purposes, once you develop the film, the contrast of your negative is fixed.* Because of all of the possible contrast situations that could exist on developed film, paper manufacturers provide a variety of paper grades (or filters for variable-contrast paper) to let you match a negative's contrast with a particular paper.

Normal-contrast printing paper (grade 2 or number 2 filter) typically renders contrast as it appears in the negative. This means that if a negative has a normal contrast range, the tones in that negative will reproduce correctly on grade 2 paper (Figure 3-6a).

Low-contrast paper (grade 1 or number 1 filter) has the ability to render a greater range of tones than normal-contrast paper. A normal-contrast negative, correctly exposed for the highlights, would look weak and gray in the shadows when printed on grade 1 paper (Figure 3-6b).

High-contrast paper (grade 3, number 3 filter or higher) renders a smaller range of tones than normal- or low-contrast

* There are exceptions. Chemical intensifiers and reducers and masking techniques can alter the contrast of a developed negative. For the most part, these techniques are complex, aren't completely reliable, and should only be used when all else fails to produce a satisfactory print. Intensifiers and reducers are discussed in Chapter 7, "Salvage Techniques."

papers. A normal-contrast negative, correctly exposed on grade 3 paper, would look acceptable in the highlights, but the shadows would appear to be dark and without enough detail (Figure 3-6c).

Figure 3-6 Matching negative contrast and paper grades.

(a) If the negative and paper contrast match, then the print will render both the highlights and the shadows correctly.

(b) If the paper contrast is too low for the negative, then exposing for the correct highlights will produce a print with gray shadow tones.

(c) If the paper contrast is too high for the negative, a correct highlight exposure will render all the important shadow tones too dark and they will probably lose detail.

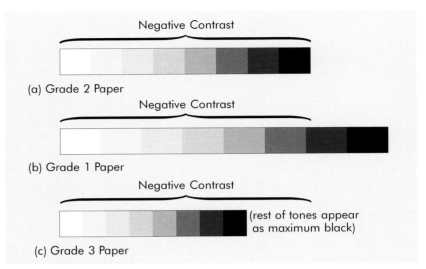

When to Change Contrast

Knowing what will happen to the tones in an image when you change paper grades allows you to devise a strategy for printing when you are working with new negatives and don't know what contrast to use. The following steps outline a typical approach. This approach combines the steps you learned in Chapter 2 for finding the correct exposure with a technique for discovering the correct contrast. Once you practice and understand their purpose, you can modify these steps to suit your particular needs.

1. Make a series of test strips on grade 2 (normal-contrast) paper to find the correct exposure for the most important highlight in the image.
 Be sure to concentrate only on the highlights; don't be influenced in your judgment of the exposure by how the shadows might look.

2. When you have decided on an exposure, make a test print of the whole image on grade 2 paper.
 This should confirm that the exposure based on the test strips is actually the correct exposure for the whole print. If not, repeat steps 1 and 2.

3. Examine the most important shadows in the test print.
 - If the shadows appear as you want them, the contrast is correct. You can use the test print to decide on any finishing steps, such as burning and dodging, for the final print.
 - If the shadows appear too dark, proceed to step 4.
 - If the shadows appear too light, proceed to step 5.

4. If the shadows on the test print appear too dark (for example, if the darkest detailed shadow is too dark to show any detail), make another print on grade 1 paper (Figure 3-7). Be sure to adjust the exposure to keep the highlights of the two prints the same.

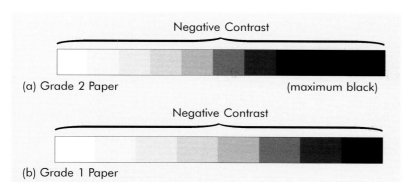

Figure 3-7 Printing a high-contrast negative on grade 1 paper. If you expose a negative for the correct highlights on grade 2 paper and the shadows appear too dark as shown in (a), switching to grade 1 paper will make the shadows appear lighter as shown in (b).

5 If the shadows appear too light (for example, if the darkest shadow looks too gray and the overall appearance of the print is flat), make another print on grade 3 paper (Figure 3-8). Be sure to adjust the exposure to keep the highlights of the two prints the same.

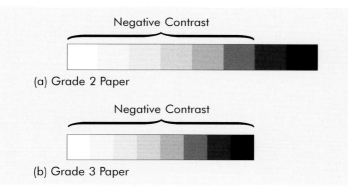

Figure 3-8 Printing a low-contrast negative on grade 3 paper. If you expose a negative for the correct highlights on grade 2 paper and the shadows appear too gray as shown in (a), switching to grade 3 paper will make the shadows appear darker as shown in (b).

When you begin exposing for the most important highlights and changing contrast for the most important shadows, you will find that the final print requires much less finishing work than you have probably given prints in the past. For example, with the most important highlight and shadow areas controlled by exposure and contrast, burning and dodging is limited to the less important parts of the image. This makes burning and dodging less critical to the success of the print.

THE RING-AROUND TEST

Even for experienced printers, it can be difficult to decide on the best exposure and contrast for a negative. In fact, for many negatives, more than one exposure and contrast produce a good print. Often, the only way to see and evaluate the choices available for printing a negative is to experiment with the different combinations.

A *ring-around* test provides a transition from the theory of correct print exposure and contrast to its practice. The ring-around is a technique that quickly and efficiently produces examples of the major exposure and contrast variations for an image. These results show you the different print statements that are possible for a particular image and help you gain experience under-standing how other negatives might be affected by exposure and contrast changes.

Preparation

For the ring-around test, use a negative that previously has printed well on normal-contrast paper and that has approximately equal amounts of highlights, shadows, and midtones. Figure 3-9 is a good example of such an image. For best results, the test negative should print well without burning or dodging. A convenient and economical print size for the ring-around test is 5 × 7 inches. As you make each print, be sure to record exposure and contrast information on the back with a soft lead pencil.

Figure 3-9 A good image to use for a ring-around test, such as this one, contains a variety of easy-to-recognize tones.

Procedure

1. Using test strips as a guide, make a print of the test negative on normal-contrast paper (grade 2 or number 2 filter), trying to achieve the best possible highlight rendering. Record the exposure time and contrast grade. This is the grade 2 reference print.
2. Make two more prints on normal-contrast paper, one with 50% less exposure than the reference print and one with 75% more exposure.
3. Using low-contrast paper (grade 1 or number 1 filter) and taking into account any exposure change between the paper grades, make a print that has identical highlights to the grade 2 reference print. Again, record the exposure time and contrast grade. This is the grade 1 reference print.
4. Make two more prints on low-contrast paper, one with 50% less exposure than the grade 1 reference print and one with 75% more exposure.

5 Repeat steps 3 and 4 using high-contrast paper (grade 3 or number 3 filter) and any other higher contrast grades that you normally use. Be sure that for each paper grade you adjust the exposure of the reference print to match the highlights in the grade 2 reference print.*

Evaluating the Test

When the prints from the ring-around test are all washed and dry, lay them out on a flat surface, such as a large table top, or pin them to a bulletin board in the following order:

1 Place the grade 2 reference print in the middle, the grade 2 print with 50% less exposure above it, and the grade 2 print with 75% more exposure below it.

2 To the right of the grade 2 prints, place the grade 1 prints in the following order: grade 1 reference print in the middle, 50% less exposure above it, and 75% more exposure below it.

3 To the left of the grade 2 prints, place the higher contrast prints (grade 3 and above) in the same order as the others: reference print in the middle, 50% less exposure above it and 75% more exposure below it. Figure 3-10 illustrates the order described.

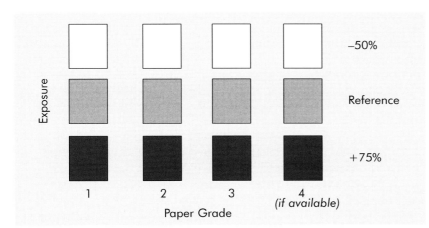

Figure 3-10 Order for arranging the prints in the ring-around test.

You have created a visual ring around what you have up to now considered the correct way to print the test image. Each print represents a different statement. Some will interest you, others will not. Study the prints carefully, and ask the following questions:

- Is the grade 2 reference print still the best way to print the negative?
- If the grade 2 reference print is not the best, what other prints in the ring-around are better?
- If the grade 2 reference print is still an acceptable print, are there prints in the ring-around that you like just as well?

* During this test you might find that the exposure factors you calculated in Chapter 2 need some adjustment. Be sure that you are sensitive to the actual tones that appear on your prints, and allow for the fact that you have already increased your ability to see small differences in print tones just by performing the printing tests in the first three chapters.

If there are several prints in the ring-around that you like, try to determine in what ways, other than exposure and contrast, they are different. This means thinking about how the different print statements produce different feelings as you look at them. It is useful to try to describe these differences in writing. A journal in which you keep records of your investigations and examples of your test prints is an invaluable future reference.

The next time you come to a negative that you are having a hard time printing, try performing a ring-around test with it. Sometimes even a partial ring-around (one or two contrast grades or exposures, for example) will help you make decisions about how to print that negative.

EXPOSURE AND DEVELOPMENT VARIABLES

As you increase your awareness of how contrast changes affect a print, you will increasingly encounter situations in which you want to make a contrast change that is less than a full paper grade.

One way some photographers make small changes in contrast is by changing the brand of paper they are using. For example, changing from Ilford's Gallerie grade 2 to Oriental Seagull grade 2 slightly increases a print's contrast. Unfortunately, this approach ignores the many differences that these papers have in overall appearance. Each brand of paper has a distinct color, ability to take toning, and ability to emphasize one part of the tonal scale over another. These differences are the subject of Chapter 5, "Choosing a Paper and a Developer."

In situations in which you need to change contrast by less than a full paper grade and also want to preserve an image's overall appearance, you can use variable-contrast paper (which offers filters in half grade increments), or you can use exposure and development variations with graded paper. This technique takes advantage of the fact that all silver-based emulsions change contrast as you change development time

Using variations in exposure and development to produce small changes in contrast is useful in most situations because it works on any brand and type of printing paper and doesn't require a special darkroom setup.

Your standard developing time is the starting point. An increase in the standard developing time increases contrast, and a decrease in the standard developing time decreases contrast. Although every brand of paper is different, you can alter the development time of most papers from one-half of the standard development time to twice the standard development time without encountering problems of uneven development or fog.

Because changing the development time affects the highlights as well as the contrast, you must compensate for the corresponding increase or decrease in highlight density by changing the exposure. You must increase exposure if you are decreasing development, and decrease exposure if you are increasing development.

The following exercise demonstrates how exposure and development changes alter contrast and offers guidelines for changing both exposure and development that work for most papers.

The Exposure and Development Variables Test

For this exercise, assume that your standard development time is 2 minutes, as recommended in Chapter 1. Use the same negative for this test that you used for the ring-around. If you like, you can save time by doing this exercise when you do the ring-around.

1 Using a piece of grade 2 paper, increase the normal exposure time you used for the ring-around test by 20%, and develop that print for 1 minute (one-half the normal development time).

2 Using a second piece of grade 2 paper, decrease the normal exposure time by 20%, and develop for 4 minutes (twice the normal development time).

3 Using a piece of grade 1 paper, increase the normal exposure time you used for that grade of paper in the ring-around test by 20%, and develop for 1 minute.

4 Using a piece of grade 3 paper, decrease the normal exposure time you used for that grade of paper in the ring-around test by 20%, and develop for 4 minutes.

5 If you used grade 4 paper in the ring-around test, repeat step 4, decreasing the normal exposure for that grade and developing for 4 minutes.

Evaluating the Test

Once all of the prints are dry, examine all of the highlights to make sure that they match. Remake any prints in which the highlights are significantly different, adjusting the exposure appropriately. Then line the prints up with the reference prints from the ring-around test so that the lowest contrast print (grade 1 paper developed for 1 minute) is on the left and the highest contrast print (grade 3 or 4 paper developed for 4 minutes) is on the right. Figure 3-11 illustrates this order.

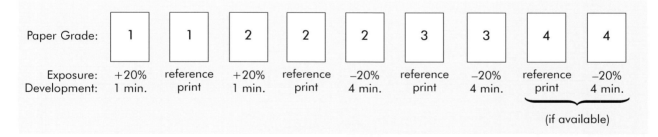

You should have a series of prints of the same image in which the contrast varies in subtle steps from very low contrast to very high contrast. Although the highlights in all of the prints are approximately the same, the shadows gradually become darker as the contrast increases. From among these variations you can choose the exact contrast that is appropriate for the image.

The exposure and development suggestions in the test provide a starting point for further experimentation. For most paper and developer combinations, changing the exposure time by 20% and doubling or halving the development time changes the contrast by about one-half grade while matching the highlights of a normally developed print. Even if this isn't true for the materials you are

Figure 3-11 Order for arranging the exposure and development variables test.

using, understanding the goal of keeping the highlights the same while increasing or decreasing the darkness of the shadows should help you devise your own procedures.*

SUMMARY

- Printing is a two-step process. It consists of first determining an exposure based on the correct highlight rendering and then adjusting the contrast for the best shadow tones.
- Four general types of shadows can appear in a print: maximum black shadows, dark gray shadows, dark detailed shadows, and medium dark shadows. To determine the correct contrast for a print, first decide which of these shadow types is the most appropriate for the important shadow tones in the image.
- Change contrast when the highlights look correct, but the shadows don't fit your idea of how they should appear.
 - If the shadows are too light and gray, change to a higher contrast paper.
 - If the shadows are too dark and don't have enough detail, change to a lower contrast paper.
- To visualize how exposure and contrast changes affect a print statement, perform a ring-around test to see examples of all of the possible variations. This test is especially useful when you are unsure of which exposure or paper grade to use.
- You can achieve more subtle variations in contrast than is possible with paper grades alone by changing the exposure and development of a print. A rule of thumb is to increase exposure by 20% and cut development time in half to lower the contrast of a given paper by approximately one-half grade. Likewise, decrease exposure by 20% and double the development time to increase contrast by approximately one-half grade.

* Some paper developers containing phenidone or pyrazolidone as a reducing agent do not produce as great a contrast difference when you change exposure and development times as do developers containing metol and hydroquinone. Developers containing phenidone and pyrazolidone include Ethol LPD and Sprint Quicksilver. Even with developers like these, you can produce noticeable contrast changes.

Photographic Chemistry— Creating a Developer

Watching an image appear in the developer tray should always be a magical event for a photographer. Control of the basic chemical processes that produce that image, however, should not be left to magic. Although few photographers think of chemical formulas when they want to improve their prints, developers can be an additional creative tool when used knowledgeably. All photographers should know why a developer works the way it does and what they can do to change a developer's effect on a print. This means learning something about a developer's chemical makeup.

STANDARD DEVELOPER CHEMICALS

Most developers for film and paper consist of the same five chemicals used in different combinations. Each has a specific and complementary function in a formula. Broken down by function, these five chemicals are two reducing agents, a preservative, an accelerator, and a restrainer.

Reducing Agents

A reducing agent is the active ingredient in a developer. During development, a reducing agent converts the milky white exposed silver halides to black metallic silver. It is this metallic silver that forms the visible image.

Standard paper developers, such as Kodak's Dektol and Ilford's ID-11, contain two reducing agents: metol* and hydroquinone. These two chemicals complement each other; metol controls the overall development of tones and hydroquinone enhances the dark shadows.

Some developers contain reducing agents other than metol and hydroquinone. The most common of these alternative reducing agents are phenidone, glycin, and diaminophenol (also known as *amidol*). Phenidone and glycin are usually used in combination with hydroquinone; amidol often appears by itself in developer formulas.

Preservative

A preservative prevents the reducing agents in a developer from combining with oxygen molecules in the air, a process known as *oxidation*. An oxidized reducing agent has released its energy combining with oxygen and can no longer reduce silver halides.

Because it is cheap and efficient, the most popular preservative in photographic developers (as well as many packaged foods) is sodium sulfite. Sodium sulfite is usually sold in one of two forms: *anhydrous* (sometimes called *desiccated*) or *crystal*. Most developer formulas published in the United States specify the anhydrous form of sodium sulfite. Because the chemical activity of the two forms is different, use the sodium sulfite conversion table in Appendix D, "Chemical Conversions and Substitutions," if you have one form of sodium sulfite and a formula specifies the other.

Sodium Sulfite and Grain Size

In addition to its role as a preservative, sodium sulfite affects the structure of the silver grains in a photographic image. During development, sodium sulfite acts on the surface of silver halide particles to reduce their tendency to clump together and form larger, more visible masses of metallic silver. The greater the concentration of sodium sulfite, the smaller the clumps of silver particles in the final image. A relatively low concentration of sodium sulfite allows larger, more visible clumps of silver to form.

Film developers, such as Kodak's D-76, that claim to be "fine grain" developers contain large amounts of sodium sulfite. Although the same effect takes place in print developers, the grain structure isn't visible and the role of sodium sulfite in print developers is primarily as a preservative.

Accelerator

An accelerator enhances the reaction of reducing agents. Formulas contain an accelerator primarily because reducing agents are the most expensive chemicals in a developer. An accelerator allows smaller amounts of a reducing agent to adequately develop an image.

Sodium carbonate (washing soda) is the most commonly used accelerator in photographic developers using metol and

* Metol (*p*-methylaminophenol sulfate) is also commonly known by its Kodak proprietary name, Elon. Other less-popular trade names for this chemical include Atolo, Monol, Pictol, Rhodol, and Viterol.

hydroquinone. It acts as an accelerator by increasing a developer's alkalinity. The more alkaline the solution, the more active the reducing agents.

Sodium carbonate is usually sold in one of two forms: *anhydrous* or *monohydrate*. In addition, sodium carbonate is sometimes found in *crystal* form. Monohydrate is the only chemically stable form of sodium carbonate, so if formula you are using specifies a different form, you should convert that amount to monohydrate. Use the sodium carbonate conversion table in Appendix D, "Chemical Conversions and Substitutions" to make this conversion.

Restrainer

A restrainer inhibits developer activity. Although it might sound like a contradiction to include a restrainer in a developer that also contains an accelerator, the two work in a complementary fashion. A developer with enough accelerator to develop a strong shadow tone will also reduce some unexposed silver in the highlights where it isn't wanted. This tone is referred to as *chemical fog*, and it is similar in appearance to safelight fog. A correctly formulated developer contains just enough restrainer to delay the appearance of chemical fog in the highlights until after the other areas of the image are fully developed.

Most developers use the chemical potassium bromide as a restrainer, although there are commercially available anti-foggants that have similar effects. The most popular of these products is Kodak's Anti-Fog No. 1 and Edwal's Liquid Orthazite.

Water

All developers that you mix from dry chemicals are dissolved in water. Even when developers come in concentrated liquid form, you still use water to dilute them. Usually, the slight impurities found in most tap water aren't a significant factor in the activity of a developer.

In some locations, this isn't true. The municipal water supply in parts of Arizona, for example, contains large amounts of alkaline chemicals that act like accelerators. Prints made in developers mixed with this water can look gray and muddy due to additional chemical fog.

If you have doubts about the quality of the water in your area, run a test using identical developers, one mixed with tap water and the other mixed with distilled water. If you can detect a difference between prints developed in these two developers, then you might want to use distilled water or water processed by reverse osmosis filtration to mix and dilute all of your developers.

Tap Water or Distilled?

Should you use tap water or distilled water for mixing developers?

Prepackaged developers, such as Kodak's Dektol or Ilford's ID-11, include chemicals to control (or *buffer*) the effects of the most common impurities and pH variables in municipal water supplies. The published formulas for these same developers do not generally include these additives. When you mix your own developers from formulas, therefore, they are more susceptible to variations in water purity than their prepackaged equivalents.

To maintain consistency when you mix developers from formulas, always use distilled water or water processed by reverse osmosis filtration. With prepackaged developers, this precaution generally isn't necessary. Tap water works fine, except in cases where the water supply contains dissolved iron or copper compounds which can cause problems for virtually any developer. This is a more likely problem with well water than municipal water supplies.

If distilled or filtered water is unavailable, add 1 gram of unadjusted sodium hexametaphosphate (photographic grade calgon) to the stock solution. This will simulate the effect of the buffering agents in prepackaged developers.

OBTAINING DARKROOM CHEMICALS

Obtaining chemicals with which to make a developer is not difficult. One- and five-pound containers of standard developer chemicals are usually common items in photography stores that carry Kodak prepackaged developers, fixers, and stop baths. If a store selling Kodak supplies doesn't stock these chemicals, it can order them for you.

Be sure that when you buy or order chemicals you are specific about what you want. There is a large difference, for example, between sodium sulfite, which you need in quantity, and sodium sulfate, which you will rarely, if ever, need.

For special formulas, mail-order businesses carry hard-to-find chemicals in small quantities. You will find the addresses of some of these businesses in Appendix G, "Supplies."

MEASURING PHOTOGRAPHIC CHEMICALS

Because you must measure precise quantities of chemicals, you should have access to an accurate scale. Triple-beam laboratory scales are very accurate but can cost more than a hundred dollars. Kitchen-type or diet scales are not accurate enough and should not be used anyway if you also use them to weigh food. One scale that is both accurate and inexpensive is a model called the Counter Balance ™, (Figure 4-1). Accurate digital scales are also becoming more common and less expensive, and are worth considering.

Figure 4-1 A triple-beam balance and a Counter Balance™ scale. The triple-beam balance on the left can measure quantities as small as 0.1 gram. It is more than accurate enough for photographic applications. The inexpensive plastic scale on the right isn't as accurate as the triple-beam balance, but it is useful for most purposes.

Whenever you weigh a quantity of a chemical, be sure to place a clean piece of paper on the balance platform and to adjust the scale to compensate for the extra weight. Creasing the paper in at least two directions can help keep small quantities of a dry powder in the middle of the paper.

Use a clean spoon or thin spatula to remove a small amount of the chemical from the container and place it on the paper. Try to remove a quantity that you estimate is less than you will actually need. Add more gradually until you have the exact amount. If you remove more of a chemical from its container than you need, throw it away instead of putting it back, or you risk contaminating the entire jar.

Never leave a spoon or spatula in a chemical container. This practice can contaminate the container and cover the handle of the utensil with chemical dust. The next time you pick up the spoon or spatula, your skin will come in contact with the dust.

MIXING PHOTOGRAPHIC CHEMICALS

Most photographic formulas list warm water (between 110° and 125° F) as the first ingredient. The warmer the water, the faster chemicals dissolve. Be careful, however, not to increase the temperature of the water beyond what is recommended because too high a temperature causes some chemicals to oxidize prematurely. Reducing agents, in particular, are sensitive to high temperatures.

Always mix chemicals in the order in which they are listed in a formula, and make sure that each chemical is dissolved before adding the next one. The order is important because some chemicals don't dissolve in the presence of other chemicals. For example, metol won't dissolve in a solution containing large amounts of sodium sulfite.

Other chemicals prevent the oxidation of a chemical you add later. For example, you should always add sodium sulfite to a solution before (or very shortly after) adding hydroquinone. Hydroquinone oxidizes rapidly when mixed in a solution without sodium sulfite.

Finally, formulas always start with less water than the total volume of the final solution. After mixing the dry chemicals (which add to the volume of the solution), add enough cool water to bring the solution up to its final volume. This ensures that the mixture has the correct volume and helps bring the solution down to its working temperature.

Containers for Mixing and Storage

In addition to making sure that your mixing and storage containers are clean and free of residual contamination, you should put some thought into the materials from which the containers are made.

Glass is a traditional choice. It is easy to keep clean and carries no residual contamination from use to use. Glass is fragile, however, and can be slippery when wet.

Plastic containers are widely available and don't break as easily. Not all kinds of plastic work equally well for mixing and storing photographic chemicals, however.

Laboratory grade graduates and containers are usually made from high density polyethylene or polypropylene. Polyethylene is tough, flexible, slightly waxy, and translucent in appearance. Polypropylene is less flexible, smooth, and glossy in appearance. Both are very resistant to contamination from common photographic chemicals, even during long-term storage.

SPI code for high density polyethylene: tough, flexible, and translucent.

SPI code for polypropylene: hard, smooth, and glossy.

SPI code for polystyrene: slick, glossy, smooth, easy to crack.

Less expensive plastic containers are generally made from polystyrene or polycarbonate, which is slick, glossy, smooth in appearance, and easy to crack. This material is acceptable for most purposes, though it absorbs chemicals slightly during long-term storage. Because of this you should only use polystyrene or polycarbonate storage containers for a single chemical. For example, never store a developer in a polystyrene container that you previously used to store stop bath, as there is a possibility of residual stop bath contaminating the developer.

When considering a plastic container, check the Society of Plastics Industry (SPI) code number usually found on the bottom of the container to determine its composition.

CREATING A PRINT DEVELOPER

The best way to learn about developer formulas is to create your own. This need not be a complex process. You can make a perfectly functional (if not exactly reproducible) paper developer with a few chemicals, some water, and simple measuring spoons.

The following sections describe an experiment in which you create your own developer, make prints during different stages of the process, and then compare the prints. The goal of this experiment is to provide a tangible demonstration of the properties of each chemical component and how they all function together in a developer.

Materials

For this exercise, you should prepare your darkroom for printing as you normally do. In addition, you need the following:
- a negative that contains an even range of tones and that prints well on grade 2 paper without burning or dodging
- three additional trays for developers (for a total of four)
- a set of inexpensive measuring spoons (not the same measuring spoons that you use to prepare food)
- small quantities of each of the five standard developer chemicals: metol (or Elon), hydroquinone, sodium sulfite, sodium carbonate, and potassium bromide (a one-pound container of each is more than enough)

Setup

Set your enlarger to make an approximately 5 × 7 inch print of the test negative. Clear some space in the darkroom sink for the additional developer trays. Begin by placing two of the additional trays side by side near your usual developer tray. Place approximately 2 quarts (or 2 liters) of 70° F (20° C) water in each (Figure 4-2).

Left Tray Right Tray

2 quarts water *2 quarts water*

Figure 4-2 Initial tray setup for print developer experiment.

Procedure

1 Run an exposure test to find the correct exposure for a print on grade 2 paper developed normally in your usual paper developer. Label this print the control print, writing with a soft lead pencil on the back. You can remove the tray containing your normal paper developer from your sink at this time if you need the extra space.
 Remember to stop, fix, and wash each print in this experiment in your normal manner.

2 Expose nine more pieces of grade 2 paper for the same time as the control print, and place them in a light-tight container, such as an old paper box.

3 Stir the following chemicals into the two developer trays filled with water:
 a. In the left tray, add 2 level teaspoons of hydroquinone and 2 heaping tablespoons of sodium sulfite. (Add a pinch of the sodium sulfite before stirring in the hydroquinone.)
 b. In the right tray, add 2 level teaspoons of metol (Elon) and 2 heaping tablespoons of sodium sulfite.

Left Tray Right Tray

2 quarts water *2 quarts water*
2 tsp. hydroquinone *2 tsp. metol (Elon)*
2 tbsp. sodium sulfite *2 tbsp. sodium sulfite*

4 a. Label one piece of exposed paper *L1* (on the back) and develop it in the left tray for 4 minutes.
 b. Label a second piece of exposed paper *R1* and develop it in the right tray for 2 to 3 minutes.

5 Stir 2 tablespoons of sodium carbonate into each tray.
 Not all the sodium carbonate will dissolve; this is normal.

Left Tray

Right Tray

2 quarts water
2 tsp. hydroquinone
2 tbsp. sodium sulfite
2 tbsp. sodium carbonate

2 quarts water
2 tsp. metol (Elon)
2 tbsp. sodium sulfite
2 tbsp. sodium carbonate

6 a. Label a piece of exposed paper *L2* and develop it in the left tray for 2 minutes.

b. Label a piece of exposed paper *R2* and develop it in the right tray for 2 minutes.

7 Stir ¼ teaspoon of potassium bromide into each tray.

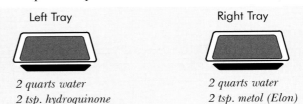

Left Tray

Right Tray

2 quarts water
2 tsp. hydroquinone
2 tbsp. sodium sulfite
2 tbsp. sodium carbonate
¼ tsp. potassium bromide

2 quarts water
2 tsp. metol (Elon)
2 tbsp. sodium sulfite
2 tbsp. sodium carbonate
¼ tsp. potassium bromide

8 a. Label a piece of exposed paper *L3* and develop it in the left tray for 4 minutes.

With some enlarging papers, you may not see an image even after four minutes in the developer.

b. Label a piece of exposed paper *R3* and develop it in the right tray for 2 minutes.

9 Place a third developer tray between the right and left trays. In the third tray combine 16 ounces (or 500 ml) of the mixture from each tray.

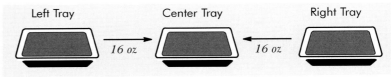

Left Tray Center Tray Right Tray

16 oz 16 oz

10 Label a piece of exposed paper *C1* and develop it in the center tray for 2 minutes.

11 To the center tray, add 1 quart (or 1000 ml) of the mixture from the left tray.

Left Tray Center Tray Right Tray

1 quart

12 Label a piece of exposed paper *C2* and develop it in the center tray for 2 minutes.

13 To the remaining contents of the left tray (16 ounces or 500 ml), add the remaining contents of the right tray (1½ quarts or 1500 ml).

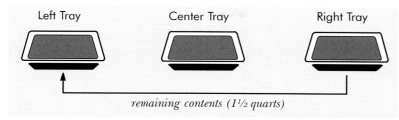

Left Tray Center Tray Right Tray

remaining contents (1½ quarts)

14 Label a piece of exposed paper *C3* and develop it in the left tray for 2 minutes.

Evaluating the Test

When all of the prints have been washed and are dry, study them, starting with the control print, to learn what has happened as you added each chemical to your developer. The figures that accompany the following descriptions illustrate prints that were processed in the manner described in the experiment. Use these illustrations to compare with the results from your own test. Your results may vary from the illustrations, but they should be similar.

The Control Print

The control print (Figure 4-3) should have a normal contrast and an even range of tones since you selected a negative with those qualities. Each of the tones should appear fully developed with bright and luminous highlights and dark and detailed shadows.

As you examine each of the test prints, compare them with the tones in the control print. The differences you observe should indicate how each chemical in the developer affects the image.

Figure 4-3 The control print. This print has a full range of tones from the texture of the snow in the foreground to the detail in the bark of the tree trunks.

Prints Developed in Reducing Agent and Preservative

Depending on your test image, the *L1* print (Figure 4-4a), developed in hydroquinone and sodium sulfite, might have a trace of an

image, or it might be completely blank. Hydroquinone is a very weak reducing agent by itself. A hydroquinone and sodium sulfite solution doesn't have enough strength, or *reduction potential*, to produce a usable image.

The *R1* print (Figure 4-4b), developed in metol and sodium sulfite, contains an image, although the shadows are not as dark as in the control print and some of the highlights are missing texture. In relation to hydroquinone, metol has 20 times the reduction potential. In fact, it is possible to have a fully functional developer containing just metol and sodium sulfite. An example of this kind of developer is D-23, a Kodak film developer available as a published formula only. D-23 is a low-contrast developer, useful when film is shot in high-contrast lighting.

(a) L1: hydroquinone and sodium sulfite

(b) R1: metol (Elon) and sodium sulfite

Figure 4-4 Prints developed in reducing agent and preservative. The L1 print is blank. The R1 print has no texture in the brightest highlights, and the tree trunks are lighter than they are in the control print.

Prints Developed in Reducing Agent, Preservative, and Accelerator

The *L2* print (Figure 4-5a) should show traces of an image, indicating that the addition of sodium carbonate has increased the ability of hydroquinone to develop an image. This image, however, has little detail in the highlights and, overall, lacks much of the tonality of the control print. Although the hydroquinone solution is still very weak, this image shows how hydroquinone primarily affects the darker image.

The *R2* print (Figure 4-5b) shows a much more fully developed image than *L2*. If you compare the highlights of *R2* to the control print, you should notice that the highlights appear slightly darker in *R2*. The addition of sodium carbonate to the metol and sodium sulfite increases the activity of metol to the point that chemical fog begins to appear in the highlights.

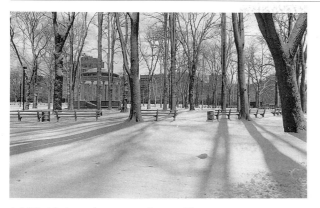

(a) L2: Hydroquinone, sodium sulfite, and sodium carbonate

(b) R2: metol (Elon), sodium sulfite, and sodium carbonate

Prints Developed in Reducing Agent, Preservative, Accelerator, and Restrainer

The image in the *L3* print (Figure 4-6a) is noticeably lighter and fainter than it was in the *L2* print. Some paper brands, in fact, may have trouble producing any image at all. The addition of potassium bromide has greatly reduced the ability of the hydroquinone solution to develop an image.

The *R3* print (Figure 4-6b) has changed in a subtle way compared to the *R2* print. Notice how the highlights in *R3* appear brighter and "cleaner" than they do in *R2*. The addition of potassium bromide has removed the chemical fog and increased the appearance of contrast. Potassium bromide complements the sodium carbonate in a developer to produce relatively dark shadows and bright, clear highlights.

Figure 4-5 Prints developed in reducing agent, preservative, and accelerator. Print L2 shows detail in the tree trunks and the middle tones, although the overall print is lighter than the control print. The R2 print is fully developed and appears darker in the highlights than the control print.

(a) L3: Hydroquinone, sodium sulfite, sodium carbonate, and potassium bromide

(b) R3: metol (Elon), sodium sulfite, sodium carbonate, and potassium bromide

Print Developed in Equal Amounts of Metol and Hydroquinone

Compare the *C1* print (Figure 4-7) to the control print. The overall tone and contrast of *C1* and the control print should be similar. Next, compare the *C1* print to the *L3* and *R3* prints. The overall range of tones from bright highlights to dark shadows in *C1* is greater than the tones in either the *L3* and *R3* prints.

Figure 4-6 Prints developed in reducing agent, preservative, accelerator, and restrainer. Print L3 has lost most of its detail except in the darker shadows, which now appear light gray. The R3 print has "cleaner"-looking highlights than the R2 print.

The mixture of metol, hydroquinone, a preservative, an accelerator, and a restrainer produces a solution that closely resembles a standard print developer. This solution produces as much detail as the metol-only solution and adds richness in the shadows through what is called the *superadditivity effect*. Superadditivity means that the reduction potential of a combined metol and hydroquinone developer is greater than the individual reduction potentials of metol and hydroquinone added together. Superadditivity in a developer occurs only when you mix metol and hydroquinone or phenidone and hydroquinone.

Figure 4-7 Print C1 developed in equal quantities of hydroquinone and metol solutions. This print has a full range of tones from highlights to shadows. These tones are similar to the control print, although the image color (not visible in this reproduction) is not.

Print Developed in More Hydroquinone than Metol

Compare the *C2* print (Figure 4-8) with the *C1* print. Look closely at the highlights and then at the shadows. *C2* should appear both brighter in the highlights and slightly darker in the shadows, indicating that it has more contrast than *C1*. (Remember that you did not adjust the exposure of the prints for the highlights.) A developer containing significantly more hydroquinone than metol will produce a higher contrast print than a developer that has each in approximately equal quantities.

Figure 4-8 Print C2 developed in ¾ hydroquinone and ¼ metol solutions. This print has darker shadows than the C1 print. The detail in some of the tree trunks has become a solid black tone.

Print Developed in More Metol than Hydroquinone

Compare the *C3* print (Figure 4-9) with both *C1* and *C2*. *C3* should appear to have less contrast than either *C1* or *C2*. A developer containing significantly more metol than hydroquinone will produce a lower contrast print than a developer that has each in approximately equal quantities.

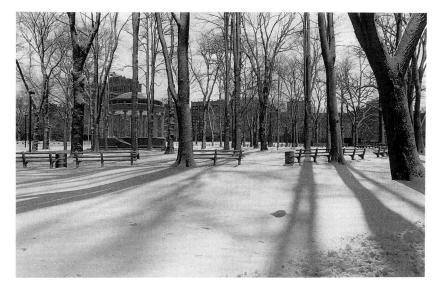

Figure 4-9 Print C3 developed in ¼ hydroquinone and ¾ metol solutions. This print has lighter shadows than the C1 print. The overall appearance of the print is flatter and grayer than the control print.

Changing the concentration of metol and hydroquinone in a developer changes the contrast of prints developed in that solution. Several developer formulas take advantage of this fact. The most popular, the Beers formula (named after Dr. Roland F. Beers, who first published it), is mixed as two solutions. One solution contains only metol, a preservative, an accelerator, and a restrainer. The second solution contains only hydroquinone, a preservative, an accelerator, and a restrainer. When you use Beers developer, you mix different quantities of each solution to produce developers with

different contrasts. The Beers formula and mixing instructions are found in Appendix E, "Developer Formulas."

OTHER PRINT PROCESSING CHEMICALS

Developer chemistry has perhaps the most dramatic effect on the appearance of a photographic print, but developers are by no means the only chemical tool creative photographers have available. In addition to toners, intensifiers, and reducers, which are described in later chapters, the stop bath, fixer, and washing aid all have important effects on the overall appearance and life of a print. Chapter 9, "Archival Processing," describes the proper mixing and use of these chemicals in more detail.

SUMMARY

- Most photographic developers consist of the same five chemicals used in different combinations: two reducing agents, a preservative, an accelerator, and a restrainer.

- Always mix chemicals in the order in which they are listed in a formula, and make sure that each chemical is dissolved before adding the next one.

- A reducing agent creates the visible image in a print by converting exposed silver halides to black metallic silver. The two most commonly used reducing agents are metol (also known as Elon) and hydroquinone.

- A preservative keeps reducing agents from oxidizing too rapidly. Sodium sulfite is the most commonly used preservative.

- An accelerator enhances the reaction of reducing agents by increasing the alkalinity of the developer solution. Sodium carbonate is normally used as an accelerator.

- A restrainer complements the accelerator by preventing chemical fog in the highlights caused by an overly active developer. Potassium bromide is a commonly used restrainer.

- When metol and hydroquinone are mixed together, their ability to reduce exposed silver halides is increased beyond their individual abilities added together. This is due to the superadditivity effect.

- A developer containing proportionally more metol than hydroquinone produces a lower-contrast image. A developer containing proportionally more hydroquinone than metol produces a higher-contrast image.

Chapter **5**

Choosing a Paper and a Developer

Next to the image on the negative, the printing paper you choose has the greatest influence on the look of the final product. A single negative may have different print statements on different printing papers. Some of these differences can be very noticeable; others can be subtle, but no less significant.

In addition, the choice of a developer can have its own unique effect on a print. Although the effects of the developer are less obvious than the choice of paper, developers can either enhance a print statement or work against it.

The goal is to match the paper and developer to the image. The right match is more than luck or trial and error. It involves learning to see subtle differences in prints and knowing how these differences affect an image. Published descriptions of paper and developer characteristics aren't much help because they are often subjective and quickly rendered obsolete by periodic manufacturing changes. You should rely on your own ability to see variations in materials and should create a library of test results to which you can refer when making decisions.

THE PHYSICS OF VIEWING PRINTS
Learning to see differences in papers and developers starts with understanding how the eye sees the image on a print. You may have

noticed that details clearly visible in a negative are often obscured in a print of that negative. At first, this may seem puzzling because photographic paper and film have similar light-sensitive emulsions. The difference, however, is that you see a negative by transmitted light and a print by reflected light.

Viewing Negatives by Transmitted Light

When you look at a negative, you see the image by means of the light that passes through the emulsion and film base to your eye. As light passes through the negative, a certain amount is absorbed by the developed silver in the emulsion (Figure 5-1). This light absorption is known as *density*.

Figure 5-1 As light passes through a negative, the silver in the developed image absorbs light. The more silver in the emulsion, the greater the absorption, and the darker the image appears to the eye. This is called transmission density.

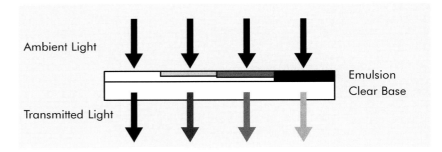

The relationship of the tones in a negative is in direct proportion to the density in the emulsion. For example, if a particular density has 50% absorption, almost 50% of the viewing light is transmitted through it (allowing for a small amount absorbed by the film base). If a density has 25% absorption, almost 75% of the viewing light is transmitted. If a density has 75% absorption, almost 25% of the light is transmitted.

Viewing Prints by Reflected Light

When you look at a print, you view the image by reflected light. Light striking the print passes through the emulsion, reflects off the paper base (where about 10% of the light is absorbed), and then passes back through the emulsion to the eye (Figure 5-2).

Figure 5-2 Because a print has an opaque backing, light passes through the image in the emulsion, bounces off the base, and passes through the image again before your eye sees it. The "double" absorption of reflection densities reduces the number of distinct tones you can see in a print compared to a negative.

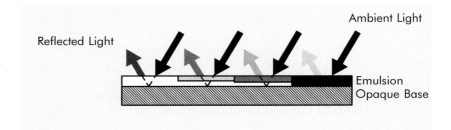

The fact that reflected light is absorbed twice by the density in the emulsion changes the relationship of the tones. High densities in a print absorb a greater percentage of light than do the same densities in a negative. For example, a density that transmits 50% of the light passing through a negative reflects less than 25% of the same light when it is on a print. A density that transmits 75% of the

viewing light will reflect only about 50%; and a density that transmits 25% will reflect less than 7%.

The result is that even though a negative and a print might have the same densities in their emulsions, the print will appear to have fewer and more tightly compressed tones than the negative. This difference is almost entirely the result of how you view the images. Try holding a print in front of a bright light so that the light shines through it. Viewed this way, the shadows will usually reveal the same details and shades of dark gray that are visible in the negative.

Silver Content and Density

Some manufacturers and vendors of printing papers advertise that their paper contains more silver than competing brands and is therefore capable of producing greater shadow densities (in other words, blacker blacks). While this may seem logical, and a good selling point, there is actually no relationship between silver content in enlarging papers and the maximum black they produce.

In fact, one test showed that the paper with the greatest silver content consistently produced the least dense shadow tones.*

The Effect of Paper Surface

The discussion of print tones assumes that all printing papers have a similar surface. In fact, some printing papers are made with a smooth surface, and others are made with a textured, or *matte*, surface. The kind of surface a paper has affects the way that light is reflected even before it passes through the image.

Smooth-surface papers reflect light like a mirror. When viewed at the wrong angle, light sources in the viewing room are reflected in the print. A matte-surface paper has an uneven surface that prevents mirrorlike reflections by scattering light in all directions (Figure 5-3).

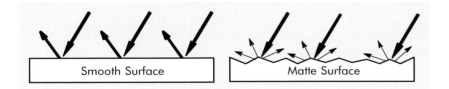

Smooth Surface Matte Surface

Figure 5-3 Paper surface affects how light is reflected.

When you encounter the reflection of a light source in a smooth-surface print, you can change the viewing angle slightly to avoid it. Because of the way matte-surface prints scatter light in all directions, there is no angle at which you do not see a small amount of reflection. As a result, tones appear more compressed on matte surface paper than they do when you view the same image on smooth surface paper. This is especially true in the darkest shadow tones. For this reason, matte surface paper is a good choice if you want to simplify the range of tones in a print even more than they would be normally.

* *Controls in Black-and-White Photography, second edition* by Richard J. Henry, Focal Press, Boston, 1988.

COMPARING PRINT TONES AND COLOR

Before you can objectively compare different print statements, you must learn to compare the two aspects of an image that are most affected by changes in papers and developers. These are tonal separation and print color. Once you learn to see these differences, you can begin to relate them to your own prints.

Separation of Print Tones

In earlier chapters, separation of print tones was discussed in terms of highlights and shadows. In addition to this overall contrast, the way that all shades of gray are distributed throughout the image can affect a print statement. Two prints that have the same contrast can look quite different because of the way that the tones between the highlights and shadows relate to each other. This type of tonal relationship is sometimes called *internal contrast* or *local contrast*.

For example, a print made on Agfa's Brovira paper will have a greater separation of tones in the highlights than the same image printed on Agfa's Portriga Rapid, even when the prints have the same overall contrast. The Portriga Rapid print, on the other hand, will have a much greater separation of tones in the shadows, and the separation of tones overall will be more evenly spaced (Figure 5-4).

(a) Portriga Rapid paper

(b) Brovira paper

Figure 5-4 The same image printed on different papers. The Portriga Rapid print (a) shows greater detail and contrast in the shadows than the same image printed on Brovira (b).

Print developers can cause similar changes in tonal relationships. A print developed in Sprint Quicksilver tends to have compressed shadow tones compared to the same image printed on the same paper and developed in Kodak Dektol. Again, this difference appears even when the overall contrast of the prints is the same.

When examining tonal separation in prints, it is useful to divide print tones into three general areas: highlights, midtones, and shadows. The differences in most materials are apparent within these broad groups and are easier to recognize than trying to compare widely separated tones. The following sections describe how you can see the effects of different tonal separation in each of these areas. Each description assumes that the prints being compared have the same overall contrast.

Highlights

When comparing the highlights in two prints, look at the most textured highlights first. Compressed highlight tones seem visually flat and lacking in detail. If details are more clearly defined in one print than another, it indicates greater separation. If the highlights in the image are reflections off smooth, shiny objects, the print that shows those highlights with the most appearance of depth also has greater highlight separation.

Middle Tones

The standard reference for a middle gray tone is the Kodak 18% reflectance card, also known as a *gray card*. The tone of this card defines the midpoint of all print tones. Tones that fall slightly above and below this value are the midtones of a print. Common examples of midtones range from the tones normally seen in the clear north sky and average Caucasian skin, to sunlit grass and light brown hair.

The midtones in a print typically have the most influence on the viewer's perception of the image. It is in these tones that our eyes are most sensitive to small differences. As with highlights, a compressed midtone region in a print seems to lack sharp detail. By comparison, a print with greater separation in the midtones appears to have more "depth."

Shadows

When comparing the separation of shadow tones in two prints, look at the shadow areas containing the most detail. Compressed shadows seem to have dark murky details. Clearly separated shadows appear to be more open, even lighter than compressed shadows. Also, in the print with more shadow separation, the area of darkest tone will be smaller and distinct from the slightly lighter shadows around it.

Print Color

Although the color of a negative is rarely a factor in black-and-white photography,* print color does have a genuine, if subtle, effect on the viewer. Most viewers do not consciously see any color in an untoned black-and-white print, even though prints are rarely a neutral gray. Instead, prints range in color from slightly warm (ivory or buff) to cold (bluish). This color is the result of the way the print's paper base and emulsion are manufactured and the way that you develop it.

Paper Color

The primary source of print color is the paper base. This color is usually part of the coating that is placed between the paper itself and the gelatin emulsion. Fiber paper has a clay or bayarta coating intended to smooth out the texture of the fibers on the paper surface. Resin-coated paper has a plastic, polyethylene coating.

* The exception is film developed in a pyro-based developer. A pyro-developed negative has an excessively red-stained image that reacts with the color sensitivity of most printing paper.

Some manufacturers purposely pigment the coating to produce a specific coloration. Many times, however, the color of the coating layer is a by-product of its chemical composition, which includes brighteners and fluorescent chemicals added to increase the amount of light reflected from the surface. The result is that what one manufacturer claims is a neutral white is usually different from what another manufacturer claims it to be.

Unfortunately, in some papers the brightening layer is water soluble and dissolves if a print is washed too long. A paper with a white-looking paper base will appear darker and sometimes even cream colored if the brightener is washed out. The washing test described in Chapter 9, "Archival Processing," indicates the practical limit for print washing. Usually, this amount of washing will not remove the brightening layer.

Image Color

More subtle than the color of the paper base is the color of the image formed in the emulsion. The silver density in a print has a particular coloration affected by its grain structure and the chemical composition of the developer used to create it. Fine-grain emulsions, such as Kodak's Polycontrast, tend to have a warm (reddish) color. Coarse-grained, bromide emulsions, such as Agfa's Brovira, tend to have a cool (bluish) color.

Image color is also affected by development. In Chapter 4, you may have noticed that the color of the test prints changed slightly as you changed the combination and concentration of chemicals in the developer you created. Each developer formula produces its own image color.

The developer formulas listed in Appendix E are grouped by their effect on print color. There are formulas that develop neutral-color images, warm-color images, and cool-color images. How noticeable this effect is depends on the paper you use. A cool-color developer will not noticeably affect the image of a warm-color paper.

Another way to change a print's color is through toning, which is the subject of Chapter 8.

Seeing Print Color

Although any statement about the psychology of print color runs the risk of being too general to be accurate, warm-color prints tend to engage a viewer emotionally, and cool-color prints tend to enforce an emotional distance. For example, you might print portraits on a warm-color paper to increase the viewer's emotional response to the subject, or you might print abstractions on a neutral or cool-color paper to produce an intellectual distance and thus reinforce the image's geometry. The important point is that print color can either enhance an image or detract from it.

You can see relative color differences by comparing two prints made on different brands of paper or developed in different developers. You can also compare a print to a gray card to determine if the print is warmer or cooler than the neutral color of

the card. It is easier to look in the midtones for the color difference because highlights are often too light and shadows are too dark to reflect a print's color accurately.

TESTING METHODS

It is nice to know that a photographer whose work you admire uses a particular type of printing paper. Ansel Adams, for example, made no secret of preferring a cold white paper with a neutral to cool emulsion color and a smooth surface when he printed.* This information, however, should not be the basis for choosing your printing paper and developer. Personal testing and evaluation are the only guides for determining which materials are best for you.

The following sections describe procedures for testing different papers and developers. These procedures will not provide the ultimate answer to the question of which paper and developer to use because there is no such answer. Instead, they involve creating a matrix of test results in which you can compare the effects of different combinations of papers and developers on your own images.

The tests are not difficult to perform, but they are time consuming, and there is no shortcut that can give you the same information and experience. Don't feel that you must test all possible paper and developer combinations at once; you can test three or four initially and continue to test as you find time.

Negatives for the Printing Tests

For all of the printing tests, choose three negatives that print well on normal-contrast paper but that emphasize different tones:

- One negative should have a varied and approximately equal range of tones. The negative you used for your ring-around test should work well. Call this the *standard negative*.
- A second negative should have mostly shadow tones. Call this the *low-key negative*.
- A third negative should have mostly highlight tones. Call this the *high-key negative*.

Each of the negatives should have the ability to clearly show you how a particular tonal area is affected by the paper and developer combination you choose to test.

Testing Papers

Because the choice of printing paper affects a print statement more than the choice of developer, begin by testing papers. The following test provides information about how your test negatives look printed on different papers with a variety of exposures and contrasts.

Materials

Select at least three different brands of printing paper. These papers should be brands you normally use or papers you are interested in working with. You should have at least one normal-, high-, and low-contrast grade of each paper. As a suggestion, try to

* *The Print* by Ansel Adams, Little, Brown, Boston, 1983.

select as wide a variety as possible from among conventional fiber papers, resin-coated papers, and variable-contrast papers. The greater the variety you include in the test, the more you will learn about how different papers affect your images.

Use the paper developer you normally use. If you have no preference, use Kodak's Dektol or another widely available print developer designed for normal use.

Procedure

1 Select the standard negative, and print a ring-around on the first brand of paper you want to test. Follow the directions for the ring-around test in Chapter 3.
 You do not need to repeat this test on the paper you used for the ring-around in Chapter 3 if you are using the same negative you used for that test. If you were not satisfied with the ring-around the first time, however, you might want to repeat it.

2 Prepare a fresh tray of developer, select the low-key negative, and print a ring-around with the same brand of paper you used in step 1.

3 Repeat step 2 with the high-key negative.

4 Repeat steps 1 through 3 with a different brand of printing paper. Continue repeating steps 1 through 3 until you have printed a ring-around of the three negatives with all of the different paper brands you are testing.

Evaluation

1 Lay out the finished prints in the same order you used to evaluate the ring-around test in Chapter 3.

2 Select the print (or prints) that have the most appropriate print statement for each image.

3 Look carefully at the prints you selected for differences in tonal separation. Look at the highlights in the prints made from the high-key negative, then look at the shadows in the prints made from the low-key negative. Finally, compare the midtones and the overall tonal range in the prints made from the standard negative.

4 Decide which of the papers you tested has the greatest highlight separation and which has the least.

5 Decide which paper has the greatest shadow separation and which has the least.

6 Decide which paper has the greatest midtone separation and which has the least.

7 Decide which paper has the most even separation of tones from highlights to shadows.

8 Finally, decide which papers have a warm color and which have a cool color. Compare the prints to each other and to a neutral gray card.

Keep notes of all of your findings. Be sure to save your test prints, and record the appropriate identifying information on the back of each.

Matching Modern Films and Papers

Relatively new film technology typified by Kodak's T-Max and Ilford's Delta films have changed the traditional tonal range of film. Where the highlight tones in older films, such as Kodak's Tri-X, are closer together (compressed) than the shadows and midtones, the highlight separation of the newer films is more even, similar to the tonal separation in other areas of the image.

Both Kodak and Ilford have created enlarging papers that match the tonal characteristics of their new films. Kodak's Polymax II and Ilford's Multigrade IV are examples. Because these papers are geared to the tonal characteristics of the new films, prints made from older film types can appear gray and "muddy" in the highlights on this paper. If you are using a modern film emulsion such as T-Max, be sure to try at least one paper designed for it in your tests.

Testing Developers

This test provides information about how developers affect printing paper. When choosing developers to test, do not feel limited to the ones available in camera stores. You might want to consult the formulas in Appendix E for developers you can mix yourself.

Materials

For the developer test, use the paper type you selected as most appropriate for each of the three test negatives. If you selected more than one paper type, choose between them for your initial tests. If you were satisfied with the accuracy of the exposure for the reference print in the paper test, you don't need to repeat that developer and paper combination.

Choose at least three different paper developers designed to yield normal contrast results. Consult the manufacturer's literature if you aren't sure about a particular developer.

Procedure

1 Select the standard negative and the paper brand you chose as most appropriate for it, and print a ring-around. Develop the prints in the first developer you are testing.

2 Prepare a tray of the next developer you want to test, and print another ring-around using the same negative and paper as in step 1.

3 Repeat step 2 with a tray of the third developer you want to test.

4 Select the low-key negative, and repeat steps 1 through 3. You may choose to do this part of the test at a later time.

5 Select the high-key negative, and repeat steps 1 through 3. You may also choose to do this part of the test at a later time.

Evaluation

1 Lay out the ring-around tests for the standard negative in the same way you evaluated the ring-around test in Chapter 3.

2 Select the print or prints from each developer you tested that have the most appropriate print statement for that image, and put away the rest. Look carefully at the prints you selected for differences in tonal separation and color.

3 Order the prints from the most widely separated tones to the most compressed tones (Figure 5-5). This order may be subjective when a print has widely separated tones in one area (like the highlights) and compressed tones in another (such as the shadows). Don't worry that you might change your mind about the order at a later date.

Figure 5-5 Ordering prints by tonal separation.

4 Decide which range of tones seems best for the image, which is second best, and so on.

5 Rearrange the same prints in order from the warmest color to the coolest color. Compare the prints to a neutral gray card to see which are warm and which are cool (Figure 5-6).

Figure 5-6 Ordering prints by print color. Typically, most prints will appear warmer than the neutral color of the gray card as indicated by the position of the gray card color in the illustration.

6 Decide which of the print colors seem best for the image, which is second best, and so on.

7 Repeat steps 1 though 6 for the prints from the low-key negative and from the high-key negative.

As with the paper test, keep careful notes of all of your findings. Be sure to save your test prints and to record the appropriate identifying information on the back of each.

Working though the paper and developer tests is exhaustive and potentially frustrating. Although it is possible that the tests have identified a specific paper and developer combination that is best for your images, it is more likely that it has only narrowed the field down from among the many possibilities and that no clear "winner" is evident.

Don't be concerned if you are temporarily undecided. The point of these exercises is to train your eyes to recognize subtle differences between prints made with different materials. The benefit is to systematize and compress the experience that thoughtful photographers gain through years of working intuitively. Your efforts will give you a library of prints that you can use to make informed decisions when choosing paper and developer combinations.

CHOOSING A PAPER AND DEVELOPER

In many cases, the needs of your negatives dictate the materials you use. If shadow detail is of primary importance, then the print and developer combination that yields the most separation in the shadow tones is probably the best choice. Likewise, if highlight texture is more important than shadow detail, you should consider using materials that emphasize highlight tones. Keep in mind that the color of the paper and developer combination you choose should also be appropriate to the image.

If you are undecided about how to print an image, make a "working" print on the paper and developer combination that produced the most even overall separation of tones and was closest to a neutral color. After it is fully processed and dry, study that print, and decide which tones you want to emphasize and what color is appropriate. Then use your test prints as a reference in choosing the best paper and developer for the final print.

If uniform print color is important, as it might be for images you plan to display together, you might be limited to papers and developers that produce similar colors. If an image requires a tonal scale only produced by a paper and developer that have a color inconsistent with the other prints in the series, you can modify the color of all your prints by toning, a process described in Chapter 8.

As a final note, some photographers advocate working with only a single paper and developer combination. In theory, working exclusively with one paper and developer is a way to understand the subtleties of those materials. This is good advice for the beginning photographer.

Working with just one combination of paper and developer, however, promotes a tendency to limit your photography to just the images that work well with these materials. It is better to have experience working with several paper and developer combinations so that the materials you use don't limit the way that you see.

SUMMARY

- A print appears to have fewer tones than a negative because when you view a print by reflected light, the density in the print emulsion absorbs the light twice before your eye can see it.
- A high-key image is one that contains a predominance of highlights. In these images, the rendering of the highlight tones is usually the most important consideration in the print statement.
- A low-key image is one that contains a predominance of shadows. In a low-key image, the rendering of the shadow tones is usually the most important consideration in the print statement.
- In an image that contains approximately equal areas of highlights, shadows, and midtones, an even separation of all the tones is a good choice unless you have a specific reason to emphasize one tonal area over another.
- The color of a print is affected primarily by the paper base and the color of the developed silver in the emulsion.
- Personal testing and evaluation, in which you compare the effects of different combinations of papers and developers on your images, are the best guides for determining which materials are appropriate for your work.

- Build a library of test results for making choices about which paper and developer to use. For example, if you are undecided about how to print a negative, study a work print to decide which tones in the image are most important. Choose a paper and developer combination from among the test prints in your library that emphasizes those tones and has an appropriate print color.

Chapter **6**

Special Contrast Solutions

Occasionally you will have to print a negative with contrast problems that can't be solved by your usual darkroom techniques.* Such problem negatives usually fall into one of three categories:

- The negative has too much contrast for grade 1 paper even if you increase the print exposure and reduce the print development time.

- The negative has too little contrast for grade 3 paper. Although most paper brands offer higher contrast grades, these grades often do not tone with the same color as the lower grades. In a series of prints where toning and uniform color are important, you need alternate high-contrast options.

- The negative has localized contrast problems. For example, when printing very high contrast negatives, correcting the overall contrast often means that the midtones appear compressed and dull. In these cases, if you want to show detail in both bright highlights and dark shadows and retain the overall tonal separation of the print, you need a way to control the contrast of the highlights and shadows separately.

* If your negatives frequently do not have the correct contrast to print on normal paper grades, you should consider changing the way you expose and develop your film. It is worth studying such techniques as the zone system to help you gain more control over the contrast of your negatives.

This chapter describes different methods you can use to solve these problems. Because each negative with a contrast problem is different, use these descriptions as a guide to adapting these techniques to your own needs.

PRINTING A VERY HIGH CONTRAST NEGATIVE

Certain scenes naturally yield very high contrast negatives. For example, almost any scene photographed in bright sunlight or with strongly directional artificial light will produce a negative with extreme contrast.

Some high-contrast negatives won't make satisfactory prints no matter what you do to print them. Before trying to print any negative, look at it carefully, using a magnifying glass if necessary. To print well, even a very high contrast negative must have visible details in the important shadow areas as well as in the highlights and middle tones (Figure 6-1).

Figure 6-1 A high-contrast negative. You can successfully print a very high contrast negative if, like the one shown here, it has adequate shadow detail. Figure 6-2 shows what this negative looks like printed for the correct highlights on normal-contrast paper.

The following sections describe ways that you can print the negative shown in Figure 6-1. As you work with your own high-contrast negatives, expect to obtain results similar to those in the illustrations.

The Control Print

To gauge your progress as you print a difficult negative, make a control print on grade 2 paper developed in your normal paper developer. When you expose for the correct highlights, a very high contrast negative will produce a print with some highlight details and few additional tones other than maximum black (Figure 6-2). The control print will tell you how you are progressing as your prints approach the contrast you want.

Figure 6-2 The control print. This is how the negative illustrated in Figure 6-1 looks printed on grade 2 paper so that the sunlit grass is correctly exposed. Although the highlights are correct, the rest of the print is almost completely black.

Low-Contrast Paper and Decreased Development

The first technique to try when printing a very high contrast negative is to combine grade 1 paper developed in your normal developer with approximately 20% more exposure and half your normal development time. The highlights in this print should match those of the control print.

Figure 6-3 Grade 1 paper with increased exposure and decreased development. Some detail is visible in the midtones (around the sunlit grass in the foreground), but overall the print is still very dark.

This is a technique you learned about in Chapter 3 to gain a finer degree of control over the contrast of a print. Although this technique is both convenient and effective for negatives that are slightly high in contrast, it usually is not enough to print a very high contrast negative successfully.

Low-Contrast Developers

Developers formulated specially to produce low-contrast results can effectively lower the contrast of a print by more than one contrast

grade. Because there are few commercially available developers designed to produce low-contrast prints, most must be mixed from formulas. Appendix E lists a variety of the most useful formulas.

If you don't want to mix a formula from bulk chemicals, a commercially available low-contrast developer is Kodak's Selectol-Soft. Selectol-Soft is also an excellent warm-color developer.

Figure 6-4 Grade 1 paper developed in GAF 120 (a low-contrast developer) for 1 minute. The print shows detail in the midtone areas and begins to show detail in the shadowed grassy areas of the foreground. Overall, however, the print still has too much contrast.

You should be aware that changing from a normal-contrast to a low-contrast developer usually means changing the print color slightly. Most low-contrast developers produce warm colors. You should, however, be able to choose a formula from those listed in Appendix E that closely matches the color of the standard developer you are using.

Print Flashing

Flashing is a contrast reducing technique that pre-exposes the printing paper before it is exposed to the negative. This technique increases highlight densities without visibly affecting midtones and shadows.

Flashing works because of the inertia that all light-sensitive silver emulsions have to exposure. What this means is that you can expose a piece of printing paper to a small amount of light without producing a visible density after it is developed. The amount of exposure necessary to produce a visible tone on printing paper is called the *exposure threshold*. When you flash a print, you expose the paper to white light up to, but not exceeding its exposure threshold. This is the *flash exposure*. Next you expose the paper to the negative you are printing, calculating the exposure time, as always, for the correct rendering of the highlights. This is the *main exposure*.

Because flashed printing paper needs less main exposure to correctly render the highlights, the shadow densities of that image will appear lighter than on paper that hasn't been flashed. The result is lower contrast. When correctly done, flashing decreases the density of the shadows in a print while allowing you to expose for the correct highlight details (Figure 6-5).

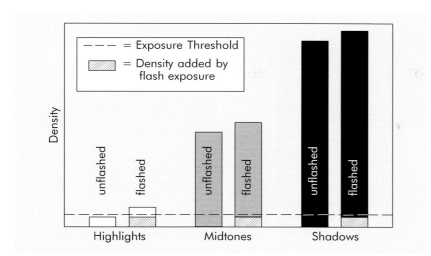

Figure 6-5 The relationship of the exposure threshold to flashed and unflashed print tones. While flashing increases the density of all of the tones in the image equally, the effect is most noticeable in the highlights where the difference is between a tone that is visible and one that isn't.

To flash printing paper, you need a low-intensity, controllable light source. In most darkrooms, there are three ways to create this type of light:

- Raise the head of your enlarger to its maximum height and close the enlarging lens to its minimum aperture. This produces a low-intensity light that you can control through the enlarger timer. If you are in the middle of printing a negative, however, you must take the negative out of the enlarger and change its height to make the flash exposure. If you discover later that you flashed incorrectly or you didn't flash enough paper, then you must repeat the process all over again.

- Suspend a small incandescent bulb from the darkroom ceiling. You can temporarily connect the bulb to the enlarger timer and flash paper without having to alter the enlarger's setting.

- Place a diffusing filter over the enlarging lens and make the flash exposure without removing the negative from the enlarger or changing the enlarger's settings. You can use a small piece of 1/8-inch white Plexiglass for the diffusing filter and add neutral-density filters, if necessary, to reduce the light intensity.

Calculating the Flash Exposure

Once you have decided how you are going to produce the flash exposure, use the following steps to calculate its duration:

1 Cut a full sheet of printing paper into test strips.

2 Expose the test strips to flash exposures of 5, 10, 15, and 20 seconds.

3 Develop the test strips in the same manner that you are planning to develop the final print.
 For example, if you are planning to use a special developer or a nonstandard development time for the final print, use these for developing the flash exposure test.

4 Once fixed, compare the test strips to a standard white patch for the paper you are using.

5 If all of the strips are visibly darker than the white patch, reduce the intensity of the light source and repeat the exposure test at the same time intervals.

6 If none of the test strips shows any density compared to the standard white patch, repeat the exposure test with longer time intervals, such as 20, 30, 40, and 50 seconds.

Once you have a set of test strips in which at least one strip shows some noticeable density and at least one strip shows no density, choose the longest exposure that shows no density as the flash exposure time.

Calculating the Main Exposure

Calculate the main exposure in the same manner that you calculate the exposure for an unflashed print, but use flashed paper for your test strips. Once you have determined the correct main exposure, use full sheets of flashed paper to make the final print. You can burn and dodge on flashed paper just as you would on unflashed paper.

Figure 6-6 Grade 1 paper with reduced development time and flash exposure. The print shows appropriate detail in both the sunlit grass and the darkest shadows on the tree trunks.

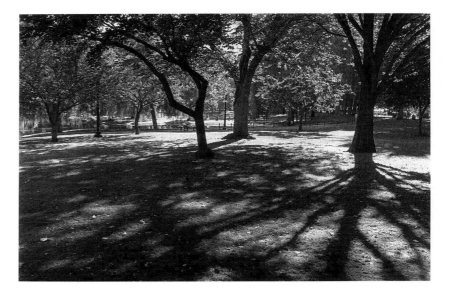

Print flashing works in many situations, but it is not a universal solution. Flashing is most appropriate for prints that have textured highlight areas, and it is less convincing if the highlights in the image are smooth and without detail. When this is the case, a flashed print can end up looking muddy and gray.

Water Bath Development

Water bath development is a technique in which you lower the contrast of a print by alternately agitating the printing paper in a tray of developer and then letting it sit still in a tray of water. The water retards the development of the shadows while allowing the highlights to develop at a near normal rate.

When you agitate printing paper in developer, the emulsion absorbs enough solution to continue producing an image even after the paper is removed from it. When you place the paper in water, the developer absorbed by the emulsion is able to continue working until it is exhausted. Because the developer is working harder and

is exhausted more rapidly in the shadows than in the highlights, the shadows stop developing shortly after the print goes into the water, while the highlights continue developing.

Procedure

The following steps outline a general working procedure for water bath development.

1 Place a tray of room temperature water next to the developer tray in your darkroom sink.

 Because you are using a water bath to print an extremely high-contrast negative, consider using a low-contrast developer.

2 After exposure, agitate the print in the developer for approximately 15 seconds.

 Agitating the print in the developer saturates the emulsion with developer.

3 Carefully transfer the print to the water tray. Place it face down, making sure that no air bubbles are trapped under the print so that the emulsion contacts the water evenly. Leave the print in the water bath for 1 minute without agitation.

 In the water bath, developer is rapidly exhausted in the shadows and continues to produce an image in the highlights.

4 Return the print to the developer tray, and agitate for 10 seconds.

 The print emulsion is resaturated with developer.

5 Transfer the print a second time to the water tray, and let it sit emulsion side down without agitation for 1 minute.
The developer is again rapidly exhausted in the shadows and continues to produce an image in the highlights.

6 Continue alternating agitation in the developer with still time in the water bath until the total time in the developer equals approximately two-thirds of your normal development time for that developer.
7 Stop and fix the print.

Figure 6-7 Grade 1 paper in a low-contrast developer combined with a water bath development. A water bath is an alternative to flashing for producing a low-contrast print. This print is similar to the one in Figure 6-6. Although the procedure is somewhat tedious and susceptible to safelight fog, you can combine flashing and water bath development for even lower contrast results.

The number of times you alternate the print between the developer and the water bath depends primarily on how much contrast the negative has. You must experiment with the following variables:

- *Print Exposure*—Water bath development affects print exposure. Be sure to prepare test strips and give them the same amount of water bath development that you plan for the full print.
- *Development Time*—Consider the suggested time in the developer of two-thirds normal development time to be only a starting point that you must confirm by testing.
- *Safelight Fog*—Because the total time that the paper will be exposed to your darkroom's safelights before going into the stop bath will be considerably longer than normal, you should consider the possibility of safelight fog. In fact, safelight fog can easily be mistaken for lower contrast. If you suspect safelight fog,

perform water bath development under reduced-intensity safelights or in the dark.

- *Developer Dilution*—If you are using a very active developer and the print develops too rapidly to control, try diluting the developer more than usual. For example, dilute Dektol 1:3 instead of 1:1 or 1:2.

- *Uneven Development*—If certain areas of the print appear uneven, or "mottled," try rocking the water bath tray once every 30 seconds by lifting a corner of the tray slightly and setting it back down.

The Sterry Process

A dilute solution of potassium or ammonium dichromate can decrease the development of an image in areas of the greatest density proportionally more than in the areas of least density. When used correctly, the result is a lower contrast image. This effect was discovered by John Sterry in the early 1900s, and is not widely used because of the relatively hazardous nature of dichromate salts.

Safety Note: Potassium Dichromate

Potassium dichromate is a chemical to which many people develop an allergic reaction. Avoid breathing the dust as you mix the Sterry formula and wear protective gloves (see Appendix A "Darkroom Safety" to determine the best type) when you handle the solution to prevent direct contact with your skin.

Procedure

1 Before starting, plan for any other low contrast solutions, such as a low-contrast developer or a reduced development time. You must be consistent with any other technique you are using, even while you are making test strips.

2 Mix 10 ml of the Sterry formula stock solution described in Appendix F "Miscellaneous Formulas" with 300 ml of water to make a working solution.

3 Expose a series of test strips of the highlight area of the negative you want to print.

4 Agitate the test strips in a tray of the Sterry solution for two to three minutes.
Wear the appropriate gloves and eye protection. Be sure not to let the Sterry solution splash on your skin.

5 Rinse the test strips by agitating in a tray of water for one minute.

6 After a minute, drain the excess water off the test strips and place in the developer.

7 Develop the test strips according to your plan for this test.

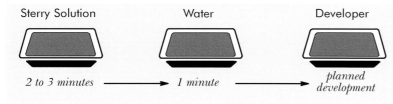

Sterry Solution	Water	Developer
2 to 3 minutes	*1 minute*	*planned development*

8 Once you determine the correct exposure time, expose and process the print in the same manner.

You can decrease the contrast of the print even more by reducing the amount of the Sterry stock solution you use in the working solution to as little as 6 ml. If you don't want as much reduction in contrast, you can use as much as 20 ml of the Sterry stock solution to make the working solution.

The Sterry process works differently with different types of printing paper, so you must test each type of paper you want to use individually. In general, bromide papers such as Agfa Brovira work best with the process and resin coated papers tend to work least well.*

Combining Low-Contrast Techniques

Most of the techniques for producing low-contrast prints are additive. If a single technique doesn't produce a low enough contrast, you can combine two or more of the techniques until you produce the print you want. There are some common sense limitations. You can't, for example, combine the Sterry process with water bath development. You can, however, combine the Sterry process with a low contrast paper and developer, as well as reduced development time.

There is no specific order in which one low-contrast technique naturally follows another. In general, you should test the techniques both individually and in different combinations to understand their effects. Then, when you come across a negative that requires it, you can combine the techniques that are the most appropriate. The figures in this section illustrate possible combinations to try.

PRINTING A LOW-CONTRAST NEGATIVE

Although most paper brands offer high-contrast grades that permit you to print almost any low-contrast negative, there are times when you need an alternative. For example, if toning and matching print color are important in a series of prints, you might want to use the same grade of paper and increase contrast by altering the developer. The result will be a print that tones in the same manner as the others in the series.

Figure 6-8 illustrates a control print of a low-contrast negative. Making a control print allows you to gauge the effect of the different high-contrast techniques as you experiment with them.

* Unpublished paper, *The Sterry Process* by James W. Henderson, ©1993.

Figure 6-8 The control print for high-contrast techniques. This print was made on grade 2 paper developed in a normal-contrast paper developer. The ferns appear as soft gray tones, and the details in them are hard to see, meaning that the print contrast is probably too low.

High-Contrast Developers

Developers formulated specially to produce high-contrast results can raise the contrast of a print by more than the equivalent of a contrast grade. Appendix E lists some useful high-contrast developer formulas.

If you don't want to mix a developer from a formula, one packaged developer that you can use for high-contrast work is Edwal T.S.T. This is a two-solution developer that you mix in different proportions for different contrasts. Mix one part T.S.T. solution A to seven parts water to make a working-strength high-contrast developer. Another alternative is to increase the contrast of a standard developer by increasing the concentration of its working solution. For example, you can use Kodak's Dektol stock solution diluted 1:1 or even without dilution, instead of diluting it 1:2 as the manufacturer recommends.

Figure 6-9 Grade 2 paper developed in a high-contrast developer with twice the normal development time. This print was made on grade 2 paper and developed in Beers high-contrast formula for 4 minutes. Compared to Figure 6-8, the shadows are darker and the ferns appear to have more detail.

Changing from a normal-contrast developer to a high-contrast developer usually means that the print color will change slightly, depending on the formula you use. Try the different high-contrast formulas in Appendix E to find one that matches the color of the standard developer you are using as closely as possible.

Increasing the Restrainer Content of a Developer

Increasing the amount of restrainer in a developer increases its contrast. When you increase the restrainer, you increase the exposure necessary before the highlights in a print develop a visible density. As you saw when you created your own developer in Chapter 4, the restrainer primarily affects the highlights, so the additional exposure makes the shadows darker and gives the print more contrast.

Procedure

When adding restrainer to a working solution of developer, it is useful to prepare a stock solution of 10% potassium bromide ahead of time. Make a convenient amount of solution by adding 10 grams of potassium bromide to 100 milliliters (ml) of water. This solution stores well in an airtight bottle.

Add the stock solution 5 ml at a time, and test the modified developer by making a print. The contrast of the print will increase as the amount of restrainer increases. Eventually, you will add so much restrainer that it is difficult to obtain a satisfactory print.

(a) 5 ml of added potassium bromide (8-second exposure)

(b) 15 ml of added potassium bromide (10-second exposure)

Figure 6-10 Comparison of prints made with different amounts of restrainer. These prints were made on grade 2 paper and developed in Beers high-contrast formula with added restrainer. The additional restrainer had the effect of increasing the print contrast. Up to a point (which varies by developer), adding more restrainer adds to the developer contrast.

Adding potassium bromide increases the green-black color of prints developed in that developer (something you can't see in the reproduction of Figure 6-10). If this color is objectionable, you can tone the print in selenium toner (see Chapter 8 for instructions) or use a synthetic restrainer, such as Kodak's Anti-Fog No. 1 or Edwal's Liquid Orthazite. These restrainers produce a blue-black print color instead of green-black.

CUSTOMIZING PRINT CONTRAST

To print successfully, some negatives require separate contrasts for the highlights and the shadows. For example, a negative with brightly lit subject matter and important details in deep shadow should be printed so that details appear in both areas without making either look dull and gray. Normally, this is impossible if you print the negative with a single contrast range low enough to show the detail in both areas.

The solution for such negatives is to customize the print contrast so that it is optimum for each area. You can do this by either splitting the print development between two different developers or splitting the exposure between two different filters if you are using variable-contrast paper.

Split Tray Development

Split tray development allows you to develop any printing paper for one contrast range in the highlights and another in the shadows. It is a technique that requires two trays of developer: one containing a low-contrast formula and one containing a normal- or a high-contrast formula.

The different trays of developer affect the highlights and shadows of the print differently. The low-contrast formula causes an even, gradual separation of tones in the print. The higher contrast formula produces dark, vigorous shadows.

Alternate the print between the two trays until the image is fully developed. By controlling the amount of time that the print spends in each tray, you control the effect that each developer has on it. With some experimentation, you can find the correct contrast balance for each negative you print.

Low-contrast developer

Normal or high-contrast developer

Figure 6-11 Split tray development. Alternating the print between two trays of developer controls the contrast of the highlights and shadows separately.

Split tray development is especially effective for producing a print with a lot of tonal separation in both the highlights and the shadows. If you do a clumsy job with split tray development, however, you can produce a print in which the highlights and shadows look awkward together. Experience is your best guide.

Procedure

Even though the essence of split tray development is experimentation, these general principles can guide you:
- The greatest effect on the overall contrast of the print is from the developer in which the print spends the most time.
- If the development times are equal, the developer you use first will have the strongest effect on the overall contrast of the print.

For example, a print that requires an overall low contrast but needs dark shadows and good shadow separation should spend most of its development time in the low-contrast tray, with only the final 10 to 15 seconds in the normal-contrast tray.

Following are two different development plans: one for very high-contrast negatives and the other for very low-contrast negatives. Use these as starting points for your own tests.

Development Plan for a Very High Contrast Image
1 Agitate the print for 1 minute in low-contrast developer.
2 Transfer the print to a normal- or high-contrast developer.
3 Agitate the print for 10 seconds.
4 Stop and fix the print.

The result is a low-contrast print that still has strong shadow separation and black, rather than gray, shadows.

Development Plan for a Low-Contrast Image
1 Agitate the print for 3 minutes in high-contrast developer.
2 Transfer the print to the low-contrast developer.
3 Agitate the print for an additional minute.
4 Stop and fix the print.

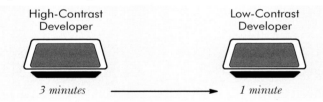

The result is a print that has a full range of tones and that doesn't lose the subtlety or separation of tones in the highlights.

Split Filter Exposure on Variable-Contrast Paper
Although the actual emulsions are more complex, it is useful to think of variable-contrast papers as containing two layers of light-sensitive emulsion: one a high-contrast layer sensitive to blue light; the other a low-contrast layer sensitive to green light. The filter sets supplied with variable-contrast papers regulate the amount of each color of light that the paper receives, balancing the exposure of the two layers to control the overall contrast between moderately low and moderately high.*

* Variable-contrast filters typically range in color from yellow (low contrast) to magenta (high contrast). A yellow filter (rather than green) allows mores total light to expose the paper, and the red light that also passes through a yellow filter doesn't add any extra exposure to the paper. Magenta, likewise, is more efficient than a blue filter.

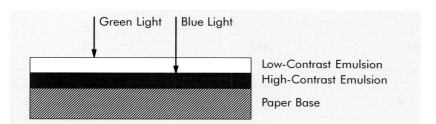

Figure 6-12 Simplified cross-section of variable-contrast paper. Green light exposes the low-contrast layer of the emulsion, and blue light exposes the high-contrast layer.

Variable-contrast paper is intended for exposure through a single filter, but you can take advantage of the two different emulsion layers to use separate exposures for each. Expose the low-contrast layer for the highlights and general details of the image, and expose the high-contrast layer to increase the density of the shadows.

Materials

You can use the lowest and highest contrast filters in your variable-contrast filter set even though these filters do not exclusively expose a single layer of the paper's emulsion. A more effective way to expose the individual layers of variable-contrast paper is to use the following:

- yellow filter, Kodak Wratten 8 (also known as K-2) or equivalent
- blue filter, Kodak Wratten 47-B or equivalent

You can purchase thin gelatin filters in the appropriate Wratten numbers and place them under the enlarging lens. The thinness of the gelatin filter produces minimum distortion of the projected image. Wratten filters are available from Kodak in various sizes and prices. If you use gelatin filters, handle them carefully because they scratch easily.

Procedure

1 Place the yellow (or low-contrast) filter in the path of the enlarger light.
2 Run a series of test strips to determine the correct low-contrast exposure.
 The correct low-contrast exposure is the one that produces the best highlight tones.
3 Once you determine the correct low-contrast exposure, expose a full sheet of paper for that time and cut it into test strips.
4 Replace the low-contrast filter with the high-contrast filter and run an exposure test for the most important shadows.
 The correct high-contrast exposure is the one that produces the darkest shadows possible without obscuring detail.
5 Once you determine the correct low-contrast and high-contrast exposures, expose a full sheet of paper, first to the low-contrast filter and then to the high-contrast filter.

After you make the first print, you can make small adjustments to the overall contrast by changing the balance of the two exposures, reducing one and increasing the other by the same percentage. For example, to reduce the contrast of a print slightly, reduce the

exposure of the high-contrast filter by 5% and add 5% to the exposure of the low-contrast filter. To increase contrast, do the opposite.

SUMMARY

- Negatives with contrast problems that prevent you from making acceptable prints using normal darkroom techniques generally fall into one of three categories:
 - negatives with extremely high contrast.
 - negatives that are low in contrast but that for aesthetic reasons, you cannot print on grade 3, 4, or 5 papers.
 - negatives that must be printed with separate contrast ranges for the highlights and the shadows.
- Negatives that contain extreme high contrast can be printed using one or a combination of the following techniques:
 - Combine grade 1 paper with 20% more exposure than normal and half of your normal development time if the negative is only slightly high in contrast.
 - Develop in a low-contrast developer formula, or use a commercially available low-contrast developer, such as Kodak's Selectol-Soft.
 - Flash the printing paper by pre-exposing it before making the main exposure.
 - Water bath—Alternate the print between a tray of developer and a tray of plain water. Agitate the print for a few seconds in the developer and let it sit in the water for a full minute. Repeat the process until the image is fully developed.
 - Sterry process—Soak the exposed print in a dilute solution of potassium or ammonium dichromate before developing.
- Negatives that have a low contrast and which you don't want to print on high-contrast paper can be printed using one of the following techniques:
 - Develop in a high-contrast developer formula, or use a commercially available developer in a greater concentration than the manufacturer recommends.
 - Increase the amount of restrainer in a developer. Prints developed in a formula with added restrainer require additional exposure to correctly render the highlights and therefore have darker shadows than those developed in an unmodified formula.
- You can customize the contrast of a print so that it is optimum in both the highlights and the shadows, even when these areas require different contrasts, by using one of the following techniques:
 - Split tray development in which you divide the development time of a print between a tray of low-contrast developer and a tray of normal- or even high-contrast developer.
 - Split filter exposure with variable-contrast paper in which you give the high contrast and low contrast layers of the emulsion separate exposures based on the tones you want to appear in each tonal area.

Salvage Techniques

No one likes to anticipate printing a problem negative. It is only prudent, however, to make some preparations for the inevitable day when an essential image is on a hopeless negative. This chapter covers some useful ways to make a satisfactory print when otherwise it would be difficult, if not impossible.

Choosing a Technique

The image salvage techniques in this chapter are organized by their application to the negative or to the print. Working with a negative has the advantage of producing repeatable prints once you have made the necessary improvements. The disadvantage of working on the negative is that any mistake is likely to be permanent and may mean a lost image.

Working with a print has the advantage that mistakes are not fatal to the original image. You can discard a print if an experiment doesn't work and perfect your technique on duplicate prints. Working with prints, however, means that it is hard to achieve repeatable results. An edition of matching prints, for example, may be impossible.

Once a negative is developed, it is usually best to concentrate on the print. Occasionally, when there are so many problems associated with a negative that no print technique works, you are

justified in trying to improve the negative. Otherwise the image is useless.

NEGATIVE TECHNIQUES

You improve a poor negative by altering its image density. If a negative doesn't have enough density, you can chemically add to that density through a process called *intensification*. If a negative has too much density, you can remove the excess through a process called *reduction*.

The following techniques for intensification and reduction work only on conventional negative film in which the image density is made of silver. Some black-and-white film, such as Ilford's XP2, is chromogenic, which means that the image is formed by the same dyes used in color negative film. If you use a chromogenic film, try the print techniques in this chapter to improve the image; reduction and intensification of the negative won't work.

Negative Intensifiers

Intensification adds density to an underexposed or underdeveloped negative by combining a metal with the silver in the image or by changing the image color. No intensifier, however, can create density where none exists. A grossly underexposed negative can't be saved no matter how much you intensify it.

There are many formulas for intensifiers using metals that add themselves to the existing image silver. These include mercury, copper, silver, and even uranium. Other intensifier formulas tone the negative to a warm brown or red color so that light projected through it appears to have greater density to the printing paper.

You shouldn't attempt to use most classic intensifier formulas because they are unpredictable and often dangerous. There are a few intensification methods that are safe to use if reasonable precautions are taken and work well on contemporary films. Three methods are described in this book, two which employ toning techniques normally used on prints (selenium and sepia), and a chromium bleach-and-redevelop formula.

These intensifiers increase the densities of the negative in proportion to the amount of silver present. The darker highlight densities in the image intensify more than the lighter midtone and shadow densities. The result is an increase in contrast similar to increasing a negative's development. The primary difference is the amount of density and contrast increase each technique gives a negative.

Preparing for Intensification

Proper fixing and handling are essential to avoid stains that can ruin the negative. The intensifying material can bond with unfixed silver halides or unwashed silver sulfide compounds, making them visible as either blotchy stains or an overall tone. To avoid stains, fix for the correct amount of time with fresh fixer and wash a negative thoroughly before you attempt to intensify it.

Contamination from external sources, such as the containers and equipment you use for mixing and storing solutions, can also cause stains. Be sure to thoroughly clean everything you use during

the intensification process. Wear safety glasses and protective gloves (see Appendix A, "Darkroom Safety," to determine the best type) while handling the solutions to prevent contamination and to protect your eyes and skin.

To avoid damaging the negative during intensification, place the strip it is on back on the processing reel (for roll film) or in a hanger (for sheet film). Intensification softens film emulsion, so the less physical contact, the less chance for scratching. If after taking these precautions you still find your negatives damaged, consider treating future negatives with a Formalin supplementary hardener (Kodak SH-1) before intensification. The formula for SH-1 is given in Appendix F, "Miscellaneous Formulas."

Selenium Intensification

Using selenium toner as an intensifier for negatives is a useful way to achieve a slight amount of intensification. Because the procedure has fewer steps than chromium intensification, there is less risk of damaging the negative.

One drawback is that the time of intensification in selenium toner varies greatly depending on the type of film with which you are working. Films with slow emulsion speeds generally intensify more rapidly than fast films. Testing each film type is the only way to establish the correct intensification time.

You can make an intensifier solution by mixing one part Kodak's Rapid Selenium Toner with three parts of a working solution washing aid at 70° F. If during your testing you find that you are over-intensifying, try a dilution of one part toner to five parts washing aid. If necessary, you can even increase this dilution to one part toner to ten parts washing aid.

Intensifying for too long in selenium toner causes an image to turn a purple-red color and eventually fade. A certain amount of red coloration increases the apparent density of the negative to printing paper, but after that point, the actual loss of density appears in the print as less contrast.

General Selenium Intensification Procedure

Note: Room lights may be on during the entire process.

1 Pre-wet the negative in room-temperature water for 1 minute. Agitate for the first 30 seconds to be sure that the emulsion absorbs the water evenly. A few drops of Photo-Flo added to the water helps ensure the even wetting of the emulsion.
2 Transfer the negative to the intensification solution. Agitate constantly for 5 to 10 minutes as needed.
3 Rinse the negative and place it in a working solution of a washing aid for 3 minutes.
4 Wash the negative as you normally wash film.

Selenium Intensification Test

1 With your camera on a tripod in front of a scene containing a wide range of tones, shoot a roll of the film you want to test. If you are using sheet film, expose four sheets.
2 Develop the film for 60% of the normal development time for that film.

3 After processing, cut off about a fourth of the roll (or take one sheet) and set it aside.

4 Agitate the remaining film in the selenium toning solution for 3 minutes.

5 Rinse the film, cut off another fourth of the roll (or take another sheet) and set it aside.

6 Agitate the remaining film in the selenium toning solution for another 3 minutes.

7 Rinse the film, cut off another fourth of the roll (or take another sheet) and set it aside.

8 Agitate the final segment (or sheet) of the film in the selenium toning solution for 6 more minutes. Wash all of the film.

9 When the film is dry, print one frame from each segment (or each sheet) of film on normal-contrast paper for the best possible highlight value.

When the prints are dry, compare them to determine how much intensification you achieved during each of the tested times. Try to determine the point at which further toning no longer produces any intensification or even reduces the contrast of the image.

(a) Print from negative before selenium intensification

(b) Print from negative after selenium intensification

Figure 7-1 Using selenium toner to intensify a negative. The slight intensification provided by toning the negative for three minutes changes the relationship between the live oak tree trunks and the Spanish moss. Toning time depends on the film type and the amount of intensification needed.

Sepia Intensification

You can intensify a negative by sepia toning it. Even though the image will not visibly appear to have more density, the warm brown color that sepia gives a silver image makes it appear to have greater density to enlarging paper, because of the paper's relative insensitivity to red light. Sepia toning generally gives a negative more intensification than selenium toning.

Sepia toning is a two-step, bleach-and-redevelop process. You can't over- or under-intensify a negative in sepia, the process simply proceeds to completion. The primary concern when using sepia toner is the presence of residual fixer in the negative, which can cause the image to lose density during the initial bleach step.

General Sepia Intensification Procedure

Note: Room lights may be on during the entire process.

1 Mix sepia toner solutions A and B from a formula such as the one in Appendix F, or purchase a commercially available sepia toner, such as Kodak Sepia Toner.

2 Pre-wet the negative in the same manner recommended for selenium intensification.

3 Transfer the negative to the bleach solution (A). Agitate the negative constantly, inspecting every 30 seconds until all traces of the black image silver has changed to a creamy yellow color. This can take up to 5 minutes.

4 Wash the negative until all traces of the yellow bleach are gone.

5 Place the negative in the toning solution (B) and agitate until the bleached image is converted to a warm brown color. This should happen within about 30 seconds. Leave the negative in the toner for twice as long as it takes to change color. This ensures that the process has gone to completion.

6 Rinse the film to remove any residual toning solution and dry.

Because sepia toning for intensification is a process in which the bleach and toning steps should continue to completion there is no need to test different intensification times. Your results from intensifying with sepia toner should always be consistent.

Chromium Intensification

Chromium intensifier is a bleach-and-redevelopment formula that changes the silver in the image to a more opaque combination of silver and chromium. You can prepare chromium intensifier from formulas such as the one provided in Appendix F. This has the advantage of allowing you to alter the amount of intensification by changing the way you mix the stock solutions. Photographers who do only occasional intensification, however, usually find that it is convenient to use Kodak's chromium intensifier, which is sold in small, easy-to-use packets.

> **Safety Note: Chromium Intensifier**
>
> The main component of chromium intensifier is potassium dichromate, a chemical to which many people develop an allergic reaction. Avoid breathing the dust as you mix the formula, and wear protective gloves (see Appendix A, "Darkroom Safety," to determine the best type) when you handle the solution to prevent direct contact with your skin.

General Chromium Intensification Procedure

Note: Room lights may be on during the entire process.

1 Pre-wet the negative in room-temperature water for 3 minutes. Agitate for the first minute to be sure that the emulsion absorbs the water evenly. A few drops of Photo-Flo added to the water helps ensure the even wetting of the emulsion.

2 Transfer the negative to the bleach bath (part A if you are using Kodak's packaged formula). Agitate constantly for 3 to 5 minutes

or until the image on the negative has completely lightened to yellow.

3 Rinse the negative in running water for 1 minute or until the rinse water no longer has a yellow color.

4 If you are using the Kodak packaged intensifier, transfer the negative to the clearing bath (part B), and agitate for 2 minutes or until the image appears as a faint milky white. If you are using the single-solution formula given in Appendix F, continue the rinse until all of the yellow is gone from the negative, approximately 5 minutes.

5 If you used part B of the Kodak formula, rinse for 1 minute.

6 Redevelop the negative with a paper developer.* Develop to completion, which for most films is less than a minute. You cannot overdevelop, although you should not leave the film in the developer longer than 5 minutes.

7 Wash the redeveloped film for 5 to 10 minutes. No fix or washing aid is necessary.

You can repeat chromium intensification three times. Each time, the intensification effect will be less. After three intensifications, the increased density obtained is not great enough to warrant the additional risk of damage to the film emulsion.

Chromium Intensification Test

Follow the same procedure outlined for the selenium intensification test:

1 Expose and process one roll (or four sheets) of the film you want to test. Develop the film for approximately 75% of the time you normally develop that film with the developer you are using.

2 Leave a fourth of the roll (or one sheet) unintensified. Intensify the rest of the film.

3 Set aside another fourth of the roll (or another sheet).

4 Intensify the remaining film a second time.

5 Set aside another fourth of the roll (or a third sheet).

6 Intensify the final fourth of the roll (or the final sheet) a third time.

7 Wash the film. When it is dry, print one frame from each segment (or each sheet) of film on normal-contrast paper for the best possible highlight value.

When the prints are dry, compare them to determine how much intensification you achieved during each step.

* Don't use a film developer for redevelopment because the long development time required, combined with the large amount of sulfites that most film developers contain, tends to dissolve the silver salts in the image before they are completely redeveloped.

(a) Print from negative before chromium intensification

(b) Print from negative after two cycles of intensification

Negative Reducers

When a negative is too dense, either because of overexposure or overdevelopment, the excess density can be removed by a chemical bleaching process. This process is commonly called *reduction*, although it bears no resemblance to the reduction that occurs during development of a silver image.

There are two primary reducer types: *subtractive*, which removes density equally from all tones in the image, and *proportional*, which removes density in proportion to the current density of the image tones.* Reduction works approximately the same for negatives and for prints.

The reducer formula most often used is Farmer's reducer, named after Howard Farmer who popularized it in 1884. This formula combines potassium ferricyanide, a bleaching agent, with sodium thiosulfate, the major component of most fixing baths. When you use Farmer's reducer, the potassium ferricyanide bleaches the silver in the image back to a silver salt, and the fixing action of the sodium thiosulfate dissolves it.

Reduction is best accomplished in small steps. You can always repeat the reduction process if the initial attempt doesn't remove enough density, but the negative is ruined if you reduce too much.

Subtractive Reducers

Farmer's reducer can be either subtractive or proportional, depending on how you mix it. Appendix F provides two Farmer's reducer formulas: one subtractive, the other proportional. Each is made from the same two stock solutions.

When the potassium ferricyanide stock solution and the sodium thiosulfate stock solution are mixed together, Farmer's reducer is subtractive. Because the effects of a subtractive reducer are greatest in the shadows, this process is useful for correcting an overexposed negative in which the excess shadow density is most obvious.

Figure 7-2 Using chromium intensifier on a negative. Before intensification, the negative produces a print with gray shadows. After being intensified two times, a negative from the same roll of film produces a print with darker shadows when printed for the same highlight tones. Chromium intensification also increases the size of the grain in the negative.

* There is a third reducer type, *superproportional*, which removes density by a greater percentage than the proportion of densities in the negative. Superproportional formulas are not in common use anymore.

General Subtractive Reduction Procedure

Note: Room lights may be on during the entire process.

1 Mix 30 ml of Farmer's reducer stock solution A and 120 ml of stock solution B with enough room-temperature water to make 1 liter of working solution. Once the solution is mixed, it has a useful life of less than 10 minutes. When exhausted, the solution turns from yellow to green.

2 Agitate the negative in the reducer for 1 minute. The image will turn yellow.

3 Rinse the negative with running water until all of the yellow has disappeared from the wash water. Inspect the image. You can repeat steps 1, 2, and 3 if more reduction is necessary.

4 Fix the negative for 1 minute, then wash (after using a washing aid) and dry normally.

Subtractive Reduction Test

1 With your camera on a tripod in front of an evenly lit scene, shoot a roll of the film you want to test, overexposing by three stops. If you are testing sheet film, expose four sheets the same way.

2 Develop the film for its normal development time.

3 After processing, cut off about one fourth of the roll (or take one sheet), and set it aside.

4 Agitate the remaining film in freshly mixed reducer for 1 minute.

5 Rinse the film, cut off another fourth of the roll (or take another sheet), and set it aside.

6 Agitate the remaining film in freshly mixed reducer for 1 minute.

7 Rinse the film, cut off another fourth of the roll (or take another sheet), and set it aside.

8 Agitate the final segment (or sheet) of the film in another bath of freshly mixed reducer for 1 minute. Wash all of the film.

9 When the film is dry, make a print from each segment (or each sheet) of film on normal-contrast paper for the best possible highlights.

When the prints are dry, compare them to see examples of what you can achieve with a subtractive reducer. Try to determine the point at which further reduction no longer produces any improvement in the printed image or actually begins to lower the contrast of the image. This indicates the point at which useful reduction is no longer possible.

Proportional Reducers

When the potassium ferricyanide stock solution and the sodium thiosulfate stock solution are kept separate and the image being reduced is alternated between the two, Farmer's reducer acts as a proportional reducer. Because a proportional reducer removes more density from the darker areas of the negative, this process is useful for overdeveloped negatives that have too much contrast.

General Proportional Reduction Procedure

1 Mix 100 ml of stock solution A with water to make 1 liter of working solution A. Mix 210 ml of stock solution B with water to make 1 liter of working solution B.

2 Agitate the negative in working solution A for 1 to 4 minutes. The longer the negative stays in solution A, the more reduction will take place. It is better to have too little reduction take place during this step than too much.

3 Transfer the negative to working solution B, and agitate for 5 minutes.

4 Rinse and inspect the negative. If more reduction is needed, repeat steps 2 and 3.

5 When you have achieved the desired amount of reduction, wash the negative thoroughly using a washing aid before the final wash.

Working solutions A and B can be used over again until solution A turns from yellow to green.

Proportional Reduction Test

1 Following the same procedure you used for testing Farmer's reducer as a subtractive formula, shoot one roll (or four sheets) of film of an evenly lit scene at a normal exposure.

2 Develop the film for twice its normal development time.

3 After processing, cut off about one fourth of the roll (or take one sheet), and set it aside.

4 Agitate the remaining film in solution A for 1 minute, and transfer it to solution B for 5 minutes.

5 Rinse the film, cut off another fourth of the roll (or take another sheet), and set it aside.

6 Agitate the remaining film in working solution A for 1 minute, and transfer it to working solution B for 5 minutes.

7 Rinse the film, cut off another fourth of the roll (or take another sheet), and set it aside.

8 Agitate the final segment (or sheet) of the film in solution A for 1 minute, and transfer it to solution B for 5 minutes. Wash all of the film.

9 When the film is dry, make a print from each segment (or each sheet) of film on normal-contrast paper for the best possible highlight value.

When the prints are dry, compare them to see examples of what you can achieve with a proportional reducer. Try to determine the point at which further reduction reduces detail in the shadow tones. This indicates the point at which useful reduction is no longer possible.

PRINT TECHNIQUES

With many available techniques that produce repeatable results, it is hard to justify printing solutions that require custom handling. There are times, however, when certain print problems require careful treatment of each print individually. These techniques

include those you can apply to a print during development and those that you can apply after the print has been processed.

Photographic folklore is full of magic recipes for printing. Entire books have been written describing special development techniques, such as hot developer, rubbing and breathing on a print, and even holding a print partially out of the developer, all of which are intended to alter the tones of selected areas of the image from what they would be if development had proceeded normally. At best, these techniques are an inconsistent way of achieving a local increase of density or contrast. What is more likely is that all of the rubbing and chemical coercion will damage the print.

Locally Applied Developer

If you are determined to try any alteration of consistent print developing practices, one process is worth experimentation. This process involves applying small amounts of concentrated reducing agent directly to the print surface to increase the density and contrast of that area. This works best for highlights and shadows that otherwise would appear weak and flat.

The best reducing agent for this purpose is phenidone. Phenidone is similar to metol in its ability to produce an image, but it is about 10 times stronger. Ilford sells small containers of phenidone that are convenient for mixing a small amount of a concentrated phenidone solution.

Preparing a Concentrated Phenidone Solution

Phenidone doesn't dissolve well in water. You could try hot water, but that will cause the phenidone to oxidize more rapidly. A better alternative is to mix phenidone with a small amount of 91% isopropyl alcohol which you can purchase in most pharmacies. Mix in the proportion of 10 grams of phenidone per 100 ml of alcohol, and store the solution in a small airtight bottle. The solution should last in the bottle for two or three months.

Procedure

1 Warm the phenidone solution by placing the bottle in a water bath of hot tap water (at least 110° F) about 10 minutes before you begin printing.
2 Give the print you want to work with a normal exposure and begin to develop it.
3 After a minute, take the print out of the developer, drain it by the corner for 10 seconds, and lay it on a flat surface.
4 Using a swab dipped in the phenidone solution, gently wipe over the area you want to darken.
5 Wait 15 seconds, replace the print in the developer, and continue with normal development.
6 Repeat this process in 30 seconds if you want additional density.

This procedure will slightly increase the activity of your print developer, a potential problem if you are using a low-contrast formula. As an alternative, try waiting until 30 seconds before the

end of development to remove the print. After applying the phenidone solution, wait an additional 30 seconds, and then place the print directly into the stop bath.

(a) Print before treatment

(b) Print after treatment

Print Intensifier

You can intensify a print in the same manner that you intensify a negative. Intensification will help restore contrast to a flat print with gray shadows. Since it is usually easier to make another print on a higher contrast paper, this procedure is described primarily for information purposes. Should you some day be faced with a situation in which you have no choice but to try to intensify a print, you can use the chromium intensifier formula given in Appendix F with the following procedure.

Procedure for Print Intensification

Note: Room lights may be on during the entire process.

1 Pre-wet the print for 1 minute in a tray of water.
2 Mix the working solution intensifier from 200 ml of chromium intensifier stock solution A, 650 ml water, and 150 ml of chromium intensifier stock solution B.
3 Place a wet print that needs intensification into the working solution.
4 Agitate for 4 to 5 minutes. If the image does not disappear at this point, add an additional 100 ml of stock solution A. Some prints fixed in a hardening fixer can take longer to bleach.
5 Wash for 20 minutes.
6 Redevelop the print in your normal paper developer for 2 to 5 minutes or until strong, rich shadows develop.

It is possible to repeat the intensification process, but the print emulsion tends to soften, so be careful. If the process damages the print emulsion, try using the Formalin supplementary hardener given in Appendix F before intensifying another print.

Print Reducer

You can reduce an overly dense print with Farmer's reducer in much the same way that you reduce the density of a negative. You can also reduce selected areas of a print, something you normally

Figure 7-3 Effect of applying concentrated phenidone to a print. London's Parliament building in the background is darker and shows greater contrast after painting the print with hot, concentrated developer. Note that it is often hard to make this technique look "natural."

can't do with a negative. This section covers only the proportional reduction of prints. It is generally not necessary to use a subtractive reducer on a print because it is much easier to make another print with less exposure.

Reducing a Print

A print made from a flat negative is a likely candidate for overall reduction if you expose it so that the highlights appear noticeably darker than you want them to be. The shadows should also be slightly darker than normal.

When such a print is bleached with a proportional reducer, the effect is to increase the contrast and the detail visible in the highlights. This happens because the additional exposure given the print increases the highlight details beyond what you can see in the highlights of a normally exposed print from the same negative.

Be aware that every brand and type of printing paper respond differently to reduction. Some papers will bleach faster than others, some papers will change color slightly while other papers will not. Before you attempt to use a reducer on a unfamiliar printing paper, run a test to determine the suitability of the technique on it.

General Procedure for Reducing a Print

Note: Room lights may be on during the entire process.

1 Mix 500 ml of Farmer's reducer stock solution B with 500 ml of water to make a tray of working solution B. Mix 100 ml of Farmer's reducer stock solution A with 900 ml of water to make a tray of working solution A. If you need more contrast, you can increase the concentration of working solution A by mixing 400 ml of stock solution A with 600 ml of water.

2 Agitate the print in the tray of working solution B for 1 minute so that the emulsion completely absorbs the sodium thiosulfate.

3 Transfer the print to the tray of working solution A and agitate it for 15 seconds.

4 Remove the print from working solution A and drain it by one corner for 10 seconds.

5 Return the print to working solution B, agitate it for 15 seconds, and examine the result.

6 If you need more reduction, repeat steps 3, 4, and 5.

7 Fix, wash, and dry the print in the normal manner.

Testing a Proportional Reducer on a Print

1 Using a negative that prints well on high-contrast paper, make four prints on grade 2 paper, exposing so that the shadows are correct and the highlights are gray and flat.

2 Set one print aside and bleach the remaining three prints for 15 seconds.

3 Set a second print aside and bleach the remaining two prints an additional 15 seconds.

4 Set one more print aside and bleach the final print for 30 more seconds.

Once the prints have been fixed, washed, and dried, compare all four with a correctly printed version on high-contrast paper. Look carefully at the highlights, shadows, and print color. Determine which of the test prints has the best range of tones and highlight details. In comparison with the print made on higher contrast paper, decide if the bleached print has a better range of tones, particularly in the highlights. This will give you an indication of the usefulness of this technique for your work.

(a) Print before reduction

(b) Print after reduction

Local Reduction of Prints

Occasionally, you will make a print that has one or more areas that you can't successfully dodge during exposure. Chemically bleaching these areas is a useful alternative. Local reduction has the advantage over dodging of allowing you to work under room light and without time pressure.

A small brush or a cotton swab is a good tool to use to apply the bleach to the surface of the print. If you use a brush that has a metal ferrule, you risk getting blue stains on the print unless you prevent the ferricyanide solution from touching the bare metal. Protect the ferrule by coating it with clear nail polish. Let a drop of polish soak in at the point where the bristles contact the metal (to seal off the inside), and then apply a thin coating to the outside of the ferrule.

Whenever iron compounds, either from an uncoated metal ferrule brush or from tap water, contaminate the bleaching solution, you will get blue stains on your print. Remove these stains by placing the affected print in a tray of print developer for 1 minute, followed by the usual fixing and washing.

General Procedure for Local Reduction

1 If the print you plan to reduce is dry, soak it for 1 minute in plain water. Then remove the wet print and blot off the surface water.

2 Just before use, mix 10 ml of Farmer's reducer stock solution A and 20 ml of Farmer's reducer stock solution B with water to make 100 ml of working solution. Add 2 or 3 drops of a wetting agent (Photo-Flo) to help the solution penetrate evenly. The working solution will be effective for about 10 minutes.

Figure 7-4 Using Farmer's reducer on a print. Farmer's reducer lightens the overall tones and slightly increases the contrast of the print as shown in the example of the vegetable stand.

3 Using either a small brush or a cotton swab, depending on the size of the area to be lightened, lightly brush the solution on the area. The reducer will exhaust itself rapidly on the surface of the print. Use a paper towel to blot up any excess.

4 Repeat step 3 until the area is as light as you want it.

5 Fix and wash the print as you normally would.

6 If there are any yellow stains around the bleached area after washing, agitate the print in a tray of 50 grams of sodium sulfite mixed with a liter of water for 5 minutes and then rewash.

Testing Local Reduction on a Print

Take a number of scrap prints and decide which areas of each print you would like to lighten. Try a variety of applicators, from spotting brushes to cotton balls, to lighten those areas. Make notes about which techniques worked best for you. Save the test prints for future reference.

(a) Print before reduction

(b) Print after reduction

Figure 7-5 Effect of local application of Farmer's reducer. The right arm and face of the model in print (b) were "painted" with Farmer's reducer, increasing the contrast between the figure and the background.

SUMMARY

• In attempting to print a poor negative, you can try to improve either the negative or the print. Improving a poor negative makes it easier to produce an edition of matched prints. Improving a poor print allows you to perfect your technique on work prints before you apply it to the final print.

• Intensification is an appropriate technique for underexposed or underdeveloped negatives. It increases the density of the image where there is already some silver, but it cannot add density where there isn't any.

• Using selenium toner for intensification is a useful way to achieve a slight increase in contrast without increasing the grain of the negative.

• Sepia toner increases contrast of a negative more than selenium. It works by changing the color of the image to a warm brown. The brown color appears to have more density to printing paper.

• Chromium intensifier is a bleach and redevelop formula that can be used up to three times to achieve a significant increase in negative contrast.

- Reduction is a technique that can correct an overly dense negative. Subtractive reduction removes density equally from all areas of the image and is useful when a negative is overexposed. Proportional reduction lowers the contrast of an image and is useful when a negative is overdeveloped.
- You can increase the contrast and the density of tones in a particular area on a print by applying a concentrated phenidone solution to that area with a brush or a swab while the print develops.
- Although it is not a recommended technique, it is possible to increase the contrast of a print by using chromium intensifier.
- You can increase the contrast of a print with overexposed highlights and normally exposed shadows by using a proportional reducer.
- You can lighten specific areas of a print by applying a reducer to those areas with a brush or a swab.

Chapter 8

Toning

For many photographers, toning is the final step in making an exhibition-quality print. This step might be a protective treatment with little or no visual effect, or it might be an obvious and intentional color change. As the final step in a planned process, toning can enhance a print statement. As a salvage attempt for a poor image, toning is usually ineffective.

This chapter discusses the uses of print toning for visual effect. Chapter 9, "Archival Processing," discusses the use of toning for print protection.

TONER TYPES

All true toners affect only the image silver and produce a color in proportion to it. Highlights and other print areas that contain little or no silver (such as the borders) retain their original color while areas of greater density show visible changes. Some coloring processes are advertised as toners when, in fact, they actually stain the emulsion and give the print an overall color. True toners can be grouped into three categories: *direct toners*, *silver conversion toners*, and *dye toners*.

Direct Toners

Direct toners bond an inorganic compound directly to the image silver, in effect coating it. The final image color is determined by the nature of compound used in the toner and is usually modified by diluting the toning solution and varying the time that the print is toned. The direct toners described in this chapter are selenium, gold, selenium/sulfide, and polysulfide toners.

Silver Conversion Toners

Silver conversion toners bleach an image and redevelop it with a new color. During the bleaching step, these toners convert image silver to a silver salt (usually a creamy white silver bromide or silver iodide) in a fashion similar to Farmer's reducer. The toning agent then redevelops the silver salt to form a new compound with a new color.

Some silver conversion toners are two-step toners; the bleach and redevelopment steps occur in separate baths. The final image color depends on the amount of bleaching that takes place in the first step. Redevelopment is usually rapid and continues to completion. Two-step silver conversion toners are frequently called *bleach-and-redevelop toners*.

Other silver conversion toners combine bleach and redevelopment in a single bath. In these formulas, the image silver is bleached and redeveloped progressively. The longer the print stays in the toning bath, the more the image is toned.

The silver conversion toners described in this chapter are sepia, iron blue, copper brown, and red toners.

Dye Toners

Normally, organic (carbon-based) dyes do not combine with inorganic compounds like silver. They will, however, combine with certain silver salts. Dye toners use a special bleach, called a *mordant*, to convert the image silver in a print to either silver iodide or silver ferricyanide so that an organic dye will adhere to it. The greater the amount of silver that is mordanted, the stronger the color.

The appeal of organic dye toners is the many colors that are available. By comparison, direct and silver conversion toners produce few color variations.

Formulas for single-step and two-step dye toners are given in Appendix F. The color produced depends on the dye used in the formula and the amount of silver that is converted by the mordant.

SPECIAL PRECAUTIONS FOR TONERS

Appendix A, "Darkroom Safety," discusses the general precautions you should follow for all photographic work. Because toners present greater health hazards than do more typical darkroom chemicals, the descriptions of specific toners contain special safety notes about that toner.

PREPARING A PRINT FOR TONING

Because toning represents an additional chemical step, processing errors or sloppy procedures that might not otherwise be visible can

show up on a toned print. When processing a print for toning, be sure that you do the following:

- Fix the print completely. This means using fresh fix for the correct amount of time. Residual (undeveloped but incompletely fixed) silver tones the same color as the image silver, causing stains.
- Use a nonhardening fixer. Hardening a print can prevent complete toning. If hardening is needed later, you can use the Formalin supplementary hardener (Kodak SH-1) formula provided in Appendix F.
- Use the dehardening formula given in Appendix F if you need to tone a print that you have hardened either inadvertently or as part of a salvage process such as described in Chapter 7, "Salvage Techniques."
- Some toners, especially silver conversion toners, reduce a print's density. Be sure to print darker than you would normally if the toner you plan to use is one of these.

TESTING TONERS

Toners react to different papers with different effects. For example, fine grain papers such as Kodak Polycontrast tone with a warmer color, while papers with a larger grain structure, such as Agfa Brovira, tone with a cooler color. Some paper brands and types accept toning well, others, even different grades of the same paper, tone poorly or not at all.

Other factors that can modify a toner's color are the mineral content of the water with which you mix the toner and the paper developer you use. The only way to predict how a paper will tone is to perform tests.

General Toner Testing Procedure

The following is a general-purpose exercise that will provide the information you need to predict how a particular paper and developer combination will react with a toner.

1 Select a negative with a variety of tones that prints well on grade 2 paper.
2 Find the correct exposure for a 5 × 7-inch print.*
3 Calculate exposures that are approximately 25% less, 10% less, 20% more, and 50% more than the correct exposure.
4 Expose and process a print for each of the exposures.
5 Repeat steps 2 through 4 for any other paper you want to test.
6 Cut each print into four approximately equal test strips. Label each piece with the paper type, relative exposure, and the toner you are planning to test.
7 Place one test strip from each print[†] in the toner you are testing for the minimum time recommended for that toner. For a two-step toner, this time applies only to the first (bleach) bath. Toning in the second bath should be to completion.

* The test recommends a 5 × 7-inch print size for the sake of economy. You may use any print size that is convenient for you.
† To get the best comparison, tone test strips from the same part of the image together.

8 Place a second test strip from each print in the toner and time how long it takes to completely tone or, in the case of a two-step toner, completely bleach the image silver.

9 Divide the difference between the minimum toning time and the maximum toning time into thirds. Tone the remaining test strips for those times. For example, if the minimum toning time was 5 minutes and the maximum toning time was 20 minutes, the remaining test strips would be toned for 10 and 15 minutes. This formula is approximate; the idea is to evenly space the toning times between the minimum and the maximum.

When the test strips are all toned and dry, compare the test strips that were toned for the minimum time. Place them side by side with the least exposure on the top (or to the left) and the greatest exposure on the bottom (or to the right). Note the effect of the toner on the shadows, highlights, and midtones at different print exposures. Compare the other test strips in the same manner (Figure 8-1). For reference, glue or tape the test strips on a piece of cardboard or in a notebook, and record the test data and your observations next to them.

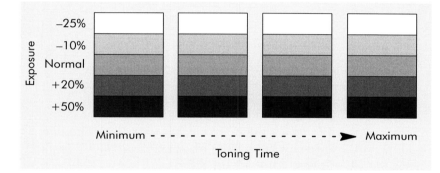

Figure 8-1 Order for arranging toning test.

NOTES ON SPECIFIC TONERS

The following sections discuss specific toner types and offer general working advice to supplement the instructions that come with the commercially available toners or the published formulas. The toners are listed in the order of their general popularity.

Selenium Toner

Selenium toner is commercially available as a liquid concentrate from Kodak (Rapid Selenium Toner) and from some other manufacturers. No formula for compounding selenium toner from dry chemicals appears in Appendix F because the powdered form of selenium is highly toxic when inhaled.

Selenium toners produce color changes that range from a mild deepening of the shadows to a strong reddish purple. For most papers, selenium is the easiest and quickest way to enrich shadows and to provide a slight color shift, usually toward a warmer color.

Many photographers have a favorite way to use selenium toner. Although most of these methods work well, almost all ignore the instructions packaged with the product, which are geared to produce a strong reddish purple color.

Safety Note: Selenium Toner

The primary hazard from selenium toning is from skin absorption. Once in the blood, selenium can cause damage to internal organs. Nitrile gloves and careful use of tongs are the best protection from skin contact, as is general cleanliness in the toning area. Use only pre-mixed selenium toners, as preparing toner from powdered selenium is a very hazardous operation.

Procedure

With the caution that all toning methods should be tested before they are used on a final print, the following method is recommended because it allows a high degree of control over the amount of color change and because it minimizes the possibility of stains.

1 Prepare two trays of a working-strength washing aid.
 Some washing aids, such as Permawash, have a limited life after being mixed into a working solution. Follow the manufacturer's recommendations for the product you are using, as oxidized washing aid can allow the selenium toner to stain your prints.

2 Add between 35 ml and 175 ml of toner concentrate per liter of solution to the second tray.

3 Agitate the print for 3 minutes in the first tray (washing aid only), then transfer it to the second tray (washing aid plus toner).

4 Agitate the print in the second tray, watching very carefully for the beginning of a color change to red in the shadows. Use a bright tungsten incandescent bulb for an inspection light to exaggerate the red color so that you can remove the print from the toner before the color change becomes too great.

5 When the print reaches the desired color, wash it in cool water. Wash water that is hotter than 85° F (approximately 30° C) can remove the selenium from the print.

6 Air-dry the print. Using heat to dry a selenium-toned print can drastically alter its color.

How fast a print tones and the color produced depend on how much toner concentrate you add to the toning solution and the type of paper you are using. Toning times range from 5 to 20 minutes.

If you encounter red splotches during toning, they are stains caused by the print having an acid pH when it reached the toner. Acid can be carried over from the fix or even from tap water, which in many communities is becoming increasingly acid. Agitating the print in a washing aid before toning neutralizes acidity.

When toning with selenium, remember that there is residual activity that continues to change the color of the print after you remove it from the solution. Rinse a print with plenty of water to be sure that toning has stopped.

Split Toning with Selenium

Certain chloride-based papers, such as Kodak AZO (a contact speed paper), and Agfa Portriga Rapid or Forte Fortezo Elegance (combination chloride- and bromide-based enlarging papers), produce an interesting effect when toned in selenium. The shadows

tone first with a warm red color. For a short time after this occurs, the highlights and midtones remain unaffected. If you stop the toning process at this point, the print has a split tone. Darker shadows and midtones are warm red, and the remaining midtones and highlights, while retaining their original color, effectively look cooler or even whiter than before. Figure 8-2 illustrates a print split toned with selenium toner.

There is little consensus about the proper procedures to use when split toning chloride-based papers. Some photographers believe that the print developer temperature is critical (between 73° and 77° F) and that unknown impurities in the water contribute to the toning effect. Other photographers find that, aside from using a fairly high concentration of selenium toner, such as 175 ml of concentrate per liter of working solution, few factors radically change how a print tones.

Figure 8-2 Split selenium toned print. A chloride-rich paper (Portriga Rapid in this case) produces a red in the shadows and remains untoned in the highlights when placed in a concentrated selenium toning solution. The result is a split tone that increases the visual depth of the image.

Sepia Toner

Sepia toner is available commercially as Kodak Sepia Toner and in a wide variety of published formulas, one of which is reproduced in Appendix F. Sepia toner is a two-step silver conversion process. The first step is a bleach that converts the image silver to silver bromide. The second step is a solution of sodium sulfide that reacts with silver bromide to precipitate a brown silver sulfide. The result is a warm brown image as illustrated in Figure 8-3.

Safety Note: Sepia Toner

The bleach component (part A) is only slightly toxic by ingestion though some formulas include potassium oxalate, which is a strong corrosive. Keep the bleach away from strong acids (such as sulfuric, hydrochloric, or perchloric) to prevent a potential release of highly toxic hydrogen cyanide gas.

The toning component (part B) contains sodium sulfide, which is corrosive and which generates hydrogen sulfide gas during mixing, storage, and use. This toxic gas, although it has a strong odor, has poor warning properties. At low concentrations, this gas deadens the nose, so that you stop noticing it. Good ventilation is important.

Figure 8-3 Sepia toned print. A slight sepia tone created by partially bleaching the image silver, enhances the skin tone of this portrait.

Procedure:

Because they are easy to handle, most photographers use Kodak's Sepia Toner packets in preference to mixing the toner from a formula. Also, when used in areas with soft water, the Kodak packets seem to stain less frequently than toner prepared from a formula.

1 Agitate the print to be toned in solution A (the bleach) until you have bleached as much of the image silver as you want. Bleaching until all traces of black silver have gone can take up to 10 minutes, depending on how fresh the bleach is. Partially bleaching a print produces a blacker brown.

2 Rinse the print for about 2 minutes or until all of the yellow is gone from the highlights and the print border.

3 Place the print in the tray of solution B (the toner). Full toning takes place in approximately 30 seconds. You cannot overtone.

4 Wash the print long enough to remove all traces of toning solution (5 to 10 minutes).

Alternative Procedure:

For a darker brown, agitate the print in solution B for up to 3 minutes before bleaching in solution A. Rinse the print for 1 minute between the initial toning bath and the bleach. After bleaching, return the print to solution B for final toning.

Selenium/Sulfide Toner

Toners containing both selenium and sulfide compounds are commercially available as Kodak Polytoner or Agfa Viradon. There is no published formula for a similar toner because of the toxic nature of powdered selenium.

The most interesting feature of a combination selenium/sulfide toner is that, depending on the dilution, the toner produces a wide range of warm tones, ranging from brown-black to a reddish brown. This is because the effect of the selenium in the toner is most noticeable at higher concentrations, and the effect of the sulfide is most noticeable at lower concentrations.

On many papers, you can achieve a brown-black at a 1:4 dilution and a warm brown at a 1:50 dilution. Using a combination toner at a 1:50 dilution on a chloride-based paper, such as Portriga Rapid, gives an interesting pink-brown. For testing, consider dilutions of 1:4, 1:24, and 1:50 as separate toners.

> **Safety Note: Selenium/Sulfide and Polysulfide Toners**
>
> Toners such as Kodak's Polytoner and Kodak Brown toner (see next section) contain sulfur compounds, and should be handled with the same cautions you use for part B of sepia toner. Polytoner and Viradon also contain selenium, so that in addition, you should also observe the cautions you use with selenium toner.

Polysulfide Toner

A single-solution polysulfide toner is available commercially in liquid concentrate form as Kodak Brown Toner. The polysulfide toner formula (Kodak T-8) in Appendix F produces results similar to the commercial package.

To use, mix as directed by the package or the formula you are using, and tone prints from 3 to 10 minutes. Because the toning action is relatively slow at room temperature, many photographers use a warm solution (up to 100° F). This requires careful handling because the surface of a warm print is soft and easy to scratch; and good ventilation because the volume of sulfur fumes released by the toner is greater when it is warm. The print color tends to be uneven until the toning process reaches completion.

The colors produced by a polysulfide toner are darker than those obtained with a bleach-and-redevelop sepia toner.

Iron Blue and Copper Brown Toners

Iron-based blue toners are available commercially as Edwal Blue Toner and Berg Brilliant Blue Toning Solution. The formula for iron blue toner in Appendix F is inexpensive and easy to prepare, and produces results equal to the commercial packages.

To use, immerse the print in the prepared toning solution until the image silver turns the desired color. There will be some yellow staining in the highlights. After toning, wash the print until the yellow stain has cleared from the highlights. Be careful not to over wash because the blue can wash out.

For most papers, the color produced is a bright cyan blue (Figure 8-4). If you want to intensify the color slightly, rinse the washed print in a weak solution of ammonia or chlorine bleach (about five drops of nonsudsing ammonia household bleach to a liter of water).

Figure 8-4 Iron blue toned print. The blue color given a print by this toner is not subtle. WIth the right image, however, the dramatic effect can be complementary.

A copper-based toner is available commercially as Berg Brown/Copper Toning Solution. Like the iron blue formula, the formula for copper toner in Appendix F is easy to prepare and use. Figure 8-4 illustrates a print split toned with copper brown toner. A variation of the copper formula that produces red colors is also listed in Appendix F.

Use copper toner in the same manner as iron blue toner. On most papers, the color produced is a dark reddish brown.

Safety Note: Iron Blue and Copper Brown Toners

Most iron toners are mixed from formulas though there are some commercially available packages, so observe standard cautions regarding mixing formulas from powdered chemicals. The primary components of iron toners have fairly low toxicity, but keep the toner off skin and avoid accidental ingestion. Don't use a formula that contains any acid other than acetic acid, as the acid isn't necessary and adds a potential hazard.

Like iron toners, most copper toners are mixed from published formulas. The primary components are mildly toxic through skin contact, inhalation, or ingestion.

Gold Toners

A variety of gold toner formulas have been published. The three most popular are listed in Appendix F: Gold Protective Toner (Kodak GP-1), Nelson Gold Toner (Kodak T-21), and Gold-Thiocarbamide Toner (Ilford IT-5) which is similar to the commercially available Kodak Blue Toner. These formulas produce colors ranging from warm brown to cool blue. All produce a very

stable image because gold is inert to most forms of chemical reaction.

Many people assume that gold toning is expensive. In fact, a gram of gold chloride can tone up to 80 8 × 10-inch prints, depending on the formula you use. If you plan your toning sessions carefully to maximize the number of prints you tone per liter of working solution, the cost is minimal, especially compared to the cost of printing paper.

> **Safety Note: Gold Toners**
>
> Most gold toners are mixed according to published formulas, so all cautions regarding mixing formulas from powdered chemicals apply. Gold chloride is absorbed through the skin, is considered an allergen, and is moderately toxic. Observe the same precautions with gold toners that you observe for selenium toners.

Gold Protective Toner (Kodak GP-1)

Kodak GP-1 is the classic gold protective toning formula that many photographers use as a final step in archivally processing their prints (see Chapter 9 for a discussion of archival processing). This toner also produces a slight blue color that can be used to create a neutral tone on warm-color papers. Tone prints in GP-1 for 10 minutes or until a slight color change occurs.

In addition, you can combine the GP-1 formula with other toners to produce strong color statements. (Figure 8-5 shows an example of what happens when you combine sepia toner with GP-1.) See the section on multiple toning later in this chapter for more information.

Figure 8-5 Combination sepia and gold toned print. The red tones in this print were created by first toning in sepia and then in gold chloride. The result is an image that expresses the feeling of a sunny day at the beach.

Nelson Gold Toner (Kodak T-21)

Nelson Gold Toner produces warm colors on paper without causing the image to turn brown the way it does with sulfide and polysulfide toners. Use this toner at temperatures between 100° F and 110° F (approximately 40° to 45° C). Vary the toning time from 5 to 20

minutes to control the amount of toning and the degree of warmth that the print color takes.

Gold-Thiocarbamide Toner (Ilford IT-5)

Gold-Thiocarbamide (thiocarbamide is also known as thiourea) toners produce a subtle blue color on most warm-color printing papers. This color is not as extreme as that produced by iron blue toners, but it is much more permanent. The intensity of blue is determined by the length of time a print stays in the toning solution; 15 to 30 minutes is considered normal. A commercially packaged gold-thiocarbamide is sold as Kodak Blue Toner.

Dye Toners

Two companies make commercially packaged dye toners; Edwal Scientific Products and Berg Color-Tone. The Edwal toners are single-step dye toners;* the Berg formulas are two-step toners.

Appendix F lists two different formulas for dye toners as well as a formula for removing iodine stains in gelatin. One formula, Kodak Dye Toner T-20, combines the mordant and the dye. The other formula uses separate mordant and dye solutions. The single-step formula is more convenient to use, but the two-step formula offers greater control over the process. For example, when using a two-step dye toner, the print can be transferred back and forth (after rinsing) between the two solutions to increase the amount of toning.

> **Safety Note: Dye Toners**
>
> Dye toners contain no strong acids and no corrosive chemicals and are generally safe to work with, assuming that you adequately ventilate your work area and avoid skin contact with the toning solution. One dye, auromine O, used to produce a yellow color, is considered a carcinogen and should be avoided.

Procedure Notes:

Dye toners can be used in a variety of ways. In general, follow the instructions given with the formulas or the packaged toners, being careful to avoid contamination of the solutions or the prints. The following notes are guides for experimentation:

- The longer the print is in the mordant solution, the greater the amount of dye that will be accepted into the print.
- You can mix different dyes or transfer a print to different toner baths to produce new colors.
- Highlights and midtones show the effect of the dyes more dramatically than shadows.
- If you get too much color from a dye bath, you can reduce the color by placing the print in a weak solution of ammonia. Add 5 to 10 drops of nonsudsing household ammonia to a liter of water to make a color reducing solution.
- The color of a dye-toned print can wash out. Wash the print only until the excess color is gone from the highlights.

* Edwal sells five color toners in identical packaging. The Edwal blue toner, however, is an iron-based toner, not a dye toner.

- Although permanent for most purposes, a dye-toned image is not archivally stable. The color in a dye-toned print will eventually fade, especially when exposed to strong light.

MULTIPLE TONING

Selenium- and sulfide-based toners create a permanent change in the image, one that can't be altered through later processing. Toners like iron blue and the various dye toners can still be manipulated after the toner is applied. You can exploit these properties to tone your prints a variety of colors and to produce a variety of effects.

In choosing toners for multiple toning, you should be aware of their color relationships. For example, a strong color like iron blue makes the color from a less intense toner, such as Polytoner, less noticeable. You can play with this psychological effect by using Polytoner on the parts of an image that you want to remain "natural" and letting the rest of the image be altered by the addition of a bright color.

Two techniques that are especially useful when multiple toning are hand-applied toner and masking.

Hand-Applied Toner

Toners such as selenium and combination selenium/sulfide leave a print inert to change by other toners. When you apply these toners to selected areas of a print, they act as a resist, preventing those areas from being altered further.

You can apply toner by hand in a variety of ways. Cotton swabs and cotton balls are useful because cotton doesn't react with the toning chemistry. For very fine work, you can use a small brush. If the brush has a metal ferrule, be sure to take the precautions noted in Chapter 7 in the section on local reduction of prints because metal contamination can ruin the toning effect. Once you use a brush to apply a toner, do not use it for any other purpose.

Procedure

1 Remove all of the surface water from a washed print with a squeegee or paper towel, and place it on a flat surface and under good light.
2 Apply the toner with a cotton swab or a small brush. You can add a drop or two of a wetting agent (such as Photo-Flo) to the toner to make it spread more evenly. For better color control, use multiple applications of dilute toner.
3 To inspect the effect of the toner or to apply a different toner, rinse the print and blot off the surface water again.

Masking

You can do multiple toning by masking parts of a print while working with one toner and then removing the mask for additional toning. A common masking material is rubber cement. Another material that works well is a product called "Photo Maskoid Liquid Frisket" sold by the Andrew Jeri Company. Both products are available in most art supply stores along with appropriate thinning agents to make their application easier.

Masking works best on resin-coated papers. The waterproof base prevents toner from migrating through the back of the print and toning the image under the mask.

Procedure

1 Select a dry print, and thin a small quantity of rubber cement or Maskoid until it is the consistency of paint.
2 Using an appropriately small brush, begin painting the area that you want to mask. After the first coat is dry, apply a second coat to be sure that you haven't left any gaps.
3 Tone the print. If you are using two toners, the first should be a selenium, sulfide, or polysulfide toner.
4 After rinsing the toned print, dry it, and then carefully remove the mask by rubbing lightly with your fingers.
5 If you plan to use a second toner, do it now.

Careful workers can mask a print, tone it, apply a mask to a different area, and tone again, building up several layers of color. For your initial experiments, attempt only a single mask.

Experiments with Multiple Toning

The large number of toners available and the different ways that they work suggest a rich avenue for experimentation. The following experiments are offered as starting points. From these you may find methods and ideas for further exploration.

One reminder: reserve print spotting and retouching until all toning is complete. Toners do not affect spotting dyes and even a subtle color change from toning will highlight the retouched areas.

Experiment: Using Selenium/Sulfide Toners as a Resist

Brush concentrated Polytoner on the area of a print that you want to protect from additional toning, wait one minute, and then wash for 3 to 5 minutes. The areas touched by the toner will appear dark brown. Then transfer the print to a tray of iron blue toner and agitate until the areas that were not affected by the Polytoner turn a bright blue.

Alternative 1

In the above experiment, substitute selenium toner, a polysulfide toner (such as Kodak Brown Toner), or Kodak Blue Toner for Polytoner.

Alternative 2

Substitute copper brown toner or red toner for the iron blue toner.

Experiment: Removing the Silver from a Toned Print

Selenium tone a print and then place it in a tray of Farmer's reducer (proportional reduction) following the instructions in Chapter 7. The untoned silver is removed by the reducer, leaving only the color of the selenium left in the print. Vary the amount of time the print is in the selenium toner to vary the final color of the print. The potential range of color varies from a bright red to a dark purple.

Alternative

Substitute Kodak Polytoner, Kodak Brown Toner, or Kodak Blue Toner for the selenium toner.

Experiment: Partially Redeveloping a Toned Print

Tone a print with iron blue toner and wash. Under a good light, place the print in a tray of diluted developer, such as Dektol 1:5 (one part stock solution to five parts water). Agitate until the midtones have returned to the original print color. Quickly transfer to a stop bath and then wash. The shadows and midtones have a normal print color, and the highlights remain blue. Alter the effects by varying the amount of toning and the amount of redevelopment.

Alternative 1

Tone the print, wash, and then squeegee or blot off all the surface water. Place the print on a flat surface under good light. Paint undiluted print developer on selected areas of the print.

Alternative 2

Substitute copper toner or red toner for iron blue toner.

Experiment: Using a Dye Toner on a Toned and Partially Redeveloped Print

Using a toned and partially redeveloped print, follow the suggestions in the previous experiment. Place the print in a dye toner. Remove the print from the dye toner when the desired color is reached and wash.

ALTERNATIVE COLORING PROCESSES

Toning is not the only way to add color to a black-and-white print. Many photographers also apply colored oil paints, dyes, or pencils by hand to black-and-white photographs. You can apply the color with brushes, cotton-tipped swabs, and even airbrushes. At least one photographer has been successful using modeler's enamels. (To make the enamel colors transparent, mix small amounts of a color with clear enamel.)

Figure 8-6 shows an example of a print that has been toned and then painted with an air-brush.

Oil Colors

The most popular and convenient oil coloring material for photographs is Marshall's Photo-Oil Colors. Sets of Marshall oils can be found in many camera stores or purchased by mail order from Light Impressions (see Appendix G, "Supplies," for address). Each set of Marshall oils comes with a thinner and a surface preparation solution as well as a set of helpful instructions.

You can also use most oil paints found in art supply stores. These paints tend to be more intense than the Marshall oils and require thinning with a combination of equal parts turpentine and linseed oil.

Oil coloring seems to work best on matte surface paper, though some photographers get good results with glossy, resin-coated paper. Place a little of the thinned paint on the surface of the print

with a cotton ball or cotton-tipped swab and then rub the color into the surface of the print until it is thinly distributed over the part of the image you want to color. If you make a mistake, clean the area with turpentine and reapply the color.

Don't try to achieve an intense color with one application, build up colors in layers. Once you apply a layer of color, let the print dry for two to three days before applying another layer.

Figure 8-6 Toned and hand-colored print. The figure in this image was first toned with Kodak Polytoner and then selectively air brushed with water based paint to bring out highlights in the hair. The resulting contrast between the colors in the figure and the untoned background creates a sense of depth in the print.

Dye Tinting

You can use dyes to either "paint" colors onto a print or you can place the entire print into a tray of dye color to tint the whole image. Some manufacturers, such as Ilford and Kodak, make dye sets for retouching color prints that work well for this process. You can also use the organic dyes from dye toners (without the mordant), batik dyes, and even vegetable dyes mixed with a little Photo-Flo.

Dye colors are very flexible. You can dilute the colors so that they provide only a light tone or use them strong for intense colors. Apply the colors with brushes or cotton swabs. If you apply too much color, you can remove some of it with with a small amount of nonsudsing household ammonia or diluted chlorine bleach solution.

Colored Pencils

Marshall makes a set of "Photo Painting Pencils" in addition to their oils. You can also use sets of standard colored pencils such as Faber-Castell "Polychromos" pencils.

Use a matte surface paper when you color a print with pencils. If the surface of the paper doesn't seem to hold the color as well as you like, try spraying the print with a matte spray (available in most art supply stores). Apply the color in small strokes and then blend with a cotton swab. As with oils, you should build up color in layers. To keep layers of different colors separate, spray each layer with matte spray and let it dry.

SUMMARY

- True toners affect only the silver in the image. Highlights and other print areas that have little or no silver are not affected while denser areas show more visible changes.

- There are three broad categories of toners: direct toners that bond an inorganic compound with the image silver, silver conversion toners that convert silver to a salt and then combine it with an inorganic compound, and dye toners that use a mordant to attach an organic dye to the image silver.

- Toning chemicals present greater health risks than standard black-and-white processing chemicals. Be sure that you read Appendix A, "Darkroom Safety," carefully and follow all cautions associated with the toner you are using.

- To prepare a print for toning, be sure to expose and develop the print to the appropriate density. Some toners lighten print tones and other toners intensify print tones. Also, be sure to fix the print completely in a nonhardening fixer.

- Different toner and paper combinations produce different results. A useful way to gather information about the effect of various toner and paper combinations is to tone test strips made at a variety of exposures for different lengths of time.

- The following toners are the most widely used:
 - *Selenium* produces colors that range from a slight warming in the shadows to a strong reddish purple, depending on the concentration of the toner and the length of toning time.
 - *Sepia* produces warm brown colors. The color depends on how much you bleach the print before toning.
 - *Combination selenium/sulfide* toners produce colors that range from brown-black at strong concentrations to a warm brown at greater dilutions. Toning time affects the intensity of the color.
 - *Polysulfide* toners produce a darker brown than sepia. The intensity of the color depends on the temperature of the toning solution and the length of toning time.
 - *Iron blue* and *copper brown* toners produce strong, vivid blues and browns depending on the amount of time the print is in the toning solution.
 - *Gold* toners produce a variety of colors that range from a mild blue to a warm brown-black, depending on the formula.
 - *Dye* toners can produce any number of vivid colors, depending on the dye used in the toning formula. The intensity of color depends on how much of the image silver is mordanted by the special bleach formula.

- You can successfully use different toners on a single print by knowing the properties of the toners you plan to use and by using hand-applied toner and masks.

- In addition to toning, you can also apply paints, dyes, and colored pencils to a print. Sets of colors are made specially for this purpose, and you can devise alternatives yourself.

Chapter

Archival Processing

Photographs are fragile. The physical object is a piece of paper subject to the stresses of alternating alkaline and acid chemical baths during processing, followed by a long immersion in water. The image is a thin layer of metallic silver, vulnerable to stains and fading from airborne sulfur and contamination from any number of common objects with which the print can come into contact.

These problems have been known since photography's beginnings, but there are still no simple solutions or even a consensus about what archival processing means. Photographers define the term *archival* in many ways, ranging from highly technical measurements of milligrams per square centimeter for residual thiosulfate to mystical claims of 2000-year image stability.

To make matters more confusing, archival standards and processes tend to change as research produces more information. The American National Standards Institute doesn't even mention the word *archival* in its *Method for Evaluating the Processing of Black-and-White Photographic Papers with Respect to the Stability of the Resultant Image*, preferring to use the word *optimum* to describe the most stable of test samples (ANSI PH4.32-1980).*

* American National Standards Institute, Inc., 1430 Broadway, New York, NY 10018.

Rather than promote a theoretical definition or unrealistically exact processes, the goal of this chapter (and the one following) is to describe practical methods that can maximize a photograph's chances for survival. This chapter concentrates on processing film and prints for maximum life. Chapter 10, "Preservation and Presentation," describes how to store photographic materials and the best way to exhibit prints.*

WHY USE ARCHIVAL PROCESSING?

Photographs are historical records. Although this seems to be a self-evident statement, it is also one of the hardest to appreciate. No one knows which of today's most mundane activities and objects will fascinate future generations, and which visual records will help historians best understand our age. Does this mean that every print should be archivally processed? One (doubtless apocryphal) piece of trivia often repeated in photographic circles is that if every print made were kept under archival conditions, the entire land mass of the planet would be several feet deep in photographs by the year 2010. The answer to the question, then, is a resounding no.

The best reason to know about archival standards and processing techniques for prints is the choice that this knowledge provides. Understanding what is necessary to process a print for maximum permanence means that you don't have to expend the time, energy, and resources on prints you want to keep for only a few years. Most prints require less care in processing and shorter washing times than photographers typically give them.

Processing film is different. Film is relatively easy to process for maximum permanence and, as the source material for prints, deserves careful handling. Although the information in this chapter about print processing applies only to those prints you intend to keep for a long time, use the suggestions for film processing for all of your negatives.

PRINTING FOR ARCHIVAL PROCESSING

When you have decided on an image that you want to print and process for maximum permanence, there are two points to keep in mind:

- Always leave at least a one-inch border on the print around the image. Once the print is processed, never trim this border because airborne contaminants attack a print from its edges. The large border is a buffer that gives you time to discover and treat a problem.
- Avoid toners and processes not mentioned in this chapter. Iron, copper, and dye toners do not produce permanent images. Rubber cement and Maskoid are full of sulfur and transfer it to the

* Chapters 9 and 10 are based on the best information available at the time of writing, but when in doubt, you should always consult the most current sources. The Image Permanence Institute, IPI/RIT, 70 Lomb Memorial Drive, Rochester, NY 14623, (716) 475-5199, researches archival issues for the photographic industry and possesses the most up-to-date information. The Rochester Institute of Technology College of Graphic Arts and Photography, One Lomb Memorial Drive, Rochester, NY 14623, (716) 475-2758, holds periodic seminars on the preservation of photographic images, during which the most current information is discussed.

print, where it stays even after the rubber cement or Maskoid is gone. Reduction and intensification tend to weaken the print emulsion and paper fibers. In general, the more you manipulate a print after it is developed, the greater the chance that the life of the print is in some way compromised.

Achieving maximum permanence may require avoiding processes that are necessary to your print statement. In such a case, you must decide whether the print statement or the permanence of the print is the important factor. It makes little sense to make an archival print that doesn't satisfy you.

Choosing a Printing Paper

There are several factors to consider when choosing a printing paper for archival processing. One is the paper's ability to release its chemical contaminants during washing. Another is its durability under normal storage and viewing conditions.

Although you can process almost all printing papers to the same standards of chemical purity, papers made with a conventional fiber backing have proved more durable than papers made with a resin coating. Resin-coated paper is manufactured with a coating of polyethylene over the paper fibers in the base and, in many situations, has much to recommend it. The resin coating prevents liquid from penetrating the base, making the washing of residual fix from the print much more efficient. Some resin-coated papers are easier to tone and manipulate than their conventional counterparts. Resin-coated papers, however, have a long and unfortunate history of failing in ways that manufacturers have been unable to predict.

In the future, there may be resin-coated paper that is as stable as conventional fiber-based papers, but for the present, avoid resin-coated paper when permanence is an issue. Eastman Kodak has acknowledged the problem and has promised to continue to produce conventional fiber papers as long as any doubt exists about the long-term stability of resin-coated paper.*

DEVELOPMENT

It is hard to justify spending the time to process prints and negatives to archival standards if they aren't well developed. Fresh developer is necessary to produce a full range of tones from highlights to shadows. For archival processing, carefully follow the manufacturer's instructions for the number of prints that a particular solution can process. Don't forget to count test strips. After you reach that limit, use the developer for work prints and contact sheets only. For film, avoid replenished developers. Use only one-shot (dilute-and-discard) developers.

* *Preservation of Photographs*, Kodak Publication F-30. Kodak's updated version of this publication, F-40, shows an example of the problem.

Resin-Coated Paper and Permanence

Because it is relatively easy to wash clean of residual chemicals, some photographers mistakenly believe that resin-coated paper is a good choice for archivally processed prints. Resin-coated paper, however, has a long history of problems with longevity. Each time manufacturers solved one problem, new ones appeared.

In the 1970s, when resin-coated paper was first introduced, the titanium dioxide brightener used to make the paper base appear white (instead of the barium sulfate used with conventional fiber paper), would oxidize and cause the surface of the print to crack. When manufacturers began to add antioxidants to their formulas in the 1980s, they discovered that the additives caused "premature aging."

Even today resin-coated prints displayed in strong light and under changing humidity and temperature conditions have been known to graze and crack on the surface in a dramatic fashion. One theory is that, unlike conventional fiber papers, the dimensional stability of the polyethylene coating prevents the base from expanding and contracting at the same rate as the print's gelatin emulsion. Another theory is that when combined with titanium dioxide, polyethylene becomes very unstable when exposed to large amounts of visible and ultraviolet light.*

STOP BATH

Most stop baths contain acetic acid (basically vinegar) and very little else. The primary purpose of a stop bath is to neutralize the alkalinity of the developer, quickly and effectively putting an end to the image development. It is most important, therefore, to be sure that the stop bath for prints is fresh. Otherwise, the fix must also act as a neutralizer, upsetting its acid balance and rendering it less effective.

For film, use a water rinse to stop development. An acid stop bath has a tendency to cause pinholes in a film's emulsion. The abrupt change in pH from alkaline to acid can cause gas bubbles to form in the emulsion and pop at the surface. At least one chemical manufacturer, Sprint Systems, makes a stop bath containing buffering agents designed to prevent this problem. Unless you use such a stop bath, fill the film developing container with water, agitate for 20 to 30 seconds, dump, and repeat three times. This will stop development quickly without running the risk of pinholes.

For prints, always count the number of prints you process in the stop bath. Discard a stop bath when you have processed half the number that the manufacturer recommends for normal use. When using an indicator stop bath, don't wait for the indicator color to change. By that time, you have begun to contaminate the fix.

* Wilhelm and Browner, *The Permanence and Care of Color Photographs*, Preservation Publishing Co., 1993, p. 586.

FIXING FOR PERMANENCE

Most fixing formulas contain either sodium thiosulfate* or ammonium thiosulfate as the active ingredient. Sodium thiosulfate is the basis of classic fixing formulas, used since the invention of photography. Ammonium thiosulfate fix is a more recent invention. It tends to work more quickly than sodium thiosulfate and is the basis of today's rapid-type fixers.

Most photographers like to think that fix simply dissolves the undeveloped silver from the emulsion. The actual chemical reaction is far more complex and is not even completely understood. The most plausible theory is that during fixing, undeveloped silver undergoes at least three separate chemical changes before it ends up as silver disodium (or silver diammonium), which is water-soluble and begins to dissolve in the fix.

Proper fixing would be easy if converting all of the undeveloped silver to silver disodium was the only important factor. You could fix film and prints until you were sure the process was complete. Unfortunately, if you fix too long, there are two serious side effects:

- As dissolved silver compounds build up in the fixing bath, they tend to be absorbed by the fibers of the paper base, where they are extremely difficult to remove.
- After the fix converts all of the undeveloped silver, it begins to convert developed silver, a process that shows up first as a loss of highlight details.

Proper fixing is a balance between converting undeveloped silver and avoiding contamination and image destruction. Because these processes all occur at the same time, you must monitor the fixing step carefully.

Fixing Film

To determine the correct fixing time, follow these steps:

1. Take an undeveloped piece of the same type of film that you are processing, and agitate it in an ounce or so of the fixer solution. For 35mm roll film, the leader that you cut off while loading the developing reel is ideal.
 Freshly developed film emulsion is quite soft, so a hardening fix is appropriate, but not necessary if you handle film carefully.
2. Time how long it takes to dissolve the milky white emulsion from the clear film base.
3. Multiply the clearing time by 2 to calculate the total fixing time.

When it takes twice as long to clear a piece of film as it did when the fixing bath was first mixed, discard it, and make a fresh solution.

* The slang for fix, *hypo*, derives from the mistaken idea among nineteenth-century photographers that sodium thiosulfate was actually sodium *hypo*sulfate, a close chemical cousin.

Fixing Prints

Some photographers advocate fixing prints in solutions of plain sodium thiosulfate crystals. This practice is based on the fact that most fixing formulas contain additional chemicals designed to maintain the activity and acidity of the fixing bath as well as to harden a print's emulsion. These additives can prolong the time needed to wash a print adequately and make most fixers unsuitable for archival processing.

For photographers who are not interested in such a purist's approach, there are two options: a two-bath system using a nonhardening sodium thiosulfate fix or a strong concentration of ammonium thiosulfate fix used for a very short time.

Two-Bath Fixing

The nonhardening fix formula (Kodak F-24) provided in Appendix F is a good example of a fixer that works well for archival processing using the two-bath method. The procedure is as follows:

1 Prepare two separate trays of working-strength fix.

2 When it is time to fix a print, place it in the first tray and agitate for 3 to 5 minutes.

3 Rinse the print in a tray of water. You can use this tray as a holding bath until you have several prints to agitate in the second fixing bath. If you do this, observe two cautions: Empty and refill the holding tray with fresh water at least every 30 minutes, and do not let the emulsion of a print dry out until all fixing is complete.

4 Transfer the print to the second fixing bath, and agitate for another 3 to 5 minutes.

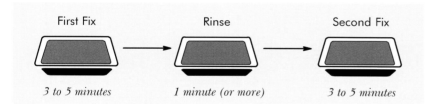

First Fix	Rinse	Second Fix
3 to 5 minutes	*1 minute (or more)*	*3 to 5 minutes*

Figure 9-1 Using a two-bath fix. Rinsing a print between the two fixing baths prolongs the life of the second bath. When the first fixing bath becomes exhausted, discard it, replace it with the second bath, and mix a new second bath.

The capacity of the F-24 formula is about 25 8 × 10-inch prints per liter of working solution. Most of the fixing takes place in the first tray. The second tray completes the fixing process and remains relatively fresh. When the first tray is exhausted, discard it, replace it with the second tray, and mix a new second tray.

Ilford's Archival Processing Sequence

In recent years, Ilford has advocated a method for fixing prints based on the theory that the less time a print spends in a fixing solution, the less chance there is for fix to penetrate the fibers in the paper base and for dissolved silver compounds to be redeposited on the emulsion. The reduced fixing time translates into a reduced washing time. Ilford calls this their "Archival Processing Sequence."

As wonderful as this theory sounds, it is not without its drawbacks. First, you must be very careful not to fix too many prints in a given amount of fix. Ilford states that you can fix up to

150 double-weight fiber-based prints in a gallon of working strength fix.* As the concentration of dissolved silver halides in the fixing solution increases, however, its ability to fix a print to archival standards is greatly reduced. If you were to fix as many prints as Ilford recommends, you will end up with approximately six times more dissolved silver in the fix than is permissible for archival processing.†

A second problem that you might encounter is that some premium quality papers, notably Kodak's Elite Fine-Art Paper, take longer to fix than average papers. Ilford's recommendations of a 30-second fix is not long enough for these papers.

Given these cautions, use the following procedure for the Ilford Archival Processing Sequence:

1 Mix a single tray of ammonium thiosulfate-based fix (rapid type) without hardener at twice the normal working strength. For example, if the manufacturer recommends a working dilution of one part concentrate to eight parts water, mix one part concentrate to four parts water.

2 When the print is ready to fix, transfer it to the fixing tray, and agitate it for 60 seconds only. Timing is very important; it is easy to under- or overfix.

3 Transfer to a fresh water rinse for 3 minutes, and then proceed with the washing aid and the final wash.

4 The final wash can be a short as 20 minutes (to be confirmed by testing—see the section "Washing Test" on page 126 for more information).

Limit the capacity of the fix for archival processing to no more than 12 8 × 10-inch prints per liter of working solution. After this, you can dilute the solution to normal working strength and continue to use it for nonarchival processing.

Testing Fixer

The amount of dissolved silver compounds in a fixing solution determines the exhaustion of that solution. When the silver concentration reaches 2 grams per liter, the solution forms insoluble silver compounds. These silver compounds can be absorbed by the emulsion and fibers of a print and are difficult, if not impossible, to wash out.

You can test for excess silver in a tray of fixer with a potassium iodide solution. When the dissolved silver in a fixer reaches unsafe levels, the test solution forms a milky yellow-white precipitate of silver iodide.

A fixing test solution, Hypo-Chek, is available from Edwal Scientific Products. To use, add a drop or two of the test solution to about an ounce of the fix to be tested. The formation of a precipitate in a sodium thiosulfate fixing solution indicates exhaustion. For an ammonium thiosulfate-based fix, exhaustion is indicated if a precipitate forms and doesn't disappear in two or three seconds.

* *The Ilford Photo Instructor Newsletter* (Spring, 1994, p. 2).
† Grant Haist, *Modern Photographic Processing volume 1* (Wiley-Interscience, 1979), p. 641.

The Fixer Test Solution formula (Kodak FT-1) listed in Appendix F performs the same function as Hypo-Chek. To use, add five drops of FT-1 to a solution of five drops of fixer and five drops of water. The formation of an obvious precipitate indicates exhaustion. A slight cloudiness isn't an indication of exhaustion.

For archival processing, a fixing test solution is helpful only for the first bath of a two-bath sodium thiosulfate fixer. The single-bath ammonium thiosulfate fixing technique requires that you carefully monitor the number of prints you fix in it.

Residual Silver Test

If a print is fixed for too long or not for long enough, the residual silver test solutions (Kodak ST-1 or the alternative given in Appendix F) will indicate it. This test works on the principle that a toner will combine with even the invisible silver in a print emulsion to create a visible color. The procedure for the residual silver test is as follows:

1 After the final wash, blot the surface water off of the print to be tested.
2 Place a drop of the test solution on the white margin.
3 After 2 minutes, rinse off the excess test solution. Any stain other than a slight cream color (for ST-1) or faint pink (for the alternative test solution) indicates the presence of residual silver compounds that will eventually discolor the print.

If the test is positive, you can refix a print in a fresh bath of nonhardening sodium thiosulfate fixer for 3 minutes. Test again after washing to confirm that the silver is now gone.

RINSE AND WASHING AID

After fixing, rinse the print in running water for 3 to 5 minutes to remove as much excess fix as possible. This makes the job of the washing aid easier.

A washing aid is a formulation of salts that promotes an ion exchange with thiosulfate compounds to make them more water-soluble. Although the various washing aids available commercially have names like Hypo Clearing Agent and Fixer Remover, the actual process neither clears nor removes residual fix. Washing aids only improve the efficiency of the final wash; they don't eliminate the need for it.

Washing aids are also important because they increase the alkalinity of the final wash. The more alkaline the wash water, the more effective the wash. This is especially important because tap water in many municipalities is becoming increasingly acidic.

For archival purposes, double the time recommended by the washing aid manufacturer. In general, this means 2 to 3 minutes for film and up to 5 minutes for prints.

WASHING

The fact that the silver disodium (or silver diammonium) left in the emulsion after fixing is water-soluble does not mean that it is gone from the print or the film. Nor does it mean that any excess thiosulfate left behind is gone either, even after using a washing aid.

Removing these contaminants is the purpose of washing. Washing is a process of diffusion and progressive dilution. Fresh water enters the washing system, forms a solution with the chemicals diffusing out of the print emulsion and paper backing, and then leaves.

Ideally, washing should continue until the emulsion and paper fibers in a print contain no greater a concentration of silver salts and residual thiosulfate than the fresh water entering the system. In fact, this is an impossible goal, and you should wash for only as long as your purposes require. The two most important factors to consider in determining a washing time are water temperature and water flow.

Water Temperature

The warmer the wash water, the more effective it is in removing residual chemicals. Water that is too warm, however, can soften an emulsion and cause damage, such as excessive grain clumping in film and even the separation of a print's emulsion from its paper base. Wash water that is too warm can also remove the effect of certain toners such as selenium. The most effective compromise for wash water temperature is between 65° and 80° F.

Water Flow

The purpose of water flow in washing prints is generally misunderstood. Many print washing systems rely on a rapid flow rate to agitate the prints, so most photographers assume that the greater the volume of water passing over the material being washed, the better. In fact, water passing over an emulsion too rapidly doesn't allow time for the residual chemicals to diffuse into solution, actually reducing washing efficiency.

There are very few standards for water flow. Kodak recommends a rate sufficient to completely fill the washer in five minutes.* You can test the rate of water flow in your apparatus by adding several drops of food coloring to the wash water and timing how long it takes to disappear. This test will also reveal if there are areas in your washing system where water doesn't circulate as efficiently as it should, leaving eddies of dye coloration after the rest of the wash water turns clear.

You can't rely on a flow rate alone, however, to tell you whether film or prints are adequately washed. For that, you must use the residual thiosulfate test described later in this chapter. Only through testing can you establish the best flow rate for your print washing system.

Film Washing

You can wash film simply and economically. Leave the film on the developing reels or hangers and in the developing tank. Fill the tank with wash water, agitate for about 30 seconds, and dump. Repeat this 10 times. It is important to allow at least 30 seconds between the fill and the dump to allow the residual chemicals in the emulsion to diffuse out into solution.

For tray-developed sheet film, either transfer the film to hangers and a tank for washing, or fill two trays with wash water,

* *Conservation of Photographs*, Kodak Publication F-40, p. 52.

and transfer back and forth every 30 seconds. Dump and refill the empty tray until you have completed 10 transfers.

A convenient way to wash film is to fill containers ahead of time with water at the proper temperature. Plastic gallon jugs are ideal for this purpose. This technique protects you from possible temperature fluctuations at the faucet and can save considerable amounts of water. A quick calculation shows that a complete wash of 35mm film in a standard four-reel developing tank takes less than three gallons of water.

Print Washing

It is difficult, if not impossible to remove the last traces of residual chemicals from photographic paper. The print emulsion and the fibers in the paper base retain residual thiosulfate tenaciously. In addition, an underfixed or overfixed print also contains incompletely removed or redeposited silver compounds that are only partially soluble in water.

Many devices sold today claim to be "archival" print washers. Although you should investigate the merits of each product individually, all that the best of these devices offer is convenience. You can construct a completely satisfactory print washer using the largest available print tray and an inexpensive tray siphon.

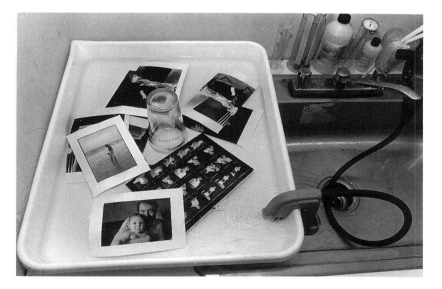

Figure 9-2 Print washing apparatus. A tray and inexpensive siphon make an excellent device to wash prints as long as you keep the prints moving. Note the inverted glass in the middle of the tray to keep the prints from clumping together.

The most important function of the print washer is to circulate wash water evenly around the prints. The more expensive print washers do this automatically, but you can achieve the same result by slowly shuffling the prints in a tray with running water. An inverted glass in the center of the tray keeps the prints from clumping in the middle.

Print Brighteners and Washing

Many printing papers have a layer of fluorescent "brighteners" between the emulsion layer and the base material. This layer increases the paper's light reflectance and makes the print highlights appear whiter and brighter.

In the past, some papers such as Ilford's Gallerie, were notorious for having the brighteners wash out during an overly long wash, leaving the dry print looking dull and with a cream colored paper base instead of brilliant white. While this problem seems to have been solved by most manufacturers, it doesn't hurt to know if your prints have a brightening layer and to confirm that washing hasn't damaged it.

To discover the presence of a brightening layer, examine your prints in a dark room under an ultra-violet "black" light. Inexpensive bulbs that fit into ordinary incandescent fixtures are available at most hardware or home supply stores. A print with brighteners has a distinctive "bluish" glow to it. If a brightening layer has been damaged by over washing, the bluish glow will appear blotchy and uneven, especially at the edges.

Washing Test

The only way to be sure that a print is adequately washed is to test it with the residual hypo testing formula (Kodak HT-2) given in Appendix F. This test uses acidified silver nitrate to create a yellow stain on emulsions containing an unacceptable amount of thiosulfates.

Washing Test Procedure

Because the stain produced by the HT-2 test is faint and easily obscured by the tones of a typical print, you must test a separate sheet of paper prepared especially for testing.

1 Process an unexposed sheet of printing paper in the same way that you would any other archival print.

2 After a 15-minute wash, blot the surface water off the test sheet and place a drop of HT-2 solution in the middle of the paper. *Prints wash from the edges in, so the center is the last area to wash completely.*

3 After 2 minutes in subdued light, flush the print with a mild salt water solution. The presence of anything more than a slight yellow stain indicates unacceptable amounts of residual thiosulfate.

4 Continue to test at 15-minute intervals until you achieve an acceptable stain. The length of time this takes is your archival print washing time, assuming the same conditions of water flow and temperature. Roughly half of this time is adequate for washing nonarchival prints.

The stain created by the HT-2 solution will continue to darken after 2 minutes. To preserve the yellow stain as it is, refix and rewash the test sheet. Preserving the test stain is not normally necessary, although you might want to keep it for your records.

Several companies sell a "hypo estimator," which is basically a printed sheet of paper or clear plastic that approximates the stains

you see at different concentrations of residual thiosulfate. The usefulness of these devices is limited because all but the faintest stains indicate that the print requires more washing.

POST TREATMENT

After processing a print, you can treat it to protect the image silver from post processing damage caused by residual sulfur from incompletely washed fixer or oxidizing atmospheric gases (mostly sulfur dioxide). Frequently, certain toners are used for this purpose, as they combine a stable material with the image silver to create a compound that is more resistant to sulfur oxidation than the silver alone. Probably the most successful toner for producing a permanent image is sepia because the silver sulfide print cannot be further degraded by additional sulfur compounds. Most photographers do not use sepia toning for archival prints, however, because of the drastic color change that takes place.

The following toners improve the stability of prints: sepia, selenium, combination selenium/sulfide, polysulfide, and all gold toning formulas. The major drawback to most of these formulas is the potentially unwanted color change. Three toners that enhance the permanence of prints without necessarily causing a noticeable color change are selenium toner, one of the gold formulas, and polysulfide toners. In addition, several companies market image stabilizing solutions that don't tone a print, but act as a buffer to prevent sulfur from oxidizing the image silver in black-and-white emulsions.

Selenium Toning

Although selenium is chemically related to sodium sulfide (the active ingredient in sepia toner), selenium toner produces only a mild deepening of the shadows when it is highly diluted. This, along with the protection added by the selenium combining with the image silver, makes selenium toning popular with photographers making archival prints.

With selenium, the toning (and therefore any protection) primarily takes place in the areas of greatest density in the image, leaving the highlights in the print relatively unprotected. For this reason, organizations concerned with the highest standards of image permanence recommend other post treatments as more effective than selenium toning.

To use for protection, follow the directions outlined for selenium toning in Chapter 8, adding only 35 to 70 ml of selenium toner concentrate to the toning solution. At this lower concentration, toning takes place very slowly, and it is easier to remove the print before a noticeable color change takes place. You can tone with selenium either immediately after fixing a print (followed by the final wash) or after the final wash (followed by another treatment with washing aid and a wash).

Gold Toning

Chemically, gold is considered a noble metal for its resistance to combination with other compounds. This means that gold won't tarnish the way that silver does when exposed to atmospheric sulfur.

Like selenium, however, the gold bonds with the silver in proportion to the image's density, giving a print more protection in the shadows than the highlights.

The Kodak GP-1 toner formula listed in Appendix F provides the protective coating of gold with a minimum of color change, usually a slight blue color in the shadows. Some photographers also claim that the GP-1 formula increases the separation of tones in the highlights, although this doesn't seem to be true for all papers or in all situations. In addition, the GP-1 formula is unique among gold toning formulas in that it contains potassium thiocyanate, the active ingredient in most image stabilizing solutions. This adds additional protection to the image from sulfur contamination beyond that of the gold itself.

Polysulfide Toning

In recent years, polysulfide toners have gained popularity as an archival post treatment for two reasons. First, the toner combines with all the image silver, highlights and shadows, at the same rate, meaning that all parts of the print are equally protected and that the contrast of the print is not affected. Second, the print is fully protected after only a short time, meaning that archival treatment can stop before a noticeable color change occurs in the image.

Kodak Brown Toner, Agfa Viradon (used at half the normal strength), and the Kodak T-8 polysulfide formula listed in Appendix F all work equally well. To use as a post treatment without significant color change, agitate the print in the toning solution at room temperature for 1 minute and then immediately transfer the print to a solution of 100 grams of sodium sulfite per liter of water (a 10% solution) for 1 minute to prevent any further color change while the print is washing.

Image Stabilizing Solutions

There are now on the market a group of relatively new products, which act as a buffer to prevent sulfur from attacking the image silver in black-and-white negatives and prints. The active ingredient in these products, potassium thiocyanate, remains in the paper or film emulsion and only reacts with silver that has oxidized into a water soluble (and hence fugitive) silver sulfide. The potassium thiocyanate combines with the silver sulfide to form silver thiocyanate, which is inert to further oxidation.

Three products that fit this description are Agfa Sistan, Fuji AgGuard, and Tetenal Stabinal. Each product is packaged with complete instructions for its use. The advantages of these image stabilizing solutions are:

- They only react with image silver after the silver is under attack from sulfur compounds.
- They do not change the image color.
- You can repeat the treatment at any time without risking damage to the print or film.
- It does not matter if a print has been toned or not.

HYPO ELIMINATOR

After a print has been washed and before it is toned, you can treat it with the hypo eliminator formula (Kodak HE-1) provided in Appendix F. A mild solution of hydrogen peroxide and ammonia, HE-1 oxidizes small amounts of thiosulfate compounds in a print.

To use, place prints in a tray of freshly mixed HE-1 solution, and agitate for 6 minutes. After use, wash prints for an additional 20 minutes.

Although it is effective, there are some drawbacks to using the hypo eliminator formula:

• HE-1 tends to soften the print emulsion so that the chances of damaging the print surface are increased. This suggests that another process is necessary: hardening.

• HE-1 tends to yellow the base of many printing papers, which some photographers find objectionable.

Generally, most photographers don't consider the benefit of using HE-1 worth the effort and added risk.

PRINT DRYING

It is possible to exercise great care while processing a print and then damage it while the print dries. Two things to avoid when drying a print are heat and contact with any potential contamination source. This means mechanical print dryers that use a canvas belt to press prints against a heated drum are a poor choice for archivally processed prints. Blotters, popular with many photographers, are also a bad choice because they are subject to contamination from previously dried prints and, even when new, can embed fibers in the print emulsion.

One way to dry prints is by clipping a corner of the wet print to a clothes line with a clothes pin. As long as the clothes pins are used only for archival prints, this method offers the least potential for damage. The only disadvantages are a slight indentation of the print corner held with the pin and the fact that, especially in dry climates, prints dried this way tend to curl badly.

Another drying method is to use fiberglass window screening stretched on a frame (Figure 9-3). Fiberglass screening is inexpensive and available at most hardware stores. The fiberglass doesn't absorb chemicals and can be easily washed if surface contamination is a problem.

To dry prints this way, remove the surface water with a squeegee and lay the print face down on the screen. If curling is a problem, you can sandwich prints between two layers of the screen. The weight of the frame of the top screen will prevent curling. Be sure to wash drying screens regularly. A small amount of chlorine bleach in the wash water followed by a fresh water rinse will ensure their cleanliness.

Figure 9-3 Drying prints on fiberglass screens. Fiberglass screens are an economical way to dry prints without damaging them. If the humidity is so low that your prints curl excessively as they dry, sandwich the wet prints between two screens.

SUMMARY

- Because the standards for archival processing are not completely clear and subject to change, it is best to think of archival processing as using those techniques that maximize a photograph's chances for long-term survival.

- One reason to learn about archival processing is to discover that only a small number of prints require such exact processing and that you can devote less time and fewer resources to the mechanics of producing prints for temporary purposes.

- Because it is relatively easy to wash film and because negatives are the source material for your prints, you should always process film for maximum permanence.

- Always develop and stop archival prints with fresh solutions and for the correct amount of time. These steps do not contribute directly to the print's life, but it is important to make the best possible print if you want it to last a long time.

- You can use one of two different fixing methods for archival prints: a two-bath system using a sodium thiosulfate-based fix or, under limited circumstances, a single bath of a concentrated ammonium thiosulfate-based fix.

- Two tests help determine proper fixing. The fixer test solution precipitates silver iodide if there is an unacceptable amount of dissolved silver in the fix. The residual silver test makes improperly fixed silver compounds in the emulsion visible by toning them.

- A washing aid promotes an ion exchange with thiosulfate compounds to make them more water-soluble and to improve the efficiency of the final wash. A washing aid is not a substitute for adequate washing.

- Print washing time is affected by the temperature and the rate of flow of the wash water.

- A residual thiosulfate test can determine if the final wash is adequate for archival purposes.

- Some toners, such as a weak solution of selenium, the gold protective formula, or a polysulfide formula used at room temperature, protect the image silver without drastically changing print color.

- Image stabilizing solutions use potassium thiocyanate to buffer the image silver from oxidizing sulfur compounds without altering the image color or contrast.

- A hypo eliminator formula oxidizes small amounts of residual thiosulfate compounds in a print at the risk of softening the emulsion and turning the paper base slightly yellow.

- Hanging wet prints on a clothes line or placing them face down on fiberglass screens allows them to dry without heat and with the least chance of contamination.

Chapter **10**

Preservation and Presentation

Photographers spend large amounts of money on cameras, film, and printing paper. They devote long hours in the darkroom. Many of these same photographers, however, neglect to follow through with the same effort when storing or displaying the fruit of all this labor. This chapter discusses these final steps of the printing process:

- print finishing, such as spotting and adding documentation
- storing negatives and prints for maximum permanence
- preparing a print for display

PRINT FINISHING
Before prints go into storage or are put up for display, they should be spotted, signed, and given any other necessary documentation. This is also the time to make decisions about adding a surface treatment.

Spotting
Even the most careful worker's prints will have a few white spots caused by dust on the negative when the print was made. Any foreign matter blocks light and forms a white "shadow" on the print. The problem is literally magnified when you make an enlargement, but it exists even when you contact print negatives.

Aside from being scrupulously clean in the darkroom and carefully dusting the negative before printing, the traditional solution for dust spots is a neutral color dye painted over the spot to make it less noticeable. This process is called *spotting*.

Some traditionalists like to make their own spotting solutions by mixing permanent ink and gum arabic, but commercial spotting dyes are widely available and easy to use. The two most popular spotting products, SpoTone from Retouch Methods Company and Touchrite from Berg Color-Tone come in small bottles of different shades of gray. To use them, mix small amounts from the appropriate bottles to match the particular color of the print on which you are working. Each product comes with complete instructions.

A practiced hand can spot a print in such a way that no traces of dust spots are visible under the most careful scrutiny. Although this is a useful skill, the real goal of spotting is camouflage, not complete eradication. Few people will study a print to discover your spotting technique.

A general rule is to spot any flaw noticeable within 10 seconds while looking at a 6-square-inch area on a print. Ignore the small flaws that invariably appear as you are working on the ones you noticed first. Even the best dyes slightly alter the surface reflectance of the print, so minimizing the amount of spotting you do actually reduces the possibility that a viewer will notice. Minimizing the time you spend spotting also reduces the possibility of accidentally harming the print during handling.

Spotting Tips

Practice is the best way to improve your spotting technique. Keep the following suggestions in mind as you practice:

- Buy a good-quality red sable brush from an art supply store and use it only for spotting. The best brush is one that will form and hold a point when it is wet and given a quick shake. Depending on preference, sizes between 0 and 0000 work best.

- Wear white cotton gloves to minimize the transfer of finger oils and dirt to the print surface. Most camera stores sell inexpensive gloves specifically for handling photographic materials.

- After you mix the appropriate color of spotting dye, let the mixture dry in a small white plastic or porcelain dish. To use, dip your brush in distilled water and touch the tip of the brush to the dried color. Once the brush absorbs a small amount of color, dab it on a paper towel or a sheet of white paper to remove any excess.

- Build up color on the print with a stippling motion rather than a brushing stroke. You can add a drop or two of Photo-Flo to the distilled water to make applying the dye easier.

- If you apply too much dye, wipe it off immediately with a cotton swab. If the dye dries, try dipping the swab in a weak solution of nonsudsing household ammonia.

- Straight lines caused by scratches on the negative are among the hardest flaws to hide. Try applying the spotting dye at right angles to the direction of the scratch.

• Spotting works best on prints that haven't been hardened. If a hardened print won't spot well and making a new print isn't an option, use the dehardening formula described in the "Archival Processing Formulas" section of Appendix F.

Fixing Black Spots ("Pinholes")

One of the hardest print defects to correct are black spots on the print caused by light shining through small, clear areas on the negative during enlargement. These clear areas are called *pinholes* and are caused by particles of dust that settle on the film surface during exposure or by emulsion damage created by going from an alkaline film developer to a strong acid stop bath. Some films, notably black-and-white infrared and some graphic arts materials, are especially prone to pinholes during processing.

There are commercial products sold to remove black spots on prints such as Spot-Off by Retouch Methods Company, or you can use Farmer's reducer as described in Chapter 7, "Salvage Techniques," to bleach the black spot out. A more convenient alternative, however, is a solution of potassium or sodium iodide. You can buy a small bottle of this solution in most pharmacies as "Decolorized Iodine Tincture," a common antiseptic. Do not use the traditional dark-colored iodine as it causes stains that will not wash out. Work with the iodine solution in the following manner:

1 With either a very fine brush or the point of a toothpick, apply a small drop of the iodine solution to any black spots on a dry print.

2 Let the print sit overnight or until the spots turn completely white.
 Bleaching continues even after the liquid dries, so there is no need to reapply the solution, just a need for patience.

3 Refix and wash the print.

4 Finally, use spotting dyes to blend the bleached area with the surrounding tones of the print.

With some practice, you can successfully remove most black spots from a print.

Signing and Documentation

Some photographers feel that until a print is signed, the person who created it hasn't fully accepted responsibility for the finished product. Other photographers feel that the date, location, and subject are essential documentation. Ultimately, what you write on a print is a personal decision, but how you do it can affect its longevity.

Use only a medium hard (number 2½ or 3) lead pencil* to write on an archivally processed print. Write only on a firm surface and, to avoid damaging the emulsion, make all marks on the back opposite a non-image area such as the print border. Some photographers also sign the front of the mounting board when a print is framed, so that their signature is visible.

* Lead is a misnomer as pencils are composed of carbon black and clay. The The greater the proportion of clay to carbon black, the harder the pencil.

For resin-coated prints, you can use a water-based India ink such as Faber-Castell Higgins Waterproof India Ink. Be sure to let the ink completely dry.

Unless it is of unusual interest, only write technical data about exposure and contrast on work prints.

Surface Treatments

Coating the surface of a print with a protective finish that modifies its surface reflectance has long been popular with photographers. This probably began in imitation of the nineteenth-century practice of varnishing paintings before exhibition.

Photographers have used various coatings over the years: wax, varnish, lacquer, even mixtures of ether and cellulose. Today, acrylic lacquers are available in convenient spray cans.

The advantages of adding a protective coating are many. Aside from making the print surface either more or less reflective, most coatings protect the print from spilled liquids, allow fingerprints to be easily wiped off, or prepare the surface for hand-applied color.

Surface treatments are best applied to prints that are not intended for archival storage. There is very little information to suggest that any surface treatment is ultimately safe for prints and much to suggest that most products will do harm. Even so called "pure" wax products should be viewed with skepticism because there is no way to predict the long-term interaction between paper emulsions and a foreign material applied to the surface.

STORAGE

Many photographers don't take negative and print storage seriously. They stuff their negatives into the plastic pages of three-ring binders and throw their prints into any convenient box. Properly filing negatives and storing prints is easy to put off in favor of the more glamorous aspects of photographing and printing.

Many factors, however, can affect photographic materials in storage. Even properly processed film and prints are susceptible to damage. Optimum storage conditions should protect photographic materials from both chemical and physical damage.

Chemical contamination can come from acid and sulfur compounds present in many film and print storage containers and in atmospheric pollution. Handling prints and negatives with bare fingers transfers salts, chlorides, and fatty acids to their surface. If a print is being displayed, the frame and mounting materials can also be sources of contamination. Physical damage is most likely to occur during handling, and from insect and fungus attack.

Sources of Environmental Contamination

Modern life may be even harder on photographs than it is on humans. Everyday objects give off gasses that can oxidize the silver in a print or negative, causing the image to change color and even fade.

The following table* lists some common sources of environmental contamination that can damage photographic prints and negatives.

Pollutant	Source
Aldehyde	New fabrics and carpets
Peroxides	Gloss paints, curing of adhesives, hair coloring products
Ozone	Car exhausts, industrial cleaning processes, photo copiers
Oxides of Nitrogen	Car exhausts

* From *Ilford Photo Instructor*, Spring, 1995, p. 20.

Proper Storage Conditions

Even with a good storage container, uncontrolled temperature and humidity can cause problems for photographic materials. Large institutions with photographic archives have the resources to control temperature and humidity carefully. Individuals usually don't. The following discussion assumes the intent to achieve the best possible storage conditions within budget and space limitations.

The ideal range of temperature and humidity for black-and-white materials is 65° to 75° F (18° to 24° C) and 45% to 55% relative humidity. Although it is best to have both temperature and humidity at constant levels, if you can only control one, then it is best to control humidity. Gelatin is more susceptible to harm from unusually high or low humidity than from extremes in temperature.

Gelatin emulsions and most papers are *hygroscopic*, meaning that, under conditions of excess humidity, they absorb moisture from the air. Even resin-coated paper absorbs moisture at the edges where the paper fibers are exposed. As moisture is absorbed by negatives and prints, a series of harmful events take place:

- The emulsion swells and softens. If a softened emulsion is touching a porous paper surface, the paper fibers will embed themselves in the emulsion. If the emulsion is touching a smooth surface, the gelatin will adhere to it and develop a glossy appearance, a defect called *ferrotyping*.

- At a relative humidity greater than 60%, mold spores and other microorganisms that are naturally present in the air become more active. Gelatin is a perfect medium for them, and as they grow, they in turn attract insects, which do even worse damage.

- Airborne sulfur in the form of sulfur dioxide, which is especially a problem in urban areas, combines with atmospheric oxygen to form sulfur trioxide. This in turn combines with moisture to form sulfuric acid, which destroys paper and silver. Iron and copper enhance this reaction, a particular problem for prints toned with iron blue and copper brown toners.

- Although high humidity is the greatest problem, below a relative humidity of 40%, gelatin emulsions can become brittle and crack.

Silvering

A common sign of deterioration on older negatives and prints (and even some more recent images) is a shiny metallic deposit on the surface of the emulsion. This phenomenon is often called *silvering*, though it has also been called *mirroring*, *bronzing*, and *plumbing*.

Silvering occurs when oxidizing gasses combine with image silver to create unstable silver ions (silver atoms with a positive charge) that actually move about the emulsion. When the silver ions reach the surface of the emulsion and come into contact with sulfur contamination they are reduced back to stable, metallic silver sulfide. On prints, silvering appears most often in the shadow areas since that is where the most silver is located.

Once silvering occurs on a print or negative, there is no known effective and permanent cure. The only solution is prevention, which means protecting the image silver from excess moisture (humidity), strong sources of ultraviolet light, and the various types of oxidizing gasses listed on on page 136.

Improving Humidity Conditions

The best solution for excess humidity is to dehumidify the area where you store photographic materials. Some air conditioners remove moisture from the air, but many do not, especially window units. You should purchase a reliable humidity gauge to monitor your storage area to see if the conditions there warrant additional effort.

For many people, it is not possible or practical to install air conditioners and dehumidifiers. In lieu of this, there are other things you can do to ensure the best conditions for your film and prints:

- Avoid storing photographic materials in unheated buildings and basements. Especially in damp climates, the relative humidity can be much higher than in similar heated spaces.
- Open storage boxes, cupboards, and drawers containing film and prints for at least 2 hours every week to promote air circulation.
- When the storage area is poorly ventilated, use commercially available drying agents, such as calcium chloride and silica gel. Be sure that these materials do not come in contact with your film and prints. Some archivists worry that they are a source of additional contamination.
- Instead of drying chemicals, leave an incandescent light bulb on in the storage area. Excess humidity is more of a problem than the slightly higher temperatures produced by the light.
- To discourage insect attack, place moth balls in storage cases, making sure that they are not in actual contact with film or prints. As with using chemical desiccants, this practice is controversial and probably shouldn't be used unless there is evidence of actual insect damage.

- If you find superficial mold and dirt on the surface of your negatives or prints, clean it off as soon as possible by gently applying film cleaner with cotton balls.

Negative Storage

Because negatives are more fragile than prints and because you can replace a print if the original negative is available, the proper storage of negatives is especially important. A description of the traditional method for storing negatives, the glassine envelope (Figure 10-1), illustrates the problems you can encounter.

- Glassine is translucent rather than transparent, meaning that the negative itself must be handled every time you need to examine the image or make a routine contact print.
- Most glassine contains acid and sulfur, which can attack the image silver.
- The glue used to seal the envelope's seams is hygroscopic. In humid climates, it attracts moisture from the air, which in turn can soften the film emulsion, making it more vulnerable to fungus and insect damage.
- Finally, the double thickness of the envelope at the seams causes uneven pressure on the negative when many negatives are stored together. The uneven pressure can distort the image on the negative over time.

Figure 10-1 Typical glassine negative envelope. Glassine is a translucent paper-based material traditionally used for negative storage. As the text indicates, there are a number of problems associated with using glassine to store your negatives.

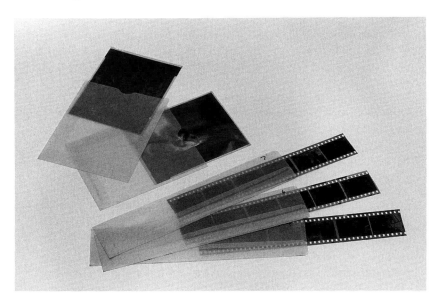

The following are descriptions of some alternatives to glassine envelopes for negative storage. No method currently available completely satisfies the need for protection and easy access and, at the same time, is forgiving of a variety of storage conditions. You should evaluate your particular needs and the limitations of each alternative when deciding how to store your negatives.

Paper Envelopes

Paper envelopes for negative storage can be made from archivally processed paper, such as Hollinger Permalife. You can fold these envelopes in a way that produces no side seams and doesn't need glue (Figure 10-2). The paper breathes, so moisture and harmful gases aren't trapped inside. Paper envelopes, however, tear easily and are opaque, requiring removal to see the image or to make contact prints. This method is best in humid climates when you need only limited access to the negatives.

Figure 10-2 Making a seamless paper negative envelope for a 4 x 5-inch negative. (a) shows the shape of the acid-free paper and the location of the folds. (b) shows the first fold. (c) shows the second fold. (d) shows the final envelope with the flaps slightly extended. As an option, you can add a top flap to the design to prevent the negative from accidently falling out of the envelope.

Clear Plastic Sleeves

The most popular choice today for storing roll film is the clear plastic sleeve. This option offers the convenience of viewing and contact printing without removing the negative from the protection of the sleeve. In addition, there are many varieties of clear sleeves available on the market to fit most negative sizes.

Of course, there are a number of cautions to observe. First, not all products are acceptably stable for long term storage. The least expensive clear sleeves are made with chemical additives called plasticizers that make the material more flexible, but which, in high humidity, can exude from the plastic as a sticky substance. This, of course, is a disaster for negatives. Avoid sleeves made from low-density polyethylene, coated polypropylene, or polyvinyl chloride (PVC). Sleeves made from high-density polyethylene, uncoated polypropylene, or transparent polyester are considered the most stable. Suppliers listed in Appendix G carry high quality sleeves.

All plastic sleeves, however, have some problems. Sleeves into which you must slide a negative can cause scratches as well as build up static electricity that attracts dust. Of the available choices, polyethylene sleeves are generally softer and tend to scratch less. As an alternative, you can use sleeves that have flaps that open up to allow you to insert and remove a negative without the possibility of scratching. Finally, some plastic sleeves, especially those made from polyethylene, can cause ferrotyping in high humidity conditions (Figure 10-3).

Figure 10-3 Negative sleeves that have ferrotyped negatives. The combination of humidity, pressure from stacking several binders together, and the smooth surface of the polyethylene sleeves has caused the negatives to ferrotype. Note the dark patterns caused by the negative surface sticking to the plastic. These negatives are ruined, and the images are permanently lost.

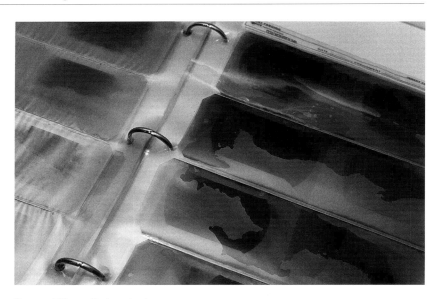

Spun Fiber Polyethylene

Recently, suppliers have begun to offer negative envelopes made from Tyvek, a trade name for spun fiber polyethylene. Although there has not been as much research done with Tyvek as with other storage materials, all indications are that this material shares the archival qualities of sheet polyethylene, but like paper, it discourages ferrotyping in high humidity. In addition, the material resists tearing. Tyvek's major drawback is that it is opaque. Negatives stored in Tyvek envelopes require additional handling to view and contact print.

Figure 10-4 Storing negatives in an acid-free cardboard box. A safe and convenient way to store negatives is to place each negative strip in a clear sleeve and then group the sleeves in an acid-free paper envelope on which you can write catalog information. Then store the envelopes in an acid-free storage box. This method allows safe handling and convenient viewing.

Storage Boxes

Once you make a choice about how to protect and organize your negatives, store them loosely in an acid-free storage box (Figure 10-4). Do not store page-size negative sleeves in three-ring binders even if the pages are conveniently punched for such

binders. The pressure of the binder on the pages and the fact that the binders are open on three sides make this a disastrous way to store your negatives.

Print Storage

The primary requirements for print storage are generally the same as for negatives. The additional size and weight of prints, however, makes the choice of storage container more critical.

Various cabinets and boxes made from acid-free materials are designed especially for print storage. Most cabinets and some boxes are made from metal with a baked-on enamel or polyester finish. These containers are the most rigid and protective available, as well as the most expensive.

Wooden cabinets and boxes can be less expensive, especially if homemade. Wood, however, is full of resins and, if bleached, contains oxidizing chemicals that can harm silver images. Seal any wooden container with water-based paint or varnish, and line it with acid-free cardboard. Water-based polyurethane varnish is especially useful for sealing wood.

The most cost-effective print storage boxes are made from archivally processed cardboard. The best designs use metal clasps to attach the corners instead of glue, which might attract insects (Figure 10-5). Suitable boxes are sold by many vendors in a variety of sizes, both alkaline buffered and unbuffered.* The biggest drawback with cardboard boxes is that they aren't very sturdy, particularly for larger-sized prints.

Figure 10-5 Print storage boxes. are available in a wide variety of sizes to match most printing papers. The boxes shown here are made from alkaline-buffered cardboard, have a drop front to make it easy to remove prints, and use metal clasps instead of glue to hold the corners together.

For individual prints, polyethylene bags are available in most popular print sizes. Don't use these bags for long-term storage, however, as polyethylene doesn't breath and under certain conditions can ferrotype the surface of the print. Regardless of the storage method, observe the following cautions:

* Alkaline-buffered storage containers can cause the dyes in some color prints and the dyes in dye-toned prints to fade faster than they ordinarily would.

- Don't store archivally processed prints with nonarchival ones. Also, don't store archival prints in a box that previously held nonarchival prints. Acid and sulfur compounds are known to migrate and may contaminate a container that has held poorly processed prints.
- Don't mount prints until you need them for display. This saves space and expense. Once prints are mounted, store them separately from unmounted prints.
- When storing unmounted prints, interleave them with sheets of acid-free paper.
- Don't stack mounted prints without window mats (see the section "Mounting Techniques" on page 145). When storing prints with window mats, place a cover sheet of acid-free paper between the print and the window.
- Fit prints as tightly as possible in their storage box to minimize movement. This means storing prints of the same size together in a box that matches the print dimensions.

MOUNTING MATERIALS

Mounting a print with a stiff backing board serves to protect the print and to enhance the conditions under which it is viewed. Although there are many techniques and materials from which to choose, understanding your purpose for mounting increases the possibility that the choices you make will add to and not detract from your print statement. There are three reasons to mount a print:

1 To hold a print flat for easy viewing. A flat print reflects light in one direction only, making it easy to position the print so that you can view it without reflections.

2 To protect the print. The mount is a barrier between the print and possible chemical contamination or physical abuse. The mount absorbs the edge dings, the fingerprints, and the coffee spills that are inevitable when a print is handled and displayed.

3 To provide a neutral viewing space around the image. The borders of the mount make it possible to view a print without interaction from the background.

You can satisfy these requirements and still have a variety of choices for type of mount board, size of the mount, and position of the print on the mount. Most photographers make their choices either to focus attention on the mounting technique and make it part of the print statement, or to make it visually neutral and not interact with the image at all.

Figure 10-6 The mount board and frame isolate the image in this print from the texture and color of the brick wall behind it. Without the neutral space that the mount board provides, the bricks would influence what we see in the image.

Mount Board

Before the relatively recent concern for archival standards in photography, the typical mounting board was a thin sheet of rag paper covering a thick core of brown wood pulp. The pulp contained large amounts of lignin, chlorine, and sulfur, typical by-products of the paper-making process. Many examples of this type of board had an obvious pebble pattern.

Today, mounting board is available without harmful chemicals and comes in a wide variety of colors and finishes. The color and quality of these boards are uniform throughout their thickness. There is little reason to use a lesser-quality board unless you are mounting a temporary study print.

Two types of archival mounting material are currently popular; they are generically known as *museum board* and *conservation board*. Museum board is made from layers of rag fiber paper. Conservation board is made from treated wood pulp and is frequently buffered with calcium carbonate so that it is slightly alkaline. Nonbuffered conservation board is also available for color and dye-toned prints.

Museum board is the traditional choice because for a long time it was the only archival mounting material available. Museum board, however, is relatively expensive, and the quality of the rag fibers used in museum board today is suspect. With the popularity of "no-iron" fabrics, pure cotton rags are increasing hard to find and polyester fibers often end up in rag paper where they form translucent blotches.

Conservation board is generally less expensive than museum board, and it is available in a greater variety of colors. In addition, because there are no fibers running directionally, pulp paper is easier to cut for window mats, especially using less expensive mat-cutting devices.

Both museum board and conservation board are available under a variety of trade names in two-ply and four-ply thicknesses (roughly 0.03 and 0.06 inches). Some companies also offer additional thicknesses.

Mount Board Sizes

Just as prints made with a single purpose or theme benefit from a consistent image size, the size of the mounting board you choose should also reflect a similar concern. Using different mount board and frame sizes in an exhibit serves to call attention to the display decisions rather than the images.

You should choose a mount board size based on the image size and standard frame sizes. Generally, a 5 × 7-inch or smaller image looks good on an 11 × 14-inch board. Images up to 8 × 10 inches work well on 12 × 16-inch or 14 × 18-inch mount boards. Larger size images (up to 11 × 14 inches) can be mounted on 16 × 20-inch or 24 × 30-inch boards.

Choosing a common mount board (and frame) size has the additional benefit of standardizing the mounting and framing process. You benefit from the economy of scale by ordering mount board and frames that are all the same size. Having similar-size storage containers is also a benefit.

The least expensive way to buy mount board is to purchase large sheets and cut them to size yourself. Check the dimensions of full sheets of board before you make a final decision about the size of your mount boards. For example, you can cut a 32 × 40-inch sheet of museum or conservation board into four 16 × 20-inch or six 12 × 16-inch boards.

Print Position

Although there are no absolute rules, most mounts should leave at least 2 inches of space around the edges of the print for protection and no more than 5 inches of space to prevent the image from appearing lost.

The following are some guidelines for positioning prints:

- With a vertical image on a vertical mount, the right and left margins should be equal, and the bottom margin should be approximately 25% larger than the top (Figure 10-7a). For example, a 9 × 11-inch image on a 16 × 20-inch mount would have right and left margins of 3½ inches, a top margin of 4 inches, and a bottom margin of 5 inches.

- With a horizontal image on a horizontal mount, the right and left margins should be equal and the bottom margin should be 25% to 35% larger than the top (Figure 10-7b). For example, a 9 × 11-inch image on a 16 × 20-inch mount would have right and left margins of 4½ inches, a top margin of approximately 3 inches, and a bottom margin of approximately 4 inches.

- With a horizontal image on a vertical mount, the right and left margins should be equal, and the bottom margin should be 25% to 50% larger than the top (Figure 10-7c). This type of positioning works best with smaller prints (5 × 7 inches or smaller) on 11 × 14-inch or smaller mounts. For example, with a 5 × 7-inch image on an 11 × 14-inch mount, the right and left margins would be 2 inches, the top margin would be between 3 and 4 inches, and the bottom margin would be between 5 and 6 inches.

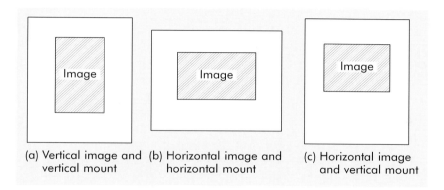

(a) Vertical image and vertical mount (b) Horizontal image and horizontal mount (c) Horizontal image and vertical mount

Figure 10-7 Three popular ways to position prints on mounts. Mounting a print in other ways tends to call attention to the mounting decisions.

MOUNTING TECHNIQUES

There are two primary techniques for mounting prints: dry mounting and window matting.*

- *Dry mounting* is a process that uses heat and pressure to glue a print to a mounting board with a material called dry mounting tissue. This process requires a dry mounting press, a device designed to provide a controlled amount of heat and pressure to the print and mounting board.
- *Window matting* places a print between two pieces of mount board. The top board has a beveled window cut in it to display the image. The print is attached to the bottom board.

Dry Mounting

Dry mounting involves trimming the border of a print and attaching it to a mounting board with a piece of specially treated tissue. The print, the tissue, and the mounting board are all placed in a heated press until the tissue permanently bonds the print and the board.

This process works because dry mounting tissue is thermoplastic. It softens under heat and flows into the porous fibers of print paper and mount board. When the tissue cools, the bond is permanent. Resin-coated papers and Polaroid prints require special low-temperature tissue.

The chief advantage of dry mounting is that prints are held very flat. In addition, dry mounting tissue is chemically inert and seals off the back of a print from chemical contamination.

The disadvantages of dry mounting are that it requires trimming the print borders, which exposes the image to direct chemical attack. In addition, dry mounting involves extra handling of the print, during which there is the potential for physical damage. Finally, the fact that a dry-mounted print is permanently attached to its mount is a problem to some archivists who prefer that a print be removable in case the mount board becomes damaged or the print requires some restoration treatment.

* The sections on mounting techniques and framing discuss the choices available to photographers who wish to display their processed prints. For specific techniques for dry mounting, cutting window mats, or framing, consult a book on framing. Some useful volumes are listed in Appendix H. Your local library may offer additional information.

General Tips for Dry Mounting

- Be sure to remove any dust and grit from the tissue, print, and mount. Foreign matter caught under the print creates a noticeable bump.

- In humid climates, dry out the mount board and print by preheating them in the dry mount press. Excess moisture can turn to steam and cause bubbles under the surface of a dry mounted print.

- Carefully check the press temperature. Some printing papers have soft emulsions that can glaze over if heated too much. Don't trust the thermostat used on most presses; instead, use temperature-indicator strips that melt at specific temperatures.

- Use a special cover sheet, called release paper, to cover the print while it is in the press. Release paper has a smooth silicon-coated surface that reduces the possibility of grit on the platen of the drymounting press from damaging the print and prevents the adhesive from drymounting tissue from adhering to the press.

- When you first remove the print from the press, the dry mounting tissue is warm and soft. Place the print under a flat weight until it cools so that the adhesion of the print and mounting board is solid.

- After the mounted print is cool, bend the mount and print backward to check for complete adhesion. If one or more corners lift off, replace the print in the press and reheat.

Figure 10-8 Types of window mats. (a) An overlapping window covers the outer edge of the image (indicated by the dotted line) by a small amount. (b) A floating window leaves space around the image visible.

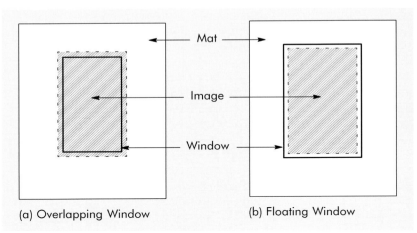

(a) Overlapping Window (b) Floating Window

Window Matting

Many photographers who make archival prints prefer to mount their prints in a sandwich between two pieces of museum board or conservation board. This arrangement is usually called a *window mat* because the top board has a beveled window cut in it to show the image.

There are two ways to cut window mats: overlapping and floating. An *overlapping window* covers the edges of the image by approximately 1/8-inch on all four sides (Figure 10-8a). A *floating window* is sized to leave approximately 1/4-inch border around the image (Figure 10-8b). The overlapping window mat is the tradition-

al way to display an image. The floating window mat is suited for images in which all of the border detail is important to the print statement.

The two pieces of board in a window mat are attached with a hinge of tape along either the top or one of the sides. The print is then positioned under the window and attached to the backing board. You can cut a window mat for a dry-mounted print, but it is difficult to match the location of the mounted print to the location of the window. Instead, it is preferable to attach the print to the bottom mount board using *mounting corners*, which are rectangles of acid-free paper folded in a triangle as shown in Figure 10-9.

Figure 10-9 Make a mounting corner by folding a rectangular piece of acid-free paper into a triangle.

The size of the paper corner depends on the size of the print you are mounting. For 8 × 10-inch paper, corners made from a 2 × ¾-inch rectangle are usually suitable. For larger paper sizes, such as 11 × 14 and 16 × 20 inches, the rectangle can be 3 × 1½ inches or larger. If the corner proves to be too large, you can cut it to size across the open end of the triangle.

Use two corners to hold the bottom of the print and one corner to hold the top of the print (Figure 10-10). The paper corners are hidden behind the window.

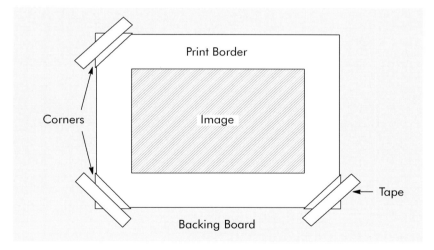

Figure 10-10 Attaching a print to a mount board with corners. Tape three corners to hold the print on the mat. Allow enough room for the print to expand in humid conditions and not buckle in the mount.

The advantage of displaying a print in a window mat is that you can remove the print when the mat becomes damaged or the print shows signs of needing restoration. In a window mat, the print doesn't need to have its edges trimmed as it does when dry mounted. Finally, the window mat keeps the print emulsion from touching the glazing of a framed print and becoming ferrotyped in a humid climate.

The disadvantages of window matting are that it requires twice as much mount board as dry mounting. To economize, you can use four-ply board for the window and two-ply for the backing. Also, cutting a beveled window requires some practice and special tools.

General Tips for Window Matting

- Use only linen or acid-free paper tape with a water-activated adhesive to attach the mounting corners and to hinge a window board to the backing board. Wet the adhesive with distilled water or mix a little baking soda with your tap water to make sure it is alkaline. Avoid pressure-sensitive tape, even if acid- and sulfur-free because the adhesive remains tacky and will eventually migrate through porous objects like the mount board.
- When mounting with corners, allow a little space for the print to swell. In humid conditions, a print can buckle if the corners are too tight.

FRAMING PRINTS

Framing is the best way to protect a print while it is on display. A properly framed print is encased by a package of materials: the frame, glazing, vapor barrier, and backing (Figure 10-11).

Figure 10-11 How a framed print is assembled.

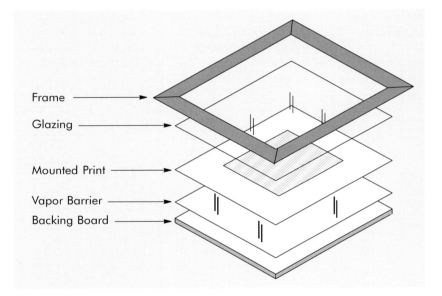

Frame

Glazing

Mounted Print

Vapor Barrier

Backing Board

Frame

The best material for the frame is metal. If the metal is painted, make sure that the paint is completely dry. Wood frames can bleed resins and other harmful products into the mount if it is not sealed with a water-based polyurethane varnish that has had at least two weeks to dry. Plastic is another common material used for frames, but to date no plastic frames are made to archival standards.

Glazing

Glazing refers to the transparent material through which you view the print. Glass and plastic are the two most common types of glazing. Glass is generally less expensive and is easier to keep clean

than plastic. In addition, glass is chemically inert and safe for archival prints. If you use glass, avoid the lightly textured nonglare glass sold by many framing stores. The surface of this glass causes a soft reflection at all viewing angles, which prevents you from clearly seeing the tones in the print.

Plastic glazing is lighter than glass, won't shatter if dropped, and is manufactured in a variety of ways that filter ultraviolet light to protect color and dye toned prints. However, plastic is hard to clean, scratches easily, and is generally more expensive than glass. Also, plastic glazing must be specially processed to be free of reactive agents that harm the long-term survival of prints, a process that adds to its expense.

Vapor Barrier and Backing Board

Behind the mounted print should be a vapor barrier and a stiff board that holds the mat and print flat. The vapor barrier is an inert layer that separates the mount from the backing. Its purpose is not to make the frame airtight. Photographs are in a constant state of change; they swell and contract from temperature and humidity changes. The vapor barrier prevents rapid humidity changes that might cause the print to buckle. You can make a satisfactory vapor seal from a sheet or two of aluminum foil or polyester (Mylar).

Even though the vapor barrier chemically isolates the mat from the backing board, not all materials are satisfactory for backing. Wood-based products, such as plywood or particle board, give off formaldehyde fumes. In addition to the suppliers listed in Appendix G, many framing shops sell acid-free corrugated board and plastic foam products suitable for backing a framed print.

SUMMARY

- Before prints are finished, they should be spotted, signed, and given any other documentation you feel is necessary.
- Spotting is the process of hiding dust spots on prints by covering the spot with a gray dye.
- Write on the back of archivally processed prints only with a medium-hard lead pencil and only opposite a nonimage area.
- Avoid any surface treatments, such as waxes and varnishes, on archivally processed prints.
- Proper storage conditions should protect film and prints from chemical and physical damage.
- The optimum range of temperature and humidity for storage and display is 65° to 75° F (18° to 24° C) and 45% to 55% relative humidity. If you can control only one of these conditions, control the humidity. Improper humidity can cause worse problems than improper temperature.
- Choices for negative storage are many, but no one method provides a full range of protection, easy access, and tolerance for a variety of storage conditions. The choice you make should reflect your individual needs.

- Prints have the same storage requirements as negatives. In addition, the size and weight of prints means that the choice of container is important.
- There are three reasons to mount a print: to hold the print flat for easier viewing, to protect the print, and to provide a controlled viewing space around the print.
- Museum board and conservation board are two archivally safe choices for mounting. Both are available in a variety of colors and thicknesses.
- Unless you have a specific reason to do otherwise, use uniform mount and frame sizes.
- Position a print on the mount so that the border is at least 2 inches wide and no more than 5 inches wide.
- There are two choices for mounting prints: dry mounting and window matting. Your choice depends on which is most convenient and best supports your print statement.
- Dry mounting uses heat and pressure to attach a print to a mounting board with a special mounting tissue.
- Window matting places the print between two pieces of mount board. There are two types of window mats: overlapping, which covers the edges of the image by approximately $1/8$-inch on all four sides, and floating, which leaves a border of approximately $1/4$ inch around the image.
- A framing package should consist of a chemically inert frame, glazing, the mounted print, a vapor barrier, and a stiff, acid-free backing board.

Darkroom Safety*

with Howard Etkind

Darkroom safety is a subject that too many photographers either ignore or misunderstand. A recent survey of darkroom safety attitudes showed that while many photographers are aware of the need for safe practices in the darkroom, there is a gap between understanding the need and knowing what to do about it. The study concluded that "individuals involved in photographic vocations do not have the same knowledge of the hazards as would an industrial worker exposed to the same level of hazards in general industry."[†]

It is the purpose of this appendix to discuss the basic principles of darkroom safety and suggest some specific techniques that photographers can use in their work. This appendix is not intended as a substitute for a review of the appropriate government regulations and standards for health and safety in effect in your area.

Always keep in mind that you bear the primary responsibility for protecting yourself by seeking the most current information on the hazards of the processes you use. There is a list of books and Internet resources in Appendix F that you can consult for this information. Your goal is to apply informed common sense to the safety practices you use in the darkroom.

SAFETY MYTHS AND MISINFORMATION

There are good reasons to have concerns about health and safety in the darkroom. It is a fact that black-and-white processes use heavy metals, strong acids, sulfur salts, and cyanide-based bleaches. These facts, however, often get translated into stories about lethal "sewer" gas, toxins that pass right through your skin and destroy vital organs, and other frightening, but mostly exaggerated myths. The truth is that most, if not all, of the chemicals used in basic photographic processes are safe as long as you understand and use the proper precautions.

* Portions of this appendix originally appeared in *Ilford Photo Instructor*, published by Ilford.
[†] Etkind, Howard W., *Safety and Health Management of Photographic Darkroom Workers*, Master's Thesis, University of Cincinnati, 1996.

Anyone looking for an example of the prevailing confusion need only read some of the discussions about selenium toner in photography groups on the Internet. Some photographers look up the safety data for the element selenium, which is very toxic in its powdered form, assume that the toner is equally hazardous and refuse to work with it. Other photographers see bottles of selenium supplements on the vitamin shelf of their local pharmacy and assume that using selenium toner will improve their health. Neither point of view, of course, is accurate.

Dosage Determines the Potential for Harm

Like selenium, most chemicals thought of as benign or even necessary for healthy life are actually acute poisons in the wrong amount. Sodium fluoride is another example. Ingested in small quantities over a long period of time, it is essential for good dental health. In large doses, however, it is extremely toxic, even lethal in approximately half the cases where people ingest 35 milligrams per kilogram of body weight.*

Darkroom chemicals rarely cause problems in the quantities that most photographers use them, but if exposure is not controlled, there a likelihood of negative long-term consequences. Your primary safety goal in the darkroom is to reduce exposure to harmful substances so that your dosage is below the threshold of potential danger.

HOW DARKROOM CHEMICALS CAUSE HARM

Protecting yourself starts with knowing how darkroom chemicals can enter your body. Every chemical reacts with the body in different ways, but most use one or more of the following avenues:

- Ingestion, usually through contaminated food or drink. From the digestive system, some chemicals can directly affect certain organs in the body.
- Injection (or penetration) through broken skin, such as a cut or badly chapped skin. Without the surface of the skin as a barrier, the chemical passes directly into the blood stream where it can affect other parts of the body.
- Absorption through the skin's outer layers and into the blood stream.
- Inhalation of material suspended in the air, such as a gas, a vapor, or a particle. The material either damages the lungs directly, or passes into the blood stream.

In addition, some materials, such as strong acids, are corrosive. Direct contact damages the skin and promotes absorption and injection.

CONTROLLING EXPOSURE

The key to working safely is controlling your exposure to the different chemicals you use. This means putting an effective barrier between you and the avenue of exposure for that chemical. The

* This is the definition of the term Lethal Dosage 50 or LD50. Ottoboni, Alice, *The Dose Makes the Poison*, Vincente Books, Berkeley, CA, 1986.

following sections discuss the methods you should employ for each avenue: ingestion, injection, skin absorption, and inhalation.

Ingestion and Injection

Ingestion and injection are easy to protect against. Make it a firm rule not to eat, drink, or groom yourself in the darkroom or any place where you handle your darkroom chemicals. If you have cuts or chapped skin, either avoid the darkroom until the skin heals, or provide a physical barrier to prevent contact with the affected area. For example, you can protect chapped hands by using gloves in addition to print tongs. See the section on gloves later in this appendix for information on choosing the proper gloves to use in the darkroom.

Skin Absorption

You can prevent skin absorption by keeping chemicals from contacting your skin or eyes. For this, you need some type of separation. Depending on the part of the body you want to protect, you might want to consider using tongs, safety glasses, or gloves.

Tongs

Tongs are the best choice for keeping your hands out of the chemicals in your processing trays. Basic cleanliness demands that you use a separate pair of tongs for each process. For example, label and use one pair of tongs for the developer, another for the stop bath, and another for fix. If you use toners or other special processes, reserve a pair of tongs for each process and use them only for that process.

Safety Glasses

Safety glasses are a must when working with solutions that could splash. Eyes readily absorb materials to pass along to the rest of the body.

Splashing is a concern with any liquid, but it is especially a problem when working with *exothermic* (heat producing) chemicals such as sodium hydroxide or strong acids like sulfuric and hydrochloric. If too much of an exothermic chemical is added to a solution at one time, the liquid can literally boil at the point of contact, creating a significant risk of contaminating everything within close range of the mixing container. If, like most people, you are carefully observing the mixing process, your eyes are probably within that range.

Gloves

While wearing gloves may seem like an obvious solution for protecting your hands, it isn't a simple solution. In the darkroom, you are working with acid, alkaline, and sometimes caustic solutions. No one glove material provides an adequate barrier in all of these situations. Latex rubber, the material used in most common kitchen or surgical type gloves is generally poor at resisting penetration (called *breakthrough*) from most chemicals used in the darkroom.

To compound the problem, thin latex gloves are prone to tears and abrasion damage. A glove with a small hole can leak and actually promote absorption by holding a small amount of the leaked chemical against the skin. In addition, many people are prone to develop an allergic reaction to natural latex, which can result in a painful skin rash or even breathing problems.

Gloves made of nitrile, a synthetic rubber compound, are a better choice than latex. Nitrile gloves offer good abrasion resistance and are an effective barrier to the dilute acids and alkalies found in general darkroom use. A wide selection of sizes and thicknesses are available from most industrial and laboratory chemical supply houses, such as the ones listed in Appendix G. In choosing gloves, consider that the thicker the glove, the more effective it is as a barrier to chemical penetration. Weigh this against the fact that the thinner the glove, the more flexible it is and the easier you will be able to handle small items in the darkroom.

Using Gloves

If you do use gloves, you should periodically clean and dry them. After use, wash your hands twice, once with the gloves on (to clean the gloves) and again with the gloves off (to clean the hands).

Be sure to inspect your gloves carefully before each use. Look for swelling, cracking, shrinking, or discoloration—all signs that there has been some change in the glove's effectiveness as a chemical barrier. If you suspect that anything is wrong with even one of a pair of gloves, discard both and use a fresh pair. Most supply houses offer discounts on boxes of 100 pairs of gloves, so it is generally economical to discard a pair after as little as one use.

Airborne Contamination

Airborne contamination is a problem when working with powdered chemicals or with volatile chemicals such as acids and solvents. There are three techniques for controlling airborne materials:

- Prevent the material from becoming airborne in the first place.
- Ventilate the darkroom or other location where you are using the materials.
- Block the contamination before it can enter the lungs.

Prevention

Preventing contaminates from becoming airborne involves careful handling and mixing of liquids and powders, and reducing evaporation by covering trays and tanks when not in use.

When you mix powdered chemicals, let the powder travel the shortest distance possible to the water so that a minimum is left suspended in the air. When you mix acids, always add acid to a larger volume of water so that heat produced during dilution is absorbed, and doesn't cause boiling and splashing.

Ventilation

After prevention, ventilation is the most effective way to control airborne contamination in most darkrooms. You can either ventilate your entire darkroom (general ventilation) or you can just ventilate the area in which you handle chemicals (local ventilation).

General, or dilution ventilation, involves an overall exhaust similar to a bathroom exhaust fan. Effective general ventilation doesn't eliminate contamination, but reduces the concentration to a safe level. General ventilation works best when airborne materials are not very hazardous and there is an adequate source of fresh air.

A good rule of thumb for general ventilation in any darkroom is to exhaust the air above the sink or work area, and provide an adequate source of fresh air from the opposite side of the room. The fan capacity should change the air in the room every three to six minutes. Calculate the volume of your darkroom (in cubic meters or cubic feet, depending on how your fan is rated) and divide by the rating of the fan. Any number greater than six means you need to use a fan with a greater capacity.

Local ventilation involves capturing the contaminant at the point of generation with some type of enclosing device, similar to a kitchen stove hood. Hoods use much less air to remove the contaminant. This is a factor when the material is hazardous and air is expensive to heat, cool, or keep free of dust.

Some processes, such as toning, don't require darkness, so you should consider performing them outside the darkroom where you can open windows and maximize the ventilation without fear of light leaks.

Checking a Ventilation System

Even if you have calculated that your fan has enough capacity for your darkroom, you should perform a test to see if the fan is actually doing an adequate job. Observation, looking for chemical dusts or mists in the air, is difficult in the darkroom working under safelights. An alternative is to use smoke (from a cigar, cigarette, or a commercially available smoke tube) or, as proposed by one expert in the field, a soap bubble kit, of the type available in most toy stores.*

Blow the bubbles (or release the smoke) at the approximate location of your processing trays, and watch to see if the bubbles are drawn to the exhaust fan. You should see steady movement. If the bubbles float slowly to the floor, you need a stronger fan or you need to improve the flow between the fresh air source and the exhaust.

While you are standing by your sink, make sure that the soap bubbles are not drawn past your face. This would be an indication that you are probably breathing your darkroom chemicals while you are working. If this happens, change the direction of the air flow in your darkroom, either by relocating the exhaust fan or the fresh air source.

Blocking Contamination

In theory, it makes sense to stop airborne contamination from entering your lungs by covering your mouth and nose with a mask or respirator while you work. In reality, masks and respirators are easy to buy, but difficult to use properly.

In regulated environments, including academic darkrooms, the use of respirators requires medical monitoring, fit testing, cleaning,

* "Checking Your Ventilation System," by Michael McCann. *Art Hazards News*, vol. 16, No. 4.

and air monitoring, conditions too difficult and costly to consider in the average darkroom. Without the safeguard of monitoring, respirators can give a false sense of security. Some darkroom chemicals (sepia toner for example) initially have a strong odor, but quickly deaden the nose, so that you may not even know if the respirator you are wearing is working correctly or not.

The biggest problem with respirators, however, is the tendency to use the respirator as a substitute for other, more appropriate, means of protection, such as ventilation. It is probably better to put your efforts into methods other than a respirator for ensuring a safe working environment.

Use of Respirators

If you do use a respirator for occasional, supplemental protection, make sure it is a National Institute of Occupational Safety and Health (NIOSH) approved unit, properly fits your size face (respirators come in different sizes), and uses a cartridge approved for acid gases and organic vapors (the color code for this type is yellow). In addition, do the following:

- Shave any facial hair which might interfere with the seal around the respirator faceplate.
- Regularly clean (and disinfect as needed) both the inside and outside of the respirator.
- When not in use, store the respirator in a resealable plastic bag to keep dust and contaminants from settling on the inside.
- Change cartridges after 8 hours of cumulative exposure. Change them more frequently if you can smell any chemical odor through the mask. Humid environments can contaminate the cartridges and cause them to lose their effectiveness more quickly.
- Do not rely on a respirator to provide protection from a suspected cancer causing chemical.

DATA SHEETS AND WARNING LABELS

Manufacturers of darkroom chemicals and the bulk chemicals used to mix photographic formulas are required to make material safety data sheets (MSDS) available upon request. You can also find many generic MSDS for bulk chemicals on the Internet. These data sheets contain much valuable information. You should obtain copies of MSDS for all the chemicals you use and review them. Consult safety and health professionals if there is anything in them you don't understand.

In addition, since the 1980s many countries require manufacturers to put warning labels on commercially sold products that have the potential to cause chronic illness. It can be easy to ignore this label, but it contains valuable information if you know how to read it.

Reading Warnng Labels

It is easy to read a warning label if you know that the labels are all required to have specific sections in the following order:

- A title using one of three signal words: *Danger* (the most serious), *Warning* (indicating a significant hazard), or *Caution* (a potentially harmful substance).
 For example, at the time of writing, a package of Kodak Dektol developer has a "Warning" designation.
- A list of potential hazards in descending order of severity.
 Dektol lists the two developing agents, hydroquinone and p-methylaminophenol sulfate (metol), as the most dangerous chemicals followed by sodium carbonate (a caustic chemical). No other chemicals are listed.
- A list of the common names of the hazardous ingredients.
 Interestingly, Kodak doesn't list metol or Elon (its propriety name for metol) as the common name for p-methylaminophenol sulfate.
- Safe handling instructions.
 Kodak's instructions for Dektol are "Avoid contact with eyes, skin, and clothing. Wash thoroughly after handling."
- Recommendations for first aid.
 Kodak lists three recommendations for Dektol: induce vomiting if ingested, flush eyes in case of eye contact, and wash with soap in case of skin contact.
- Sources of further information.
 Kodak refers users to the MSDS for Dektol and also provides a U.S. telephone number for further product information.

SAFETY NOTES ON SPECIFIC CHEMICALS

The following sections discuss the particular hazards associated with specific darkroom chemicals and list ways to protect yourself. The sections are organized in the order in which you typically encounter each chemical in the darkroom.

Developers

The powdered chemicals in most commercially packaged developers are highly toxic by inhalation and ingestion, and moderately toxic by skin contact. Certain developing agents are more toxic than others. Of the three most common developing agents, metol can cause allergic reactions, hydroquinone is a suspected mutagen (a precursor of a carcinogen), and phenidone is slightly toxic through skin contact. Other, more specialized developing agents can be even more toxic, especially para-phenylene diamine (found primarily in a few specialized film developers), catechol, and pyrogallic acid.

Of the other chemicals commonly found in developers, sodium carbonate is caustic, and potassium bromide and sodium sulfite are moderately toxic by inhalation and ingestion.

Protection

Exercise the greatest care when mixing developers from powders. Make sure that there is plenty of ventilation where you mix the developer and do everything you can to minimize the dust from becoming airborne. If meeting these conditions is difficult, consider using only developers that are sold as liquid concentrates.

When using a developer, minimize any skin contact. In particular use tongs to handle prints in the developer. If you find that developer is still getting on your hands with frequency, consider wearing nitrile gloves.

Stop Bath

The stock solution of most commercial stop bath is a concentrated acid (Kodak Indicator Stop Bath is a 28% solution) and can cause burns if you spill the stock on unprotected skin. Breathing the fumes from the concentrate can be very irritating to the lining of your sinus passages, and ingestion can be fatal in all but the smallest quantities.

Working strength stop bath is less harmful, though long-term exposure to the fumes is something to avoid, especially if you are prone to breathing problems such as asthma.

Protection

When mixing concentrated stop bath with water, always have plenty of ventilation and wear eye protection. If you are prone to spilling, wear nitrile gloves and a long sleeve shirt as well. Flush any spills of the concentrate with plenty of water. While using working strength stop bath, be sure that the darkroom is well ventilated.

Fixer

The powdered form of sodium thiosulfate is not especially toxic through skin contact. Ingestion causes a severe laxative effect. In a working solution, both sodium and ammonium thiosulfate decompose over time (or through heating) to form sulfur dioxide, an acidic and toxic gas.

Protection

General precautions about minimizing skin contact and providing good ventilation should be followed when using a fixer. If a partially used tray of fix is not going to be used for a while, either cover the tray or store the fix in an airtight bottle reserved especially for that purpose.

Washing Aid

Sodium sulfite, the primary chemical in most washing aids is only moderately toxic by inhalation or ingestion, though some people have severe allergic reactions to it. Working strength washing aid is generally not considered especially toxic through skin contact. The primary caution to observe is to not let washing aid sit for too long in an open tray as the sodium sulfite will eventually decompose into sulfur dioxide.

Reducers and Intensifiers

The primary component in Farmer's reducer, potassium ferricyanide is only slightly toxic unless it is mixed with a strong acid or heated. Chromium intensifier formulas contain both potassium (or ammonium) dichromate and hydrochloric acid. Both are toxic through inhalation and ingestion. In addition, chromium com-

pounds can cause an allergic reaction called contact dermatitis through repeated skin contact, while hydrochloric acid is corrosive.

Protection

When mixing and using Farmer's reducer, be sure you have adequate ventilation and avoid skin contact.

When mixing a chromium intensifier, wear eye protection, minimize airborne contamination, and provide plenty of ventilation. During use, be sure to avoid all skin contact and use adequate ventilation to prevent breathing any of the acid fumes.

Toners

The following sections describe how to work with the most common type of toners.

Sepia

The bleach component (part A) is only slightly toxic by ingestion though some formulas include potassium oxalate, which is a strong corrosive. Keep the bleach away from strong acids (sulfuric, hydrochloric, and perchloric) to prevent a potential release of highly toxic hydrogen cyanide gas.

The toning component (part B) contains sodium sulfide which is corrosive and generates hydrogen sulfide gas during mixing, storage, and use. This gas causes death in high concentrations, and although it has a strong odor, it has poor warning properties. At low concentrations, this gas deadens the nose, so that you stop noticing it. The only answer is adequate ventilation.

Selenium

The primary hazard from selenium toning is skin absorption. Once in the blood, selenium can cause damage to internal organs. Nitrile gloves and careful use of tongs are the best prevention, as is general cleanliness in the toning area. Use only pre-mixed selenium toners, as preparing toner from powdered selenium is a very hazardous operation.

Gold Toners

Most gold toners are mixed from bulk chemicals according to published formulas, so all cautions regarding mixing powders apply. Gold chloride is absorbed through the skin, is considered an allergen, and is moderately toxic. Observe the same precautions as for selenium.

Brown and Polytoner

These toners contain sulfur compounds and have hazards similar to part B of sepia toner. Polytoner also contains selenium and has all the hazards associated with selenium.

Iron Based Toners

Most iron toners are mixed from formulas, though there are some commercially available packages, so observe precautions regarding mixing powders. The primary components of iron toners have fairly low toxicity, but keep the toner off the skin and avoid

accidental ingestion. Don't use any formula that contains an acid other than acetic, as the acid isn't necessary and adds a potential hazard.

Copper Based Toners

Like iron toners, most copper toners are mixed from published formulas. The primary components are mildly toxic through skin contact, inhalation, or ingestion.

Dye Toners

Dye toners contain no strong acids and no corrosive chemicals and are generally safe to work with, assuming adequate ventilation and avoidance of skin contact. One dye, auromine O, used to produce a yellow color, is considered a carcinogen and should be avoided.

Miscellaneous Chemicals

The average black-and-white darkroom may contain many other chemicals other than the ones mentioned specifically in this appendix. If you are using an unfamiliar chemical, be sure to obtain the MSDS for that chemical and study it. Be aware that some photographic chemicals do not react well with common household cleaners. Chlorine bleach, for example can release highly toxic chlorine gas if it mixes with an acid.

Additional Cautions for Pregnant Women and Households With Small Children

The previous cautions apply to every darkroom worker. Women who are pregnant and households with small children must observe special cautions. Certain chemicals that are only moderately toxic to most people, such as potassium bromide, can cause harm to a fetus. In general, pregnant women should avoid working with darkroom chemicals in powdered form and, of course, should consult their health care provider about the advisability of working in the darkroom in general.

Small children in a household with photographic chemicals are at risk in the same way that they would be from most household cleaning products. Careful supervision as well as locks on the darkroom door and on the storage location of any chemicals outside the darkroom are wise precautions.

Appendix **B**

Enlarger Alignment

If a negative in an enlarger is held in a plane exactly parallel to the baseboard (on which the easel sits), then it is possible to get a uniformly sharp enlargement (Figure B-1). If any part of the negative falls outside a parallel plane, then one part of the image may be focused on the printing paper, but the rest will be slightly out of focus.

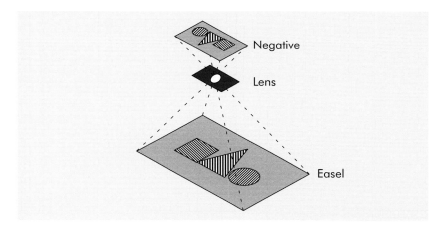

Figure B-1 For a print to be uniformly sharp, the planes of the negative, the lens, and the easel must all be parallel.

Usually, you notice that an enlarger is out-of-alignment when the image in the center and three corners of a print are sharp, and the fourth corner appears slightly out of focus. Sometimes, an alignment problem can be so severe that half a print will be sharp, and half out of focus. Stopping the enlarging lens down to increase the depth of field only corrects slight alignment problems; the best solution is to make sure that the negative stage, lens board, and baseboard are all exactly parallel.

CHECKING ALIGNMENT

Never assume that an enlarger is correctly aligned. Moving, hard use, and large temperature changes can contribute to misalignment. Even new enlargers aren't always correctly aligned as a result of inadequate quality control during manufacture or rough handling

during shipping. It is important, then, to check an enlarger before you first use it and to continue to check its alignment at regular intervals.

Alignment Test

An out-of-alignment enlarger is hard to spot during ordinary use. Some images do not have enough fine detail in all corners for you to notice if one corner is slightly out of focus. It is better to test specifically for alignment problems.

A useful alignment test involves making a print of a special test negative. On a print, you can see if the image projected by the enlarger is sharp from corner to corner. If you only look at an image projected on the baseboard, your eyes can't resolve the detail accurately enough to see any but the greatest alignment problems. A focusing aid usually isn't much help because most focusing devices don't let you see the corners of a projected image.

The Test Negative

The best negative for an alignment test is one with high contrast and uniformly fine detail in the center and all four corners. Very few images you can photograph fit this requirement as well as one you can make from a piece of film that has been exposed and developed to a maximum density. With 35mm roll film, the black leader, usually discarded after development, is ideal. You can also make a suitable density negative by pointing your camera at a blank wall, putting the lens out of focus, and overexposing by the equivalent of five or more f-stops.

If you are using a piece of film leader for your test negative, define the actual "image" area by placing the film in your negative carrier and tracing the outline of the opening on the emulsion side of the film. Next, place the film on a flat surface, and scratch a rough X through the emulsion from each corner of the image area to the center. Be careful that you don't scratch so hard that you distort the clear film base. The "image" you scratch on the film should contain many jagged edges and fine details on which you can easily focus (Figure B-2).

Figure B-2 Example of an X pattern scratched on a piece of black film.

Alignment Test Procedure

With the alignment test negative in the enlarger, do the following:
1 Project an image large enough to cover a full 8 × 10-inch sheet of paper without cropping any of the scratched-on "image."

2 Open the enlarging lens to its maximum aperture, and focus the projected image at its center, where the X crosses.

3 Leaving the lens wide open, make a series of test strips. You are looking for an exposure that produces a fully black X without losing any of the fine detail in the scratches. Switch to grade 3 or higher paper, if necessary, to increase the contrast of the image without having the fine details fill in.

4 Make a full-size print of the test negative.

Evaluating the Alignment Test Print

When the print is developed, stopped, and fully fixed, examine it under bright light. Use a magnifying glass, if necessary, to discover if the fine detail in the print is uniformly sharp.

- If the test print is sharp in the center and in all four corners, your enlarger is in alignment.

- If the test print is sharp in the center, but one or two corners are fuzzy, the enlarger is out of alignment.

- If the center of the print is sharp, but all four corners are out of focus, heat from the enlarging lamp has caused the negative to buckle or "pop" so that it is no longer perfectly flat. Turn off the enlarging lamp and let the enlarger cool down before trying the alignment test again. Some enlarger designs are more prone to overheating the negative than others. If you can't solve an overheating problem by reducing the amount of time the enlarger light is on while focusing or by placing heat-absorbing glass between the enlarger lamp and the negative, you should consider replacing your enlarger.

ALIGNING AN ENLARGER

Enlargers vary as to how easy they are to align. Some enlargers, such as the Omega B and D series (often available used), are manufactured with adjustment screws on the negative and lens stages and are relatively easy to align with only a screwdriver. In other enlargers, notably the Beseler 23C and MCRX series, the negative and lens stages are manufactured in one piece, and alignment can be tricky at best. Before you begin the alignment process described here, examine your enlarger and decide what tools and methods you need to employ to physically change the relationship of the negative stage, the lens board, and the baseboard.

Some enlarger manufacturers sell special tools to help in aligning an enlarger. These devices work no better than an inexpensive carpenter's level you can purchase at any hardware store. An adequate level need be no longer than 6 inches. A smaller level, sometimes called a *line level* will also work.

Leveling the Baseboard

First, make sure that the baseboard of the enlarger is level. Do this by placing the carpenter's level on the baseboard in six different places: once on each of the four sides and once on each of the diagonals (Figure B-3).

Figure B-3 Checking the level of the baseboard. To make sure that the enlarger baseboard is level, check it in at least six locations: once on each of the edges and also from corner to corner.

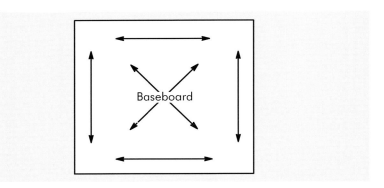

Place small pieces of cardboard under any corners that are too low and continue checking until the baseboard is perfectly level. If you discover during this process that the baseboard is warped and cannot be accurately leveled, place your easel on the baseboard, and level the easel instead.

Leveling the Negative Stage

To determine if the negative stage is parallel to the baseboard, place the level where the negative carrier normally rests. Check the same locations on the negative stage that you checked on the baseboard. Depending on the enlarger and the size of the level, you might have to remove the condensers or the entire enlarger head to accomplish this.

If removing the enlarger head isn't possible, place a sheet of glass of approximately 8 × 10 inches in the negative stage so that the long end projects from the front of the unit. Close the enlarger on the glass to hold it firmly, and place the level on the portion that protrudes (Figure B-4).

Figure B-4 Alternative method for checking the level of the negative stage. If you cannot fit your level directly on the negative stage, put a piece of glass in the negative stage and place the level on the glass.

If the negative stage isn't level, make the necessary adjustments to your enlarger to make it level, being careful that the baseboard remains steady while you are working.

Leveling the Lens Board

The final step is to place the carpenter's level on the lens board and determine if it is parallel to both the baseboard and the negative stage. As with the negative stage, doing this is easier with some enlargers than with others. You may have to remove the flexible bellows that connects the negative stage to the lens board in order to place the level directly on it. For certain enlarger models, you can purchase a lens board that allows you to adjust the attitude of the lens relative to the negative and baseboard.

Making the lens board parallel to the baseboard and negative stage is an essential step that is often overlooked. Even if the negative and printing paper are precisely parallel, an out-of-alignment enlarging lens changes the image's plane of focus.

Double Checking

Once you have leveled both the negative carrier and the lens board, recheck the baseboard to make sure that it hasn't moved off level while you were working. If you find that it has, repeat the entire procedure until you are satisfied that all three points on your enlarger are parallel.

Finally, if the condenser of your enlarger rests directly on the negative carrier (as, for example, on many Omega models), place the empty negative carrier in the negative stage, lower the lamp house onto it, and loosen the screws holding the condenser so that it rests flat on the carrier. Then retighten the screws. This ensures that the enlarger won't leak light around the negative stage.

Appendix C

Variable-Contrast Filter Equivalents

Several manufacturers sell filter sets to control the contrast of variable contrast paper. A filter set from one company works with paper made by another, though the results will not be the same for all contrast grades due to differences in paper formulation.

As an alternative to the filter sets, many photographers like to use the filters built into enlargers designed for color printing. This approach has advantages since most color printing heads use dichroic filters which maintain stable color throughout their life, and the filters themselves are located inside the enlarger head where they are less susceptible to dust and damage from handling.

The drawbacks to this approach are that the filters used in one brand of enlarger are slightly different from those used in another. There can even be variations in the filters between two models of the same enlarger brand. As well, the less expensive models of color heads have less precise filter adjustments, so that you don't always get exactly the same filtration every time you dial a specific filtration number. For these reasons, consider any table of variable-contrast filter equivalents to be a starting point for your own experimentation.

TABLE OF VARIABLE-CONTRAST FILTER EQUIVALENTS

The following table, adapted from literature published by Ilford, lists color printing filter equivalents as starting points for most color enlarging heads. The column labeled "Equal Exposure" balances the yellow and magenta filtration to produce roughly equal exposure times between grade ½ and grade 4. The column labeled "Shortest Exposure" recommends the minimum filtration needed to achieve a particular contrast regardless of how the filtration affects the overall exposure. Once you determine the best filtration for your enlarger and paper brand, you can calibrate the exposure factor for each contrast grade in the manner described for calibrating emulsion speeds in Chapter 2.

Contrast	Equal Exposure	Shortest Exposure
Grade 00	162 Yellow	199 Yellow
Grade 0	90 Yellow	90 Yellow
Grade ½	78 Yellow 5 Magenta	70 Yellow
Grade 1	68 Yellow 10 Magenta	50 Yellow
Grade 1½	49 Yellow 23 Magenta	30 Yellow
Grade 2	41 Yellow 32 Magenta	No Filter
Grade 2½	32 Yellow 42 Magenta	5 Magenta
Grade 3	23 Yellow 56 Magenta	25 Magenta
Grade 3½	15 Yellow 75 Magenta	50 Magenta
Grade 4	6 Yellow 102 Magenta	80 Magenta
Grade 4½	150 Magenta	140 Magenta
Grade 5	N/A	199 Magenta

Note

Some color heads don't have enough magenta filtration to produce the highest contrast or enough yellow filtration to produce the lowest contrast grades. You may have to supplement the built-in filters with the appropriate color filter held below the lens.

Appendix

Chemical Conversions and Substitutions

The following information can be useful when you are mixing formulas and need to know how to make certain calculations and substitutions. The sections in this appendix include:

- substituting percentage solutions for a specified amount of a dry chemical
- converting alternate forms of sodium carbonate
- converting alternate forms of sodium sulfite
- converting alternate forms of sodium thiosulfate
- diluting solutions from one percentage concentration to another

SUBSTITUTING PERCENTAGE SOLUTIONS FOR DRY CHEMICALS

Some developer formulas require a very small amount of a dry chemical, such as the restrainer, potassium bromide. If measuring a very small amount of a dry chemical is difficult, you can prepare a 10% stock solution of it and add 10 ml of that solution for every gram of the dry chemical specified in the formula. For example, 2 grams equals 20 ml of a 10% solution, and 0.8 grams equals 8 ml of a 10% solution. Prepare a 10% solution of any chemical by dissolving 10 grams of dry chemical in 100 ml of water.

CONVERTING ALTERNATE FORMS OF SODIUM CARBONATE

Sodium carbonate is commonly found in three different forms, anhydrous (or desiccated), monohydrated, and crystal. The difference is the amount of water that each form contains. Anhydrous sodium carbonate technically contains no water, though in practice it may be as much as 2% water. Monohydrated sodium carbonate contains about 15% water, and crystal sodium carbonate contains about 63% water.

Monohydrated sodium carbonate is the only chemically stable one of these forms. The anhydrous form tends to absorb moisture from the air and the crystal form tends to lose water to the air. The

result is that the actual strength of both anhydrous and crystal sodium carbonate change over time, making their use unpredictable.

Whenever you encounter a formula that specifies a form of sodium carbonate other than monohydrate, you should convert that quantity to the equivalent in monohydrated sodium carbonate. This way you will always be using the same strength of the chemical regardless of the current humidity conditions. Use the following table to make the conversion from either anhydrous or crystal form of sodium carbonate to the monohydrate form:

If the Formula Specifies:	Multiply by:
Sodium carbonate (anhydrous)	1.20
Sodium carbonate (crystal)	2.33

CONVERTING ALTERNATE FORMS OF SODIUM SULFITE

Usually, formulas with sodium sulfite require the anhydrous, or desiccated, form of the chemical. If you have a formula that requires the crystal form of sodium sulfite or if only the crystal form is available, you can use the following table for conversions:

If the Formula Specifies:	And You Have:	Multiply by:
Sodium sulfite (anhydrous)	Sodium sulfite (crystal)	0.5
Sodium sulfite (crystal)	Sodium sulfite (anhydrous)	2.0

CONVERTING ALTERNATE FORMS OF SODIUM THIOSULFATE

Most formulas that use sodium thiosulfate require the crystal form (pentahydrate). If you have a formula that requires the anhydrous form or if you have only the anhydrous form available, you can use the following table for conversions:

If the Formula Specifies:	And You Have:	Multiply by:
Sodium thiosulfate (crystal)	Sodium thiosulfate (anhydrous)	1.6
Sodium thiosulfate (anhydrous)	Sodium thiosulfate (crystal)	0.6

DILUTING SOLUTIONS

Some formulas require a specific percentage dilution of a particular solution. A traditional method* for creating a new percentage dilution from a solution of known percentage is illustrated in the following chart (Figure D-1).

* The earliest publication of the "×" chart described here appears to be in *The Chemistry of Photography*, Mallinkrodt Chemical Works, St. Louis, MO, 1929.

Figure D-1 A traditional method for diluting percentage solutions.

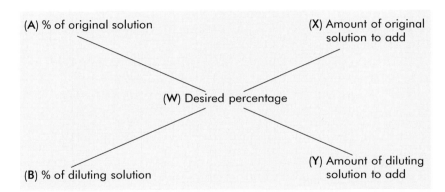

To use the chart, you need to know the percent dilution of the original solution (A), the percent dilution of the desired solution (W), and the percent of the diluting solution (B). Note that if you are using water as the diluting solution, the percentage is assumed to be zero (0%).

Next, subtract the desired percentage (W) from the original percentage (A) to get the amount of the diluting solution to add to make 100 units of the desired solution. Likewise, subtract the percent of the diluting solution (B) from the percent of the desired solution (W) to get the amount of the original solution (X) to add to the diluting solution.

An example of how this works is shown in Figure D-2 by diluting glacial acetic acid (essentially a 100% solution) to 28% acetic acid (equivalent to the stock solution stop bath widely available from Kodak and other manufacturers).

Figure D-2 Using the chart to dilute glacial acetic acid to 100 ml of 28% acetic acid. (Remember, always add acid to a solution, do not a solution to the acid.)

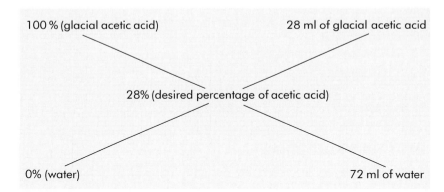

Starting with 100 (the percent dilution of the acid), you subtract 28 (the desired percent solution) to get 72 (the number of ml of water to make up 100 ml of the desired solution). Then you subtract 0 (the percent dilution of water) from 28 (again, the desired percentage) to get 28 (the number of ml of acid to make up 100 ml of the desired solution). The total of each side of the chart (A plus B and X plus Y) should always equal 100.

Developer Formulas

The formulas in this appendix are among the most useful found in the formularies listed in Appendix H. They are organized in the following order:

- neutral-color developers
- warm-color developers
- cold-color developers
- low-contrast developers
- high-contrast developers
- Beers variable-contrast developer

NEUTRAL-COLOR DEVELOPERS

Neutral-color developers tend to produce an image with the least noticeable bias toward either a warm or cold color possible for a given printing paper. For example, when a warm-color paper is developed in a neutral-color developer, the result is still a reddish print, but less so than when the same paper is developed in a warm-color developer.

If a paper has a slight greenish cast when developed in one of the following developers, you can substitute a commercial anti-foggant, such as Edwal's Liquid Orthazite or Kodak's Benzotriazole, for the potassium bromide in the formula. These preparations produce a more neutral color than potassium bromide. Follow the manufacturer's recommendations for how much of a particular anti-foggant to substitute for potassium bromide.

Kodak D-72

This formula is known as a universal Elon-hydroquinone paper developer. A variation of D-72 is sold prepackaged as Dektol.

Water (110° F)	500.0 ml
Metol (Elon)	3.0 grams
Sodium sulfite (anhydrous)	45.0 grams
Hydroquinone	12.0 grams
Sodium carbonate (monohydrate)	80.0 grams
Potassium bromide	2.0 grams
Cold water to make	1.0 liter

How to Use

Dilute 1:2. Normal development time is 2 minutes.

Ilford ID-20

This formula tends to produce the most neutral color with bromide-based papers, such as Kodabromide and Ilfobrom.

Water (110° F)	750.0 ml
Metol (Elon)	1.5 grams
Sodium sulfite (anhydrous)	25.0 grams
Hydroquinone	6.0 grams
Sodium carbonate (monohydrate)	35.0 grams
Potassium bromide	2.0 grams
Cold water to make	1.0 liter

How to Use

Dilute 1:1. Normal development time is 2 minutes.

Agfa Metinol U Equivalent

Metinol U used to be more widely distributed and sold than it is currently. A proprietary formula, Metinol U produces the most neutral color possible on Brovira papers. This formula produces equivalent results to Metinol U.

Water (110° F)	3.0 liters
Metol (Elon)	4.0 grams
Sodium sulfite (anhydrous)	52.0 grams
Hydroquinone	12.0 grams
Sodium carbonate (monohydrate)	120.0 grams
Potassium bromide	4.0 ml*
Cold water to make	4.0 liters

* of a 10% stock solution. See page 168 for a description of how to make a percentage solution.

How to Use

Do not dilute the stock solution. Normal development time is 2 minutes.

Beers Developer (Normal Contrast)

When mixed for normal contrast, Beers formula is an excellent neutral-color developer. See the section on Beers variable-contrast developer on page 180 for more information.

GAF 113

This formula contains Amidol and thus is more expensive to prepare than most of the other developer formulas listed here. GAF 113, however, yields very rich, deep black shadow tones and may be worth the trouble and expense to some photographers.

Water (room temperature)	750.0 ml
Sodium sulfite (anhydrous)	44.0 grams
Potassium bromide	0.5 grams
Amidol	6.6 grams
Room-temperature water to make	1.0 liter

How to Use

Mix the developer just before using because it cannot be stored after it is mixed. Do not mix the dry chemicals with hot water. Use without dilution for normal contrast, or dilute as much as 1:20 to produce very low contrast without losing dark shadows. Normal development time is 2 minutes.

WARM-COLOR DEVELOPERS

Warm-color developers produce a variety of image colors, depending on the formula and the paper being used. Warm-color papers developed in warm-color developers tend to produce colors that range from brown-black to very warm brown. Neutral-color papers developed in warm-color developers tend to produce warm black and brown-black colors.

Kodak D-52

A variation of this formula is sold pre-packaged as Kodak Selectol. This formula has a long life as a stock solution.

Water (110° F)	500.0 ml
Metol (Elon)	1.5 grams
Sodium sulfite (anhydrous)	22.5 grams
Hydroquinone	6.0 grams
Sodium carbonate (monohydrate)	17.0 grams
Potassium bromide	1.5 grams
Cold water to make	1.0 liter

How to Use

Dilute 1:1. Normal development time is 2 minutes.

Xerox HD-6

Before the advent of dry paper copying machines, Xerox (then known as the Haloid Corporation) used to sell photographic materials and publish formulas. While similar to Kodak D-52, HD-6 has a lot of fans. This formula produces rich, warm colors with very even tonal separation.

Water (120° F)	750.0 ml
Metol (Elon)	1.5 grams
Sodium sulfite (anhydrous)	25.0 grams
Hydroquinone	6.5 grams
Sodium carbonate (monohydrate)	17.5 grams
Potassium bromide	1.5 grams
Cold water to make	1.0 liter

How to Use

Dilute 1:1. Normal development time is 2 minutes.

Agfa 120

This developer produces a variety of brown to warm black colors on various papers, depending on dilution and exposure times.

Water (110° F)	750.0 ml
Sodium sulfite (anhydrous)	60.0 grams
Hydroquinone	24.0 grams

Sodium carbonate (monohydrate)	80.0 grams
Cold water to make	1.0 liter

How to Use

For Brovira, you can produce a warm black color at a dilution of 1:5 and a development time of 4 to 5 minutes. For Portriga Rapid, you can produce a brown-black color at a 1:4 dilution and a development time of 3 minutes. Try Ilford and Kodak papers at 1:5 and 4 to 5 minutes of development.

Gevaert G.262

This is a specialized warm-color paper developer that contains no metol. Image color tends toward red as you either increase the dilution or change the development time from 1½ to 6 minutes. Some printing papers (Kodak, in particular) react in unusual and inconsistent ways to this developer.

Water (120° F)	750.0 ml
Sodium sulfite (anhydrous)	70.0 grams
Hydroquinone	25.0 grams
Sodium carbonate (monohydrate)	90.0 grams
Potassium bromide	2.0 grams
Cold water to make	1.0 liter

How to Use

Undiluted, the image color will be brown-black. Diluted 1:2, the image color will be brown. Diluted 1:4, the image color will be brown-red. Diluted 1:6, the image color will be red.

Maxim Muir's Clorhydroquinone-Substitute Developer

Clorhydroquinone was a popular warm-color reducing agent before 1940, but is now virtually impossible to obtain. Maxim Muir has cleverly calculated the proportions of metol and hydroquinone that approximate the effect of Clorhydroquinone and substituted them in this classic formula. As an added advantage, mixing the accelerator in a separate solution increases the shelf life of the stock developer.

Stock Solution A

Water (110° F)	750.0 ml
Metol (Elon)	1.0 grams
Sodium sulfite (anhydrous)	64.0 grams
Sodium metabisulfite	16.0 grams
Hydroquinone	19.0 grams
Potassium bromide (see How to Use)	2.0 to 8.0 grams
Cold water to make	1.0 liter

Stock Solution B

Water (110° F)	750.0 ml
Potassium carbonate	80.0 grams
Cold water to make	1.0 liter

How to Use

Mix one part stock solution A, one part stock solution B, and six parts water. The amount of potassium bromide you use depends on the type of paper and the image color you want. When you use this developer with a new paper, mix stock solution A with 2.0 grams of potassium bromide and add a 10% solution of potassium bromide to the working developer in 20 ml amounts (up to a total of 60 ml) as needed.*

Once you determine the amount of potassium bromide you prefer, add 2 additional grams of potassium bromide to stock solution A for each 20 ml of the 10% solution you added during your test. Do not mix stock solution A with more than a total of 8 grams of potassium bromide, or the developer will not develop a good shadow tone. This is a slow working developer, development time is between 2½ and 4 minutes.

* See page 168 for a description of how to make a percentage solution.

COLD-COLOR DEVELOPERS

Although it is relatively easy to increase the warmth of an image by increasing the amount of potassium bromide in a developer, it is much more difficult to create a cold color because a normally active developer with only a small amount of restrainer will produce chemical fog. The effects of cold-color developers are subtle and often only noticeable when used in combination with cool- or neutral-color papers.

DuPont 54-D

This formula is, for practical purposes, identical to a Kodak formula published as D-73. The effects of this developer on image color are very subtle with most modern paper emulsions.

Water (110° F)	750.0 ml
Metol (Elon)	2.7 grams
Sodium sulfite (anhydrous)	40.0 grams
Hydroquinone	10.6 grams
Sodium carbonate (monohydrate)	75.0 grams
Potassium bromide	0.8 grams
Cold water to make	1.0 liter

How to Use

Dilute 1:2. Normal development time is 2 minutes.

Burki and Jenny Cold-Tone Developer

Published in 1943, this formula produces a more noticeable blue coloration than DuPont 54-D on most papers.

Water (110° F)	750.0 ml
Metol (Elon)	3.0 grams
Sodium sulfite (anhydrous)	40.0 grams
Hydroquinone	12.0 grams
Sodium carbonate (monohydrate)	75.0 grams
Potassium bromide	0.8 gram
Benzotriazole (or Kodak Anti-Fog No.1)	6.0 ml*
Cold water to make	1.0 liter

* of a 1% stock solution. See page 168 for a description of how to make a percentage solution. You can increase the blue color by adding up to 15 ml of the benzotriazole solution.

How to Use

Dilute 1:2. Normal development time is 2 minutes.

GAF 130

Glycin, one of the reducing agents in this formula, is expensive but used in small quantities. Because this developer produces excellent tonal separation on most papers, the added expense may be worthwhile.

Water (110° F)	750.0 ml
Metol (Elon)	2.2 grams
Sodium sulfite (anhydrous)	50.0 grams
Hydroquinone	11.0 grams
Sodium carbonate (monohydrate)	78.0 grams
Potassium bromide	5.5 grams
Glycin	11.0 grams
Cold water to make	1.0 liter

How to Use

Normal dilution is 1:1, although you can use this developer undiluted for greater contrast and diluted 1:2 for lower contrast. Normal development time is 2 minutes.

Maxim Muir's "Hotshot"

This developer works on the principle that increasing the developer activity (created by a high alkalinity) and substituting phenidone and benzotriazole for the more traditional metol and potassium bromide encourage a cool print color.

Water (125° F)	650.0 ml
Sodium sulfite (anhydrous)	180.0 grams
Hydroquinone	53.0 grams
Phenidone	2.2 grams
Benzotriazole	1.5 grams
Sodium hydroxide (see mixing instructions)	11.0 grams
Cold water to make	1.0 liter

Mixing Instructions

Because of the caustic nature of sodium hydroxide (see safety note), this developer is somewhat tricky to mix. Please follow these instructions carefully.

- Mix the sodium sulfite, hydroquinone, phenidone, and benzotriazole with the hot (125° F) water. Not all the ingredients will dissolve at this time.
- Allow the mixture to cool to about 75° F and then add the sodium hydroxide while carefully stirring. Most of the undissolved chemicals will dissolve during this process.
- Add cold water to make a total volume of 1 liter.

> **Safety Note: Sodium Hydroxide**
>
> Sodium hydroxide is a very caustic chemical. When the dry chemical is added to a solution, heat evolves, creating a potential for "splashing," so add only small amounts of the chemical at a time to cool solutions. Always use gloves and eye protection when working with the dry chemical or concentrated solutions. If the dry chemical or a solution containing sodium hydroxide touches your skin, flush immediately with water or dilute vinegar.

How to Use

Normal dilution is 1:5. You can use this developer at a 1:3 or 1:2 dilution for greater contrast although at the risk of increased chemical fog. Normal development time is 2 minutes. The high developer activity means a short working life. Plan to develop no more than 10 sheets of 8 × 10 inch paper (including test strips) per liter of working solution.

LOW-CONTRAST DEVELOPERS

Low-contrast developers noticeably reduce the contrast of any printing paper, although the effect is usually less than that obtained by a full paper grade. The advantages of using a low-contrast developer include having a finer degree of contrast control and the ability to obtain a greater range of contrast on some papers that come in only a limited number of contrast grades.

GAF 120

GAF 120 is one of the most popular low-contrast developers. This formula produces an image similar to Kodak's Selectol-Soft, a proprietary developer.

Water (110° F)	750.0 ml
Metol (Elon)	12.3 grams
Sodium sulfite (anhydrous)	36.0 grams
Sodium carbonate (monohydrate)	36.0 grams
Potassium bromide	1.8 grams
Cold water to make	1.0 liter

How to Use

Dilute 1:2. Normal development time is 2 minutes.

Ilford ID-3

This formula is slightly cloudy when mixed and will darken as you use it, but it has a long working life. ID-3 is also suitable for developing film when low contrast is needed.

Water (120° F)	1.0 liter
Metol (Elon)	3.0 grams
Sodium sulfite (anhydrous)	12.5 grams
Sodium carbonate (monohydrate)	21.75 grams
Potassium bromide	0.5 gram
Cold water to make	2.0 liters

How to Use

Do not dilute. Normal development time is 2 minutes.

Agfa 105

This formula can be considered a low-contrast version of Metinol U (see page 172 and compare the formulas). This makes it useful when you want the same image color but need a lower contrast result.

Water (110° F)	750.0 ml
Metol (Elon)	3.0 grams
Sodium sulfite (anhydrous)	15.0 grams
Sodium carbonate (monohydrate)	15.0 grams
Potassium bromide	1.0 grams
Cold water to make	1.0 liter

How to Use

Do not dilute. Normal development time is 1½ minutes.

Beers Developer (Low Contrast)

When mixed for low contrast, Beers formula is an excellent neutral-color, low-contrast developer. See the section on Beers variable-contrast developer on page 180 for more information.

HIGH-CONTRAST DEVELOPERS

High-contrast developer formulas typically contain a greater percentage of hydroquinone than metol. To make up for the lower reduction potential of hydroquinone, these formulas usually contain additional sodium carbonate.

High-contrast developers allow a degree of contrast control finer than a full paper grade and increase the range of contrast for papers that have only a limited number of available grades.

Agfa 108

This is a high-contrast developer that works well with most normal-contrast papers. It has a slight green cast when mixed with potassium bromide. A more neutral color will result if you substitute 30 ml of Edwal Liquid Orthazite for the potassium bromide.

Water (120° F)	500.0 ml
Metol (Elon)	5.0 grams
Sodium sulfite (anhydrous)	40.0 grams
Hydroquinone	6.0 grams
Sodium carbonate (monohydrate)	40.0 grams
Potassium bromide	2.0 grams
Cold water to make	1.0 liter

How to Use

Do not dilute. Normal development time is 2 minutes. A longer development time will increase contrast even more.

Beers Developer (High Contrast)

When mixed for high contrast, Beers formula is an excellent neutral-color, high-contrast developer. See the section on Beers variable-contrast developer on page 180 for more information.

Defender 57-D

Originally created for high-contrast copy paper, this formula creates a warm-color image suitable for some papers.

Water (120° F)	500.0 ml
Metol (Elon)	1.5 grams
Sodium sulfite (anhydrous)	19.5 grams
Hydroquinone	6.0 grams
Sodium carbonate (monohydrate)	24.0 grams
Potassium bromide	0.8 gram
Cold water to make	1.0 liter

How to Use

Do not dilute. Normal development time is 1 to 2 minutes and up to 4 minutes for higher contrast.

Edwal 120

The pyrocatechol (also known as pyrocatechin and catechol) in this developer is chemically similar to hydroquinone, but with a greater reduction potential. Normally a formula with pyrocatechol gives bromide prints a rich brown color. Adding the optional potassium bromide to this formula yields prints with a neutral or, as you increase the amount of potassium bromide, even a cold color.

Solution A

Water (120° F)	500.0 ml
Pyrocatechol (1,2-Dihydroxybenzene)	20.0 grams
Sodium sulfite (anhydrous)	40.0 grams
Cold water to make	1.0 liter

Solution B

Water (120° F)	500.0 ml
Potassium carbonate (anhydrous)	120.0 grams*
Potassium bromide (optional)	2.0 to 6.0 grams
Cold water to make	1.0 liter

* Although the results won't be exactly the same, you can substitute 184 grams of sodium carbonate (monohydrate) for the potassium carbonate.

Safety Note: Pyrocatechol

Pyrocatechol (also known as pyrocatchin or catechol) is a more toxic reducing agent than metol or hydroquinone. Be very careful to avoid inhalation of the powder during mixing, skin contact from either the powder or the solution, or ingestion.

How to Use

Mix one part of solution A and two parts of solution B with one part water. Normal development time is 2 minutes.

Alternate Formula for Edwal 120

Because of the expense of pyrocatechol and the fact that most special purpose developers aren't used frequently, some photographers prefer to mix Edwal 120 as a single-solution developer. Store

the following formula in an air tight container and use within a week of mixing.

Water (120° F)	500.0 ml
Pyrocatechol (1,2-Dihydroxybenzene)	5.0 grams
Sodium sulfite (anhydrous)	10.0 grams
Potassium carbonate (anhydrous)	60.0 grams*
Potassium bromide (optional)	1.0 to 3.0 grams
Cold water to make	1.0 liter

* Although the results won't be exactly the same, you can substitute 67 grams of sodium carbonate (monohydrate) for the potassium carbonate.

BEERS VARIABLE-CONTRAST DEVELOPER

Beers formula is the classic variable-contrast paper developer. In its normal-contrast dilution, it produces a very neutral image color for most papers.

Solution A

Water (110° F)	750.0 ml
Metol (Elon)	8.0 grams
Sodium sulfite (anhydrous)	23.0 grams
Sodium carbonate (monohydrate)	23.5 grams
Potassium bromide	1.1 grams
Cold water to make	1.0 liter

Solution B

Water (110° F)	750.0 ml
Sodium sulfite (anhydrous)	23.0 grams
Hydroquinone	8.0 grams
Sodium carbonate (monohydrate)	31.5 grams
Potassium bromide	2.2 grams
Cold water to make	1.0 liter

Contrast-Control Dilutions

The stock solutions are mixed in different ratios and diluted with water to make working solutions for contrast control. The total range of control is about one full paper grade.

	Low	2	3	Medium	5	6	High
Solution A	500 ml	435 ml	372 ml	310 ml	250 ml	190 ml	128 ml
Solution B	0 ml	65 ml	128 ml	190 ml	250 ml	310 ml	872 ml
Water	500 ml	500 ml	500 ml	500 ml	500 ml	500 ml	0 ml

How to Use

Normal development time is 1½ to 2 minutes.

Miscellaneous Formulas

The formulas in this appendix are organized in the following order:
- reduction and intensification (covered in Chapter 7)
- toners (covered in Chapter 8)
- archival processing (covered in Chapter 9)

REDUCTION AND INTENSIFICATION

The following formulas are useful when repairing flaws in negatives and prints that cannot be fixed using other printing techniques. Reducers and intensifiers are most useful when a negative or print is either badly exposed or improperly developed.

Farmer's Reducer—DuPont 1-R (Subtractive)

DuPont formula 1-R is a subtractive reducer useful for removing excess density from overexposed negatives or prints.

Stock Solution A

Water (hot)	300.0 ml
Potassium ferricyanide	37.5 grams
Cold water to make	500.0 ml

Stock Solution B

Water (hot)	1.5 liters
Sodium thiosulfate (crystal)	480.0 grams
Cold water to make	2.0 liters

Working Solution

Stock solution A	30.0 ml
Stock solution B	120.0 ml
Cold water to make	1.0 liter

How to Use

Agitate the negative being reduced in the working solution for up to 5 minutes, depending on the amount of reduction needed. Stop reduction by washing with running water. The process can be repeated using a fresh working solution.

Farmer's Reducer—DuPont 1a-P (Proportional)

DuPont formula 1a-P is a proportional reducer useful for removing excess contrast from overdeveloped negatives or prints.

Working Solution A

Stock solution A	100.0 ml
Cold water to make	1.0 liter

Working Solution B

Stock solution B	210.0 ml
Cold water to make	1.0 liter

How to Use

Prepare from the stock solutions used to mix the DuPont Subtractive formula 1-R. Agitate the negative or print in working solution A for 1 to 4 minutes. Transfer to Solution B for 5 minutes. Rinse, inspect, and repeat as necessary. After reduction is complete, wash thoroughly.

Standard Chromium Intensifier

This is a bleach-and-redevelopment process that increases the contrast of an image by changing the image silver to a more opaque combination of silver and chromium.

Stock Solution A

Water (120° F)	500.0 ml
Potassium dichromate	100.0 grams
Cold water to make	1.0 liter

Safety Note: Potassium Dichromate

Always use gloves when handling solutions containing potassium dichromate. If the solution touches your skin, flush immediately with water.

Stock Solution B

Water (room temperature)	900.0 ml
Hydrochloric acid	100.0 ml

Working Solution

Just before use, mix the stock solutions as follows:

Strong intensification:	10 parts A	100 parts water	2 parts B
Medium intensification:	20 parts A	100 parts water	10 parts B
Slight intensification:	20 parts A	100 parts water	40 parts B

Safety Note: Mixing Acids

Always add an acid or an acid solution last in any formula or working solution.

How to Use

Agitate in your choice of working solution until the image has completely lightened to yellow. Wash and redevelop in a paper developer. Repeat up to three times, if necessary, to add intensification.

Formalin Supplementary Hardener—Kodak SH-1

A hardener is necessary when a process softens an emulsion so much that damage is likely to result. Kodak's Formalin Hardener is useful when reducing or intensifying prints or negatives or when using the HE-1 solution for archival processing.

Water (room temperature)	500.0 ml
Formaldehyde (37%)	10.0 ml
Sodium carbonate (monohydrate)	5.9 grams
Room-temperature water to make	1.0 liter

How to Use

Agitate film and prints in the hardening solution for 3 minutes at room temperature, rinse, agitate for 5 minutes in a fresh stop bath, and wash.

Safety Note: Formaldeyde

Always use gloves and provide plenty of ventilation when handling solutions containing formaldehyde. Not only is formaldehyde a suspected carcinogen, but it is toxic by skin contact and even more toxic by inhalation and ingestion.

TONERS

Toning affects the color of a print and in some cases can protect the silver image from fading. The formulas in this section are listed in alphabetical order.

Copper Brown Toner

This formula produces red-brown colors, depending on the paper emulsion. Start with a slightly overexposed print because the ferricyanide bleaches the print while toning.

Solution A

Water (room temperature)	500.0 ml
Copper sulfate	6.2 grams
Potassium citrate (either green or brown)	25.0 grams
Cold water to make	1.0 liter

Solution B

Water (room temperature)	500.0 ml
Potassium ferricyanide	5.2 grams
Potassium citrate (either green or brown)	25.0 grams
Cold water to make	1.0 liter

How to Use

Mix equal parts of each solution just before use. Tone by inspection and stop by washing when the desired color is reached.

Dye Toners

A mordanting bleach allows organic dyes to attach themselves to image silver. The following dyes can be used in either the single-solution or two-solution dye toner formulas. These dyes are available in small quantities from Eastman Chemicals Company (see Appendix G).

Dye	Catalog Number
Bismark brown (brown)	113 3255
Fuchsin (red)	113 3461
Malachite green (green)*	112 5939
Methyl violet (violet)†	112 6846
Methylene blue BB (blue)	107 0739
Rhodamine B (red)	117 1867
Safranin O (red)	113 3354

* Use 0.4 gram (instead of 0.2 gram) in the following toner formulas.
† Use 0.1 gram (instead of 0.2 gram) in the following toner formulas.

Single-Solution Dye Toner (Kodak T-20)

Dye	0.2 gram
Methyl alcohol	100.0 ml
Potassium ferricyanide	1.0 gram
Glacial acetic acid	5.0 ml*
Distilled water to make	1.0 liter

* You can substitute 18 ml of 28% acetic acid.

How to Use

Agitate prints in the T-20 toning solution from three to nine minutes at room temperature. Be careful not to overtone because the print may develop a chalky appearance and seem to lose contrast.

Two-Solution Dye Toner (Kodak T-17a)

Mordant

Distilled water	500.0 ml
Iodine	15.0 grams
Potassium iodide	50.0 grams
Glacial acetic acid	25.0 ml*
Distilled water to make	1.0 liter

* You can substitute 90 ml of 28 percent acetic acid.

Dye Bath

Water	500.0 ml
Dye	0.2 gram
Acetic acid (10%)*	5.0 ml
Water to make	1.0 liter

* Made by mixing one part glacial acetic acid to nine parts water or one part 28 percent acetic acid to three parts water. See page 169 for more information.

How to Use

Place the print to be toned in the mordant for 1 to 5 minutes. The image will turn a brownish gray. The longer you bleach, the more silver is mordanted and the deeper the dye tone will be. Then wash

for 5 minutes or until all of the bleach is removed from the print, and agitate in the Kodak T-17a dye bath for 2 to 5 minutes. Rinse, use stain remover if necessary, and wash.

Stain Remover

If there is an iodine stain in the gelatin of the print after toning, immerse the print into the following stain remover for no longer than 5 minutes.

Sodium bisulfite	500.0 grams
Water	750.0 ml
Sulfuric acid	100.0 ml*

* Gradually add the acid to the solution after all of the sodium bisulfite is dissolved.

Gold Toners

Gold toners are very flexible, offering a range of colors from warm brown to a cool blue. In addition, the inert quality of gold makes toned prints extremely stable.

Gold Protective Toner (Kodak GP-1)

GP-1 produces a slightly cool blue tone on bromide papers. When used on a previously sepia-toned print, it produces bright red colors. Works most consistently when mixed with distilled water.

Distilled water (room temperature)	750.0 ml
1% gold chloride solution	10.0 ml
Sodium thiocyanate	10.0 grams*
Distilled cold water to make	1.0 liter

* Dissolve sodium thiocyanate separately in about 40 ml of distilled water and add to the gold chloride. Ammonium or potassium thiocyanate may be substituted.

How to Use

Mix immediately before use. Tone fully washed prints for about 10 minutes or until a slight image color occurs. Then wash for an additional 10 minutes. Capacity is 30 8 × 10-inch prints per liter.

Nelson Gold Toner (Kodak T-21)

T-21 is somewhat difficult to prepare. It produces a wide variety of warm brown-black colors, depending on the length of time a print is in the toner.

Stock Solution A

Warm water (125° F)	4.0 liters
Sodium thiosulfate (crystal)	960.0 grams*
Ammonium persulfate	120.0 grams

* Make sure that the sodium thiosulfate is completely dissolved before adding ammonium persulfate. The solution should turn milky. If it doesn't, raise the temperature and stir until it does. Then cool the solution to room temperature, and add a solution composed of the following:

Cold water	64.0 ml
Silver nitrate	5.2 grams
Sodium chloride	5.2 grams*

* Make sure that the silver nitrate is completely dissolved before adding the sodium chloride.

Stock Solution B

Water	64.0 ml
Gold chloride	1.0 gram

How to Use

Add 125 ml of stock solution B to the entire amount of stock solution A. When a sediment has formed at the bottom of the container, pour off the clear liquid from the top to use. Use the toning solution between 100° and 110° F. Tone for 5 to 20 minutes, depending on the desired color. Be sure that all prints are completely wet before toning.

Gold-Thiocarbamide Toner (Ilford IT-5)

Creates blue tones on most papers similar to Kodak Blue Toner.

Stock Solution A

Thiocarbamide (Thiourea)	14.0 grams
Water to make	1.0 liter

Stock Solution B

Critic acid crystals	14.0 grams
Water to make	1.0 liter

Stock Solution C

Gold chloride	6.0 grams
Water to make	1.0 liter

How to Use

Take one part of Stock Solution A, one part of Stock Solution B, one part of Stock Solution C, and add 10 parts of water. Tone prints for 15 to 30 minutes depending on the color desired. Wash prints completely after toning is complete.

> **Safety Note: Thiocarbamide (Thiourea)**
> Always protect yourself from inhalation and skin contact when handling thiocarbamide. This chemical has been shown to be a powerful carcinogen in laboratory animals.

Iron Blue Toner

This toner is easy to mix and use. It produces a vivid cyan blue on most printing papers.

Water (110° F)	500.0 ml
Ferric ammonium citrate (green scales)	4.0 grams
Oxalic acid	4.0 grams
Potassium ferricyanide	4.0 grams
Cold water to make	2.0 liters

How to Use

Agitate the print in a tray of toner for 5 to 10 minutes or until the color of the print is what you want. Then wash until all of the

yellow is removed from the white borders of the print. Overwashing or washing in overly chlorinated water will cause the blue to fade.

Polysulfide Toner (Kodak T-8)

This is a single-solution sulfide toner. The brown tones produced on most papers are darker than the tones that a bleach-and-redevelop toner like sepia will produce. Can also be used as a post treatment to increase the life of prints.

Water (110° F)	750.0 ml
Polysulfide (liver of sulfur)	7.5 grams
Sodium carbonate (monohydrate)	2.4 grams
Cold water to make	1.0 liter

How to Use

- For a color change, agitate the print in the toner for 15 to 20 minutes at 70° F or for 3 to 4 minutes at 100° F.
- For archival purposes, agitate the print for approximately 1 minute at approximately 70° F, followed by 1 minute in a 10% solution of sodium sulfite.

Wash the print well after toning to remove any sediment that might be left on the surface from a partially exhausted toner. You can lightly brush off the sediment if washing is not enough. Capacity is approximately 40 8 × 10-inch prints per liter.

Red Toner

This toner produces rich red colors on most papers. Start with a slightly overexposed print because the ferricyanide bleaches the print while toning.

Water (110° F)	500.0 ml
Ammonium carbonate (saturated)*	60.0 ml
Copper sulfate	1.5 grams
Potassium ferricyanide	3.0 grams
Cold water to make	2.0 liters

* To make a saturated solution, add 50 grams of ammonium carbonate to 250 ml of water and let it stand for several days, shaking periodically. Not all of the ammonium carbonate will dissolve at room temperature. To use, decant the solution (i.e., pour off and use only the liquid, leaving any undissolved ammonium carbonate behind).

How to Use

Mix immediately before using, and tone for a minute longer than it takes to produce a red color in the darkest shadows or until the desired effect is reached. Then rinse the print, refix, and wash, using a washing aid as usual. Pink stains in the highlights can be cleared by soaking the print in a weak solution of nonsudsing household ammonia (ammonium hydroxide): approximately 5 drops per liter of water.

Sepia

Sepia toner produces warm colors, primarily on neutral-color papers.

Bleaching Solution A

Water (110° F)	1.0 liter
Potassium ferricyanide	75.0 grams
Potassium bromide	75.0 grams
Potassium oxalate	195.0 grams
28% Acetic acid	40.0 ml
Cold water to make	2.0 liters

Toning Solution B

Water (room temperature)	300.0 ml
Sodium sulfide (not sulfite)	45.0 grams
Cold water to make	500.0 ml

How to Use

Mix 500 ml of solution A with 500 ml of water in a tray and agitate the print until all traces of black silver have gone (can be up to 10 minutes, depending on how fresh the bleach is). You can bleach for less time if you want a darker brown. Rinse the bleached print for 2 minutes to remove the yellow and then place it in a tray containing 125 ml of solution B per liter of water. Full toning takes place in about 30 seconds. You cannot overtone. **Use only in a well-ventilated area.**

Alternative Sepia Toning Solution B

The following formula is a sepia toning solution that doesn't produce hydrogen sulfide gas.

Water (room temperature)	500.0 ml
Thiocarbamide (Thiourea)	0.2 grams
Sodium Carbonate (monohydrate)	100.0 grams
Cold water to make	1.0 liter

> **Safety Note: Thiocarbamide (Thiourea)**
>
> Always protect yourself from inhalation and skin contact when handling thiocarbamide. This chemical has been shown to be a powerful carcinogen in laboratory animals.

ARCHIVAL PROCESSING

The long-term preservation of photographs requires careful control of the printing process and rigorous testing to be certain that all harmful compounds are removed from the photographic paper. The following formulas make careful processing easier and provide tests for the two compounds most harmful to prints: undissolved silver and residual sulfur.

Nonhardening Fix (Kodak F-24)

A nonhardening fix has an advantage over formulas containing a hardener for toning and archival washing. A nonhardened print will accept toning more evenly and will release sulfur compounds more easily when washed.

Water (125° F)	500.0 ml
Sodium thiosulfate (crystal)	240.0 grams
Sodium sulfite (anhydrous)	10.0 grams

| Sodium bisulfite | 25.0 grams |
| Cold water to make | 1.0 liter |

How to Use

A two-bath system is recommended. Agitate constantly in each tray for 3 to 5 minutes. A storage tray of running water may be used between the trays to prolong the life of the second tray. Move the second tray up when the first is exhausted and mix a fresh second tray. Capacity is 25 8 × 10-inch prints per liter.

Fixer Test (Kodak FT-1)

The FT-1 test works because excess silver in a fixing solution forms a milky yellow-white precipitate in the presence of certain iodine compounds.

Water (room temperature)	750.0 ml
Potassium iodide	190.0 grams
Room-temperature water to make	1.0 liter

How to Use

Add five drops of FT-1 to a solution of 5 drops of fixer and 5 drops of water. The formation of an obvious precipitate indicates exhaustion. A slight cloudiness isn't an indication of exhaustion.

Washing Aid

The following formula is similar to Kodak's Hypo Clearing Agent.

Water (125° F)	500.0 ml
Sodium sulfite (anhydrous)	200.0 grams
Sodium bisulfite	2.0 grams
Cold water to make	1.0 liter

How to Use

Dilute 1:9 to make a working solution.

Hypo Eliminator (Kodak HE-1)

The HE-1 formula oxidizes residual amounts of fix in an emulsion to a compound that is harmless to silver images. This formula can cause the base of some papers to turn from white to cream.

Water (room temperature)	500.0 ml
Hydrogen peroxide (3% solution)	125.0 ml
Ammonia (3% solution)	100.0 ml*
Room-temperature water to make	1.0 liter

* To make ammonia solution, add 1 part 28 percent ammonia to nine parts water.

How to Use

Prepare immediately before use. After prints have been toned (except for gold toners) and washed, place in a tray of HE-1, and agitate for six minutes. Wash again for 20 minutes. *Caution:* print emulsions are softened in this process, so be careful, or use the Formalin supplementary hardener (SH-1). Capacity is 50 8 × 10-inch prints per liter.

Dehardening Solution

Most toners and many archival after treatments are not as effective if a print has been hardened during fixing. The following formula will soften the emulsion of a hardened print so that toning, spotting, and washing are more effective.

Water (room temperature)	750.0 ml
Sodium carbonate (monohydrate)	20.0 grams
Room-temperature water to make	1.0 liter

How to Use

Soak the print for up to 10 minutes in the solution, agitating occasionally.

Residual Hypo Test (Kodak HT-2)

The HT-2 solution reacts with fix to cause a yellow-brown stain. The darker the stain, the more fix remains in the emulsion. The solution should be stored in a dark glass bottle away from strong light. Because you use this solution only a drop at a time, a convenient storage container is a small brown eye dropper bottle, available at most drug stores.

Water (room temperature)	750.0 ml
28% Acetic Acid	125.0 ml
Silver nitrate	7.5 grams*
Room-temperature water to make	1.0 liter

* Silver nitrate requires 24 hours to completely dissolve.

How to Use

Place a drop on the center of a blank white piece of print paper that has been washed with the prints to be tested. After 2 minutes in subdued light, flush the print with a mild salt water solution. The presence of anything more than a slight yellow stain indicates that fix remains in the print and that the prints need more washing.

Residual Silver Test (Kodak ST-1)

The ST-1 test detects the presence of undissolved silver compounds in the print. These can be the result of either inadequate fixing or overfixing in which previously dissolved silver is absorbed into the paper fibers.

Water (room temperature)	60.0 ml
Sodium sulfide (not sulfite)	7.5 grams
Room-temperature water to make	100.0 ml

How to Use

Place a drop of the solution on a clear area of the print, such as the border. Wait 5 minutes. A noticeable brown stain indicates excess silver in the emulsion. Use only in a well-ventilated area. The solution keeps only 3 months.

Alternative Residual Silver Test Solution

Another residual silver test solution can be made from a 10% solution of selenium toner concentrate, mixed as follows.

Water (room temperature)	90.0 ml
Selenium toner concentrate	10.0 ml

How to Use

Use this solution in the same manner as ST-1. Residual silver is indicated by a red stain.

Wetting Agent for Film

Wetting agents like Kodak's Photo-flo diluted with tap water can cause problems with precipitated minerals forming spots on film emulsions. Mixing a wetting agent in the following manner will eliminate most problems.

Distilled Water	3.0 liters
70% or 91% Isopropyl alcohol	100.0 ml.
Kodak Photoflo 200 (or equivalent)	10.0 ml.
Distilled Water to make	4.0 liters

How to Use

Soak the washed film for 1 to 2 minutes in the solution and hang to dry without wiping. The solution can be reused and will keep for several months in a tightly closed bottle.

Appendix

Supplies

The following is a list of suppliers that sell unusual or hard-to-get items through the mail. In most cases, you can write, call, or visit their web site for information. Note that most of the 800 and 888 numbers are for use only inside the United States.

ARCHIVAL STORAGE

Franklin Distributors Corp
P.O. Box 320
Denville, NJ 07834
1-888-249-4870
(973) 267-2710
www.franklindistribcorp.com

Polypropylene negative storage sleeves and related negative storage devices.

The Hollinger Corp.
P.O. Box 8360
Fredericksburg, VA 22401
1-800-634-0491
(703) 671-6600
www.gshost.com/hollinger corp

Archival storage boxes, Tyvek negative storage envelopes, mat board, and Permalife paper for interleaving and cover sheets. Discounts for quantity purchases.

Light Impressions
P.O. Box 22708
Rochester, NY 14692-2708
1-800-828-6216
(716) 271-8960
www.lightimpressionsdirect.com

Archival supplies and other products, many made especially for Light Impressions. Separate catalogs for books, archival supplies, and general photographic equipment.

Photofile
466 Central Ave., Suite 31
Northfield, IL 60093
(847) 441-5450
www.photofil.com

Innovative polyester film storage devices.

TALAS
Division of Technical Library
Services, Inc.
568 Broadway
New York, NY 10012-3225
(212) 219-0770

Archival supplies, primarily for libraries. Many products are useful to photographers.

University Products
517 Main Street
P.O. Box 101
Holyoke, MA 01041-0101
1-800-336-4847
www.universityproducts.com

Archival storage and framing supplies for artists working in all mediums.

CHEMICALS, GENERAL

Artcraft Chemicals, Inc.
P.O. Box 583
Schenectady, NY 12301
1-800-682-1730
(518) 355-8700

Chemicals and literature especially for photographers. Many pre-packaged kits for special processes.

Bryant Laboratory, Inc.
1101 Fifth Street
Berkeley, CA 94710
(510) 528-2948
www.sirius.com/~bry_lab

Chemicals and laboratory equipment selected specifically for artists.

Photographer's Formulary
P.O. Box 950
Condon, MT 59826-0950
1-800-922-5255
(406) 543-4534
www.photoformulary.com

Hard-to-find chemicals and packaged versions of popular formulas not normally available in stores.

**Sprint Systems of
Photography**
100 Dexter Street
Pawtucket, RI 02860
(401) 728-0913
www.sprintsystems.com

Innovative darkroom chemicals in liquid concentrate form. Available in some camera stores as well as through mail order.

Tri-Ess Sciences, Inc.
1020 W. Chestnut Street
Burbank, CA 91506
1-800-274-6910
www.tri-esssciences.com

Darkroom chemicals, labware, and scales for photographers. Will sell in small quantities.

CHEMICALS, SPECIALTY

Berg Color-Tone, Inc.
72 Ward Road
Lancaster, NY 14086
(716) 681-2696
www.bergcolortone.com

Specialty toners and print-retouching supplies as well as a source of toning information. One of only two sources for commercially packaged dye toners.

D.F. Goldsmith Chemical and Metal Corporation
909 Pitner Avenue
Evanston, IL 60202
(847) 869-7800
www.dfgoldsmith.com

Gold chloride sold by the gram and silver nitrate sold by the ounce. Call or check the web site for a current price quotation. Be sure to specify the quantities you are interested in.

Eastman Chemicals Company
P.O. Box 431
Kingsport, TN 37662-0431
1-800-327-8626
www.eastman.com

The only known source for organic dyes used in dye toner formulas. Also a source of standard laboratory chemicals.

DARKROOM EQUIPMENT

Aristo Grid Lamp Products
35 Lumber Road
Roslyn, NY 11576
www.aristogrid.com

Cold light heads to fit most enlargers.

Classic Enlargers
145 Jeanne Court
Stamford, CT 06903
(203) 329-9228
www.classic-enlargers.com

Sale of refurbished Omega D-series enlargers and parts, plus fabrication of hard-to-get enlarger parts.

Darkroom Innovations
P.O. Box 19450
Fountain Hills, AZ 85269
(480) 767-7105
www.darkroom-innovations.com

A line of useful, high quality, darkroom equipment.

Edmund Scientific
101 East Gloucester Pike
Barrington, NJ 08007-1380
1-800-728-6999
www.scientificsonline.com

An eclectic source of laboratory equipment and science "toys." Not the cheapest source, but has many useful items not easy to find elsewhere.

Kinetronics
1778 Main Street
Sarasota, FL 34236
1-800-624-3204
(941) 951-2432
www.kinetronics.com

Antistatic brushes, cloths, film cleaners, and other devices for removing dust from film.

Light Impressions
P.O. Box 22708
Rochester, NY 14692-2708
1-800-828-6216
(716) 271-8960
www.lightimpressionsdirect.com

See description under "Archival Storage."

Summitek
3647 West 1987 South
Salt Lake City, UT 84104
(801) 972-8744
www.summitek.com

Archival print and film washers.

Versalab
1509 Sunnyside
Loveland, CO 80538
(970) 622-0240
www.versalab.com

No frills alignment devices, printwashers, and densitometers.

FRAMES AND MAT BOARD

Crescent Cardboard Co.
100 W. Willow Road
Wheeling, IL 60090
1-800-323-1055
(847) 537-3400
www.artboards.com

Comprehensive source of museum and conservation board. Although many dealers carry this line of mat board, none can offer the depth of selection that you can get directly from the manufacturer.

Light Impressions
P.O. Box 22708
Rochester, NY 14692-2708
1-800-828-6216
(716) 271-8960
www.lightimpressionsdirect.com

See description under "Archival Storage."

University Products
517 Main Street
P.O. Box 101
Holyoke, MA 01041-0101
1-800-336-4847
www.universityproducts.com

See description under "Archival Storage."

Westfall Framing
P.O. Box 13524
Tallahassee, FL 32317
1-800-874-3164
(904) 878-3564

Wood and metal sectional frames and many other supplies for framing. Informative catalog.

SAFETY & ENVIRONMENT

Lab Safety Supply
P.O. Box 1368
Janesville, WI 53547-1368
1-800-543-8810
www.LabSafety.com

Comprehensive source of safety equipment, including nitrile gloves, safety glasses, and respirators. Catalog and web site offer useful safety information.

Terragreen
P.O. Box 540
Cherry Valley, NY 13320
(607) 264-3480
www.cherryvalley.com/terragreen

Information and products for environmentally responsible disposal of photographic chemicals.

MISCELLANEOUS

General Production Services
883 S. East Street
Anaheim, CA 92805
(714) 535-2271

Manufacturer of "Lens Clens Industrial Optical Cleaner," a legendary lens cleaning solution. Expensive per ounce, but a little goes a long way.

INTERNATIONAL

Purchasing supplies from another country can be expensive and getting darkroom chemicals through customs can prove frustrating. The following are some suppliers located outside the United States.

Boreal Laboratories Ltd.
399 Vansickle Road
St. Catherines, Ont. L2S 3T4
Canada
1-800-387-9393
www.boreal.com

Laboratory supply company supplying science equipment to schools throughout Canada. Source of chemicals, scales, and other labware.

Conservation Resources Ltd.
Unit 1 Pony Road
Horspath Industrial Estate
Cowley, Oxfordshire,
OX4 2RD
United Kingdom
(0)1 865 747755
www.conservationsources.com

Carries print storage boxes, mat boards, negative sleeves, and more.

Northwest Scientific Supply
P.O. Box 6100
#301-3060 Cedar Hill Road
Victoria, BC V8T 3J5
Canada
www.nwscience.com

Laboratory supply company catering to schools and industry. Source of chemicals, scales, and other labware.

Nymoc Products Co.
24 McGee Street
Toronto, Ont. M4M 2K9
Canada
(416) 465-1929

Chemical supply company that caters to the needs of photographers. Call ahead for prices and availability (no catalog available).

Silverprint Ltd.
12 Valentine Place
London SE1 8QH
United Kingdon
www.solverprint.co.uk

Carries a variety of films, papers, and chemicals, including materials for alternative photographic printing processes.

Appendix **H**

Books

The following is a list of worthwhile publications that cover subjects discussed in this book. Although some of these books are no longer in print, many may be found in libraries or used bookstores. A valuable Internet source of used books is *www.bookfinder.com*.

GENERAL

Beyond Basic Photography
Horenstein, Henry
Boston, MA
Little, Brown, 1977

Excellent text covering all aspects of photography.

The Craft of Photography
Vestal, David
New York, NY
Harper and Row, 1975

General-purpose text. Notable for the clearly stated opinions of the author, a thoughtful photographer and experienced teacher.

Eastman Kodak Company
Department 454
343 State Street
Rochester, NY 14650
www.kodak.com

Kodak sells (and gives away) a wide range of literature on all aspects of photography. See Kodak's web site for a current list or send for publication L-1, "Index to Photographic Information."

Exploring Black and White Photography
Gassan, Arnold
Dubuque, IA
Wm. C. Brown, 1989

One of the best books on basic and intermediate photographic processes. Contains a practical chapter on photographic aesthetics, unusual for a book of this type.

Into Your Darkroom Step by Step
Curtin, Dennis, and Steve Mussleman
Boston, MA
Focal Press, 1981

A clearly illustrated review of basic darkroom procedures. Contains many practical suggestions for new workers.

Photographic Chemistry
Eaton, George T.
Hastings-on-Hudson, NY
Morgan & Morgan, Inc., 1965

A clearly written primer on the chemical processes in black-and-white and color photography. No formulas, just basic knowledge that all photographers should have.

Photographic Possibilities
Hirsh, Robert
Boston, MA
Focal Press, 1991

A wide-ranging discussion with many specific examples of different photographic techniques and how they might be used creatively.

The Print
Adams, Ansel
Boston, MA
Little, Brown, 1983

Much of Ansel Adams's writings are rightfully enshrined in the pantheon of technical photographic literature. His volume on printing is a classic, though it is somewhat biased toward a representational approach to photography.

Photographic Printing
Hattersley, Ralph
Englewood Cliffs, NJ
Prentice-Hall, 1977

Interesting descriptions of a number of pictorial techniques, such as texture screens, print solarization, and something called the Emmerman process.

DARKROOM DESIGN AND CONSTRUCTION

Build Your Own Home Darkroom
Duren, Lista, and Will McDonald
Amherst, NY
Amherst Media, 1990

A concise, well-written guide to creating a darkroom in a house or apartment. Easy-to-follow instructions.

The Darkroom Builder's Handbook
Hausman, Carl, and Stephen DiRado
Blue Ridge Summit, PA
TAB Books, 1985

Practical information on the design and construction of darkrooms on a budget. Easy to read and follow. A final chapter on making prints and critiquing images is less useful.

The Darkroom Handbook
Curtin, Dennis, and Joe DeMaio
Boston, MA
Curtin and London, 1979

A clear and useful text on buying darkroom materials and building darkroom equipment.

Photolab Design
Kodak Publication K-13
Catalog No. 152 7977
Rochester, NY
Eastman Kodak Co., 1977

Geared mostly to commercial labs and photographers with a trust fund. Contains a useful section on darkroom floor plans and serves as a wish list of equipment to purchase or to make yourself.

FORMULARIES

150 Do-It-Yourself Black and White Photographic Formulas
Dignan, Patrick, ed.
North Hollywood, CA
Dignan Photographic, 1977

A chaotic book, mostly concerned with film development. Still, well worth mining for nuggets of valuable information.

PhotoLab Index
Pittaro, Ernest, ed.
Hastings-on-Hudson, NY
Morgan and Morgan, 1939

The standard reference work for photographic processes. Continually updated, although older editions tend to have a more comprehensive listing of formulas than current editions.

Photographic Facts and Formulas, 4th ed.
Wall, E.J., and Franklin Jordan
Garden City, NY
American Photographic Publishing, 1975

A classic formulary, occasionally updated. Although some of the processes in the latest edition haven't been updated to accommodate contemporary materials, this book is still a valuable catalog of formulas not easily available elsewhere.

TECHNICAL

Controls in Black and White Photography, 2nd ed.
Henry, Richard J.
Boston, MA
Focal Press, 1988

The published results of exhaustive personal testing by a meticulous worker. This book answers questions most photographers haven't thought of yet.

Modern Photographic Processing
Haist, Grant
New York, NY
John Wiley and Sons, 1979

A two-volume classic of technical photographic literature. Contains clear explanations of virtually all photographic processes written by a long-time associate at the Kodak Research Laboratory. Hard to find, but worth the effort.

Photographic Sensitometry
Todd, Hollis N., and Richard D. Zakia
Hastings-on-Hudson, NY
Morgan and Morgan, 1969

This study of tone control in photography relies primarily on data gathered by exposing and processing film. The principles discussed here, however, apply to all photographic emulsions.

ARCHIVAL PROCESSING AND PRESERVATION

American National Standards Institute
1430 Broadway
New York, NY 10018
www.ansi.org

ANSI standards describe performance and test methods for many products, including photographic materials. You can download a current catalog of ANSI standards for a nominal cost.

Care and Identification of 19th-Century Photographic Prints
Reilly, James M.
Rochester, NY
Eastman Kodak, 1986

Despite the title, contains a wealth of information that pertains to contemporary photographic materials.

Collection, Use, and Care of Historical Photographs
Weinstein, Robert, and Larry Booth
Nashville, TN
American Association for State and Local History, 1977

Practical information for the storage and care of photographs as well as restoration of older or damaged images.

Conservation of Photographs
Kodak Publication F-40
Eaton, George T.
Rochester, NY
Eastman Kodak Co., 1985

Comprehensive work on the various aspects of conserving and collecting photographs. Beautifully reproduced color photographs make the book expensive and less focused on the issues of black-and-white photography.

The Life of a Photograph
Keefe, Laurence E., and Dennis Inch
Boston, MA
Focal Press, 1990

A complete description of archival processing, matting, framing, and storage. Includes both practical and theoretical information.

The Permanence and Care of Color Photographs
Wilhelm, Henry, and Carol Browner
Grinnell, IA
Preservation Publishing Company, 1993

The most exhaustive work to date about the lasting properties of both color and black-and-white photographic materials. Includes much practical information about proper selection and storage of film and printing paper.

The Use of Water in Photographic Processing
Kodak Publication J-53
Rochester, NY
Eastman Kodak Company, 1978

A short pamphlet discussing the theory of washing, water quality, and how to conserve water during processing.

The Wash Book
Conrad, Roger
Newhall, CA
Teamworks, 1978

The published results of personal testing for washing effectiveness and water conservation. Contains practical information about how to wash prints properly.

SAFETY

Clinical Toxicology for Commercial Products
Gosselin, Robert E., et al
Williams and Wilkins,
Baltimore, 1984, 5th edition.

Ground breaking work when first published in the 1950s. Still considered a standard reference on chemical safety.

The Dose Makes the Poison
Ottoboni, M. Alice
Berkley, CA
Vincenta Press, 1984

A plain language primer on toxicology. Although not specifically about photography, a must read for photographers working in the darkroom. Gives perspective on realistically assessing the risks involved.

Industrial Ventilation, A Manual of Recommended Practice
American Conference of Governmental Industrial Hygienists
Cincinnati, 1992, 21st edition.

Written for professionals in the field. Covers all aspects of air physics, dilution ventilation, and ventilation hoods.

Making Darkrooms Saferooms
Tell, Judy, ed.
Durham, NC
National Press Photographers Association, 1989

A variety of essays discussing the practical application of darkroom safety. Available directly from the NPPA (3200 Croasdaile Drive, Suite 306, Durham, NC 27705).

Material Safety Data Sheets
www.msdsonline.com
www.worldsafety.com
www.hazard.com

Internet locations of Material Safety Data Sheets (MSDS) and other valuable safety information. Also check the manufacturer's web site (e.g., www.kodak.com, www.ilford.com, etc.)

Patty's Industrial Hygiene
Harris, Robert, Ed.
John Wiley and Sons
New York, 2000, 5th edition

Standard reference in occupational health and safety for over 50 years. Very technical and expensive to buy, but available in many reference libraries.

Overexposure: Health Hazards in Photography
Shaw, Susan
Carmel, CA
The Friends of Photography, 1983

A comprehensive work on chemical hazards in photography. Better at discussing the details than providing an overall view of the subject.

Safe Practices in the Arts and Crafts
Barazani, Gail
New York, NY
College Art Association, 1978

A general work on safety issues related to all arts materials. Includes a section on photography.

Index

P

R

Photo Credits

All photographs by the author unless credited.